WORLD PRESS PHOTO

13

Thames & Hudson
Art Institute Library

CONTENTS

World Press Photo of the Year 2012 winner / **Paul Hansen**

Christine Olsson

Paul Hansen is a Swedish photo-journalist and has worked for the daily newspaper Dagens Nyheter *since 2000. He began his career as a photographer with* Göteborgs-Tidningen *in 1984, then, after a period working freelance in New York, spent eight years with* Expressen *in Stockholm. Hansen has received numerous awards, including being named Photographer of the Year by Pictures of the Year International in 2010 and 2013, Photographer of the Year in Sweden seven times, and two first place awards from National Press Photographers Association. He is based in Stockholm.*

How did you become interested in photography and in photojournalism?
My interest in photography began in childhood, long before I had even heard of photojournalism, when an uncle gave me a camera. It became a ticket, a way to see the world, to explore it. Photojournalism and more complex storytelling was something that developed naturally, when I started my first job at *Göteborgs-Tidningen*.

In a world where so many photojournalists work freelance, you are a staff photographer with Dagens Nyheter. *Does being with a newspaper shape the way you work?*
My journalistic driving force is the same whether I work freelance or as staff, but being a staff photographer makes it easier to develop long-term stories, and to pitch ideas that—if they came from a freelancer—might be seen as an additional expense. Also, I very much enjoy bouncing my ideas off other journalists and editors, an opportunity that working in a newspaper environment affords. I worked as a freelancer in New York for almost four years, so I realize what it means in terms of financial insecurity, and having to meet journalistic priorities that are not your own. This is especially true when it comes to stories with potential personal safety issues, such as in conflict situations. Being a staff photographer makes it easier to make difficult on-the-spot decisions. I try to evaluate dangerous situations on the basis of the relevant facts, and not take unnecessary risks because of the feeling that if you don't get the pictures, you won't get paid.

What are your thoughts about the position of photography in the print media at the moment?
Robert Capa, while on assignment in the prelude to what became the Vietnam War, supposedly saw a TV broadcast of scenes he had shot that day, and announced: "Still photography is dead." In one way he had a point, still photography as the main vehicle of visual journalism had been affected in a major way—but in declaring it deceased he was wrong. The development of one medium doesn't necessarily mean the demise of another, and the same goes for new media today. I do not think there is a

crisis in photography, as such. Certainly, there is a crisis for the printed media that very much affects photography. But in a world where images are playing an increasingly widespread and important part, editors should be aware of cutting back on photojournalism. A vibrant and dynamic photo department not only helps give a newspaper or magazine its unique voice, it also functions as a strong journalistic driving force within the paper.

Can you describe the circumstances behind the winning photo?
For me, the story of this photo started the previous night. A Norwegian doctor told me about an attack earlier that evening on a family home in which three people had died—a father and his two sons. The doctor was concerned about how he was going to be able to tell the surviving mother that her husband and sons were dead, and their house was destroyed. I had to fight back my own tears as I listened. It was only one of many similar stories that night.
Next morning, I set out with a journalist to cover the day's events. One of these was a funeral in Jabaliya. At the local morgue, several families had come to retrieve their dead. We decided to cover one of the funerals, and started to follow the mourners, who, according to custom, first carry the deceased home, then to the mosque and cemetery. We followed the procession for some time, but it never seemed to arrive at the family home—and it struck me that this must be the Hijazi family I had heard about the night before. There was no house to go to. After a while, the mourners arrived at an alleyway, which elongated the crowd. I went on ahead, walking backwards for a while until sunlight bounced off the walls and gave the moment its light.

It was a terrible day. It's hard to cover any funeral, especially one with children. Having a daughter of my own made it even more heart-rending for me.

The bodies of two-year-old Suhaib Hijazi and his elder brother Muhammad, almost four, are carried by their uncles to a mosque for their funeral, in Gaza City. The children were killed when their home was destroyed by an Israeli airstrike on 19 November. The strike also killed their father, Fouad, and severely injured their mother and four other siblings. Israel had begun an intense offensive against Hamas-ruled Gaza on 14 November, in response to continued rocket fire from Palestinian militant groups. In the first days of the offensive, Israel struck at targets of military and strategic importance, though the scope of attack later widened to include residences suspected of harboring Hamas militants. By the time a ceasefire was brokered on 21 November, over 150 people had been killed in Gaza. Of these, 103 were thought to be civilians, including at least 30 children.

Spot News / **Paul Hansen**

Sweden, *Dagens Nyheter* / 1st Prize Singles

World Press Photo of the Year 2012

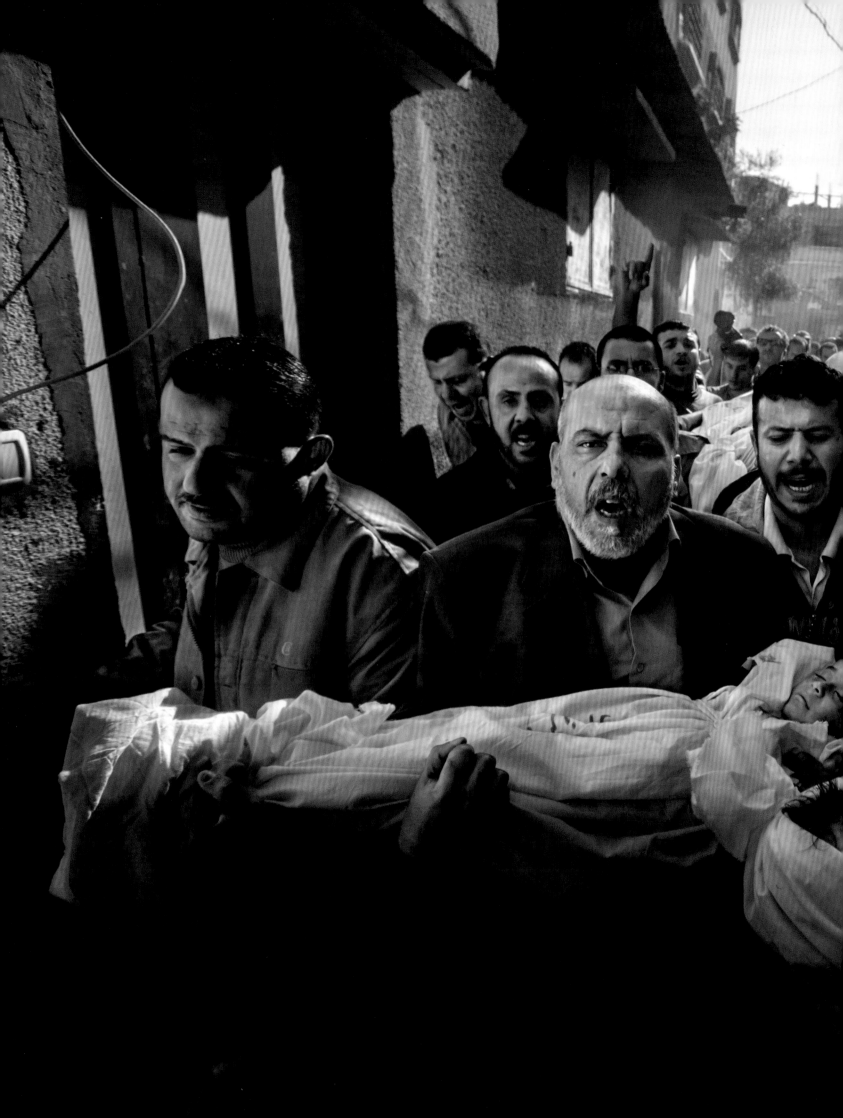

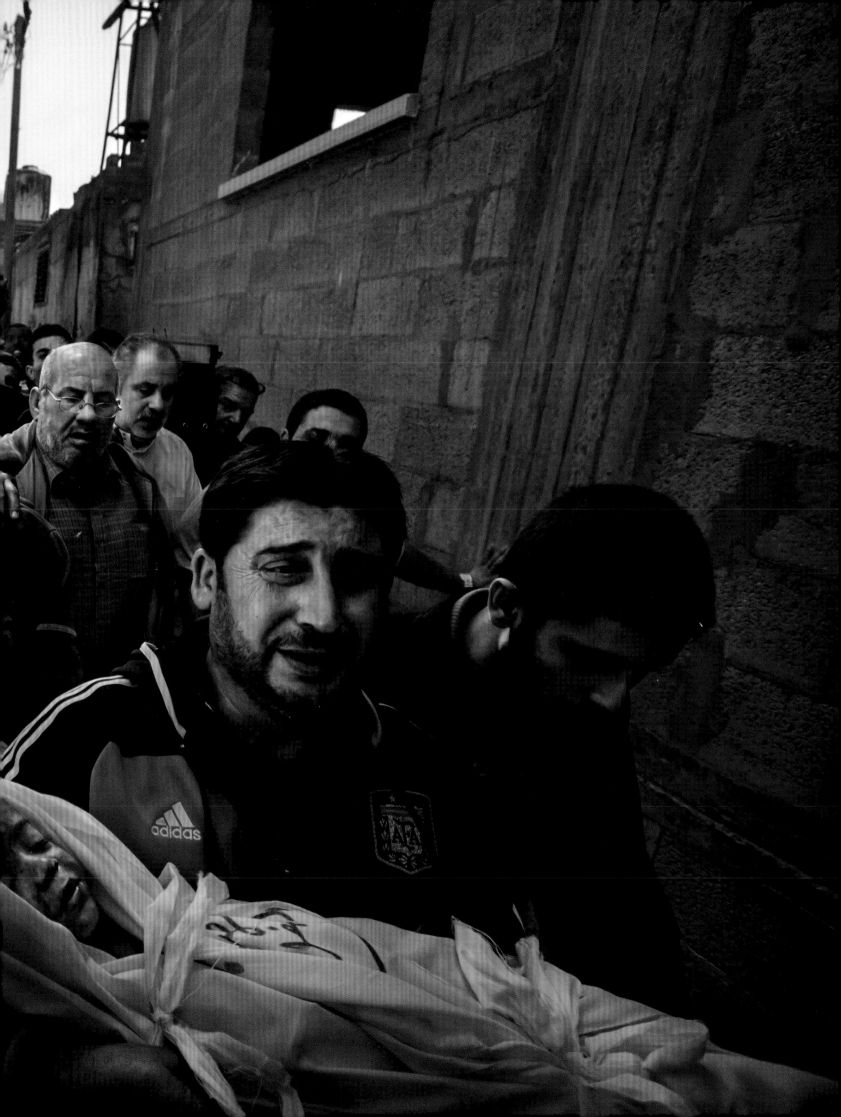

Chair of the 2013 Jury / **Santiago Lyon**

The 2013 World Press Photo juries gathered in a chilly Amsterdam in February, to start their work of distilling 103,481 images down to the award winners in nine categories.

Specialized first-round juries advanced nearly 10,000 images for the final jury to contemplate. As chair of that jury, my goals were twofold—firstly, to be mindful that the winning images should reflect the global nature of the entries, their journalistic strength, and their powerful photography. In short, three words: world, press, photo.

Secondly, I wanted to make sure that every jury member had an opportunity to express their opinion about every photo, and thus many hours were spent hearing a broad range of different views on each image before we voted. This approach, combined with the well-thought-out process that the World Press Photo Foundation has perfected over more than half a century, made for a meticulous judging.

Paul Hansen's World Press Photo of the Year is a powerful and direct image from Gaza that functions on multiple levels. It reaches your head, your heart, and your stomach—all the keys to effective photojournalism.

When I look at the results—both the World Press Photo of the Year, and all the other photos that were given prizes—I see stellar examples of first-rate photojournalism that are powerful, that are lasting, and that will reach all those who contemplate them. In addition, the winning images will undoubtedly serve to inspire current and future photographers, thus playing an important role in the crucial work of documenting global events and telling compelling stories, through which we can better understand the complex world in which we live.

Santiago Lyon
Vice President and Director of Photography
The Associated Press

SPOT NEWS

SINGLES
1st Prize / **Paul Hansen**
2nd Prize / **Emin Özmen**
3rd Prize / **Adel Hana**
STORIES
1st Prize / **Bernat Armangue**
2nd Prize / **Fabio Bucciarelli**
3rd Prize / **Javier Manzano**

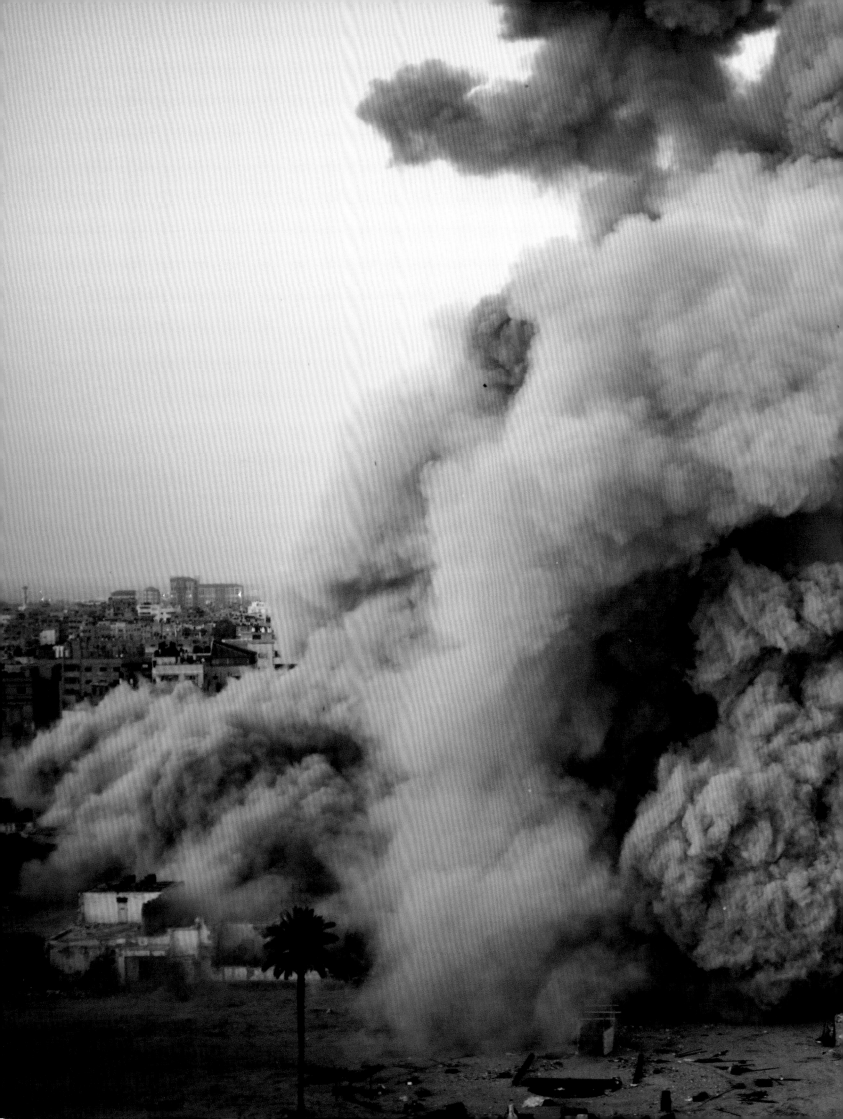

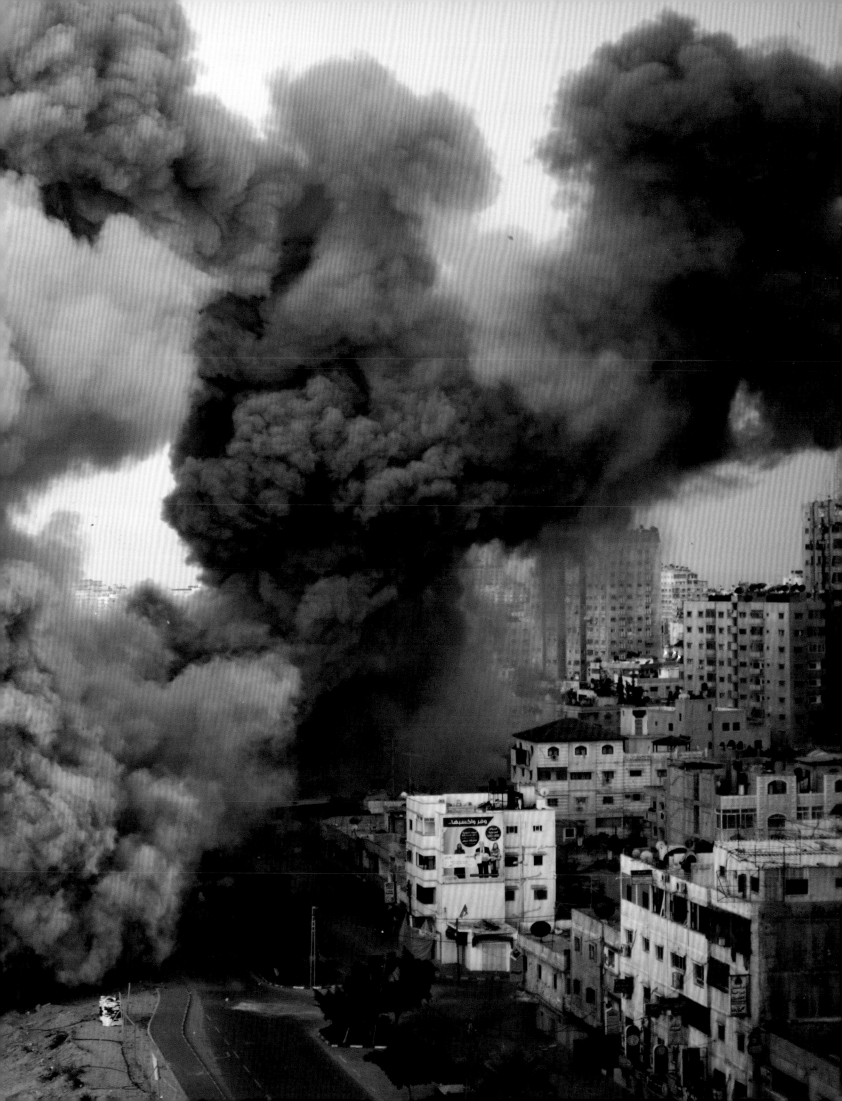

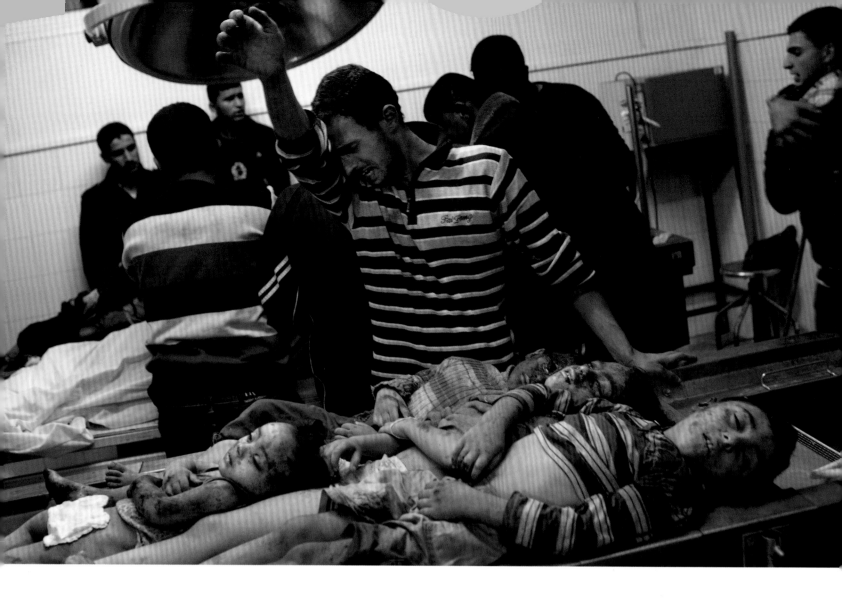

Israel launched a military offensive against targets in Hamas-ruled Gaza, on 14 November.
Israeli authorities said that Operation Pillar of Defense was aimed at protecting citizens
from the hundreds of missiles fired into Israel by militants in Gaza. Initially, Israeli air-
strikes were directed at rocket-storage sites and Hamas security facilities, as well as at
smuggling tunnels and electricity sources. On the first day of the attack, Ahmed al-Jabari,
the commander of Hamas's military wing, was killed in a pinpoint airstrike as he was
riding in a car on a Gaza street. Attacks soon escalated to include the police headquarters
in Gaza City, and homes of suspected Hamas activists. Civilian casualties began to
rise. A ceasefire was reached on 21 November. Previous spread: Smoke rises in Gaza
City, after an Israeli airstrike on 18 November. Above: A man cries beside the bodies of
four children, in the morgue of Al-Shifa Hospital in Gaza City. Health officials said the
children and five women were among the dead after a missile destroyed a house in a
residential neighborhood. Facing page, top: A woman mourns at the funeral of Salem
Paul Sweliem, a Greek Orthodox carpenter hit by shrapnel during an airstrike on a high-
rise in Gaza City that killed a leading militant. Below: A Palestinian man kisses the hand
of a dead relative in the morgue of Al-Shifa Hospital.

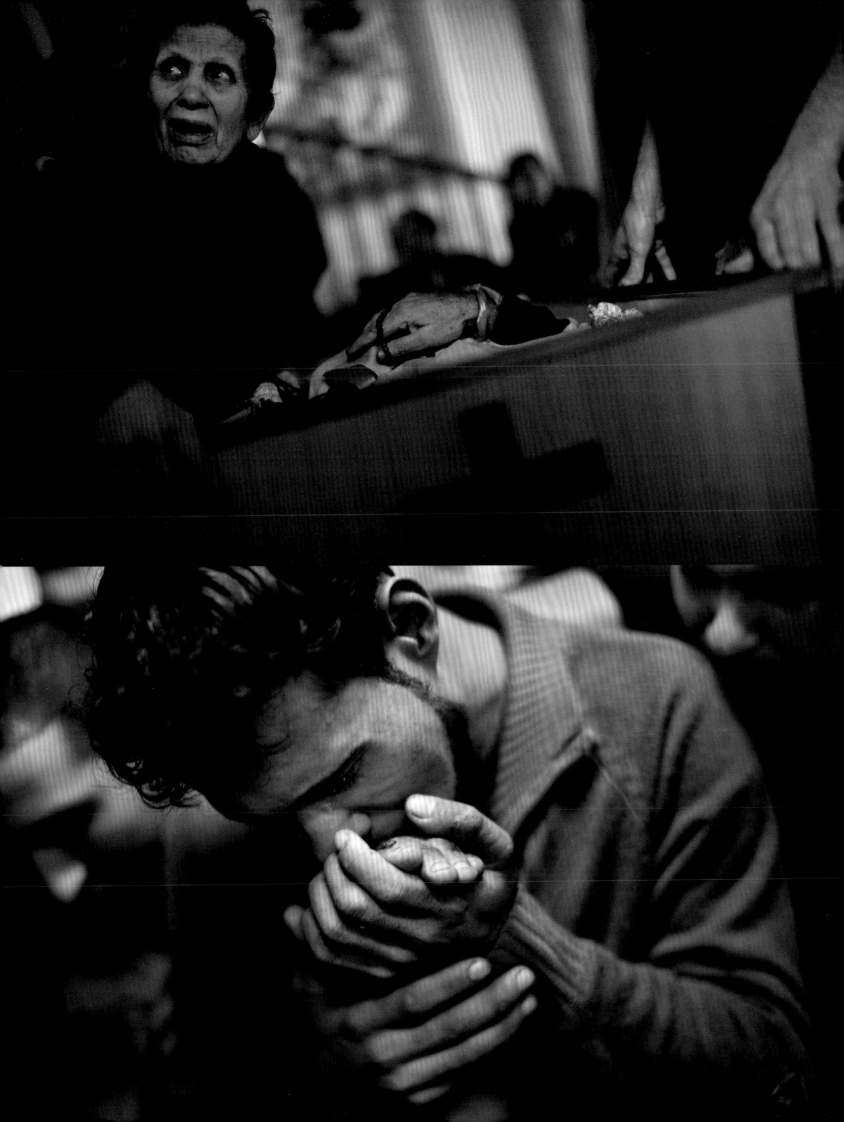

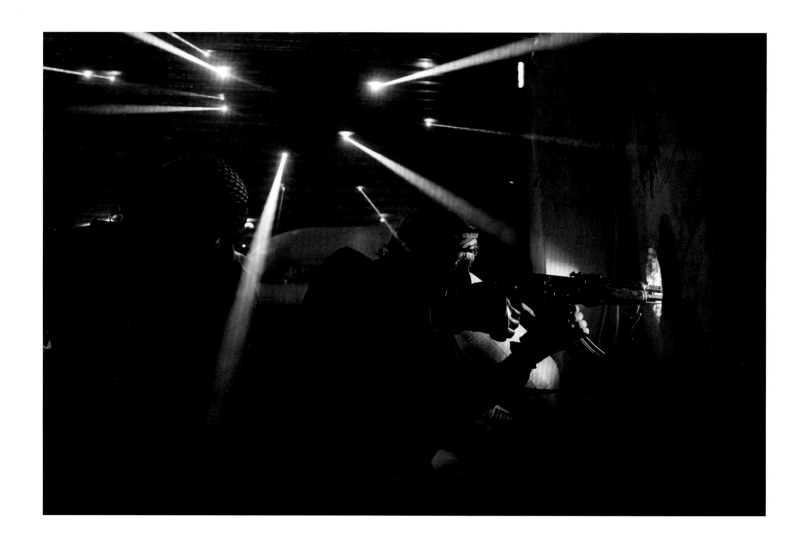

In July, the rebel Free Syrian Army (FSA) entered Aleppo, Syria's largest city and commercial capital. Above: FSA fighters stand guard in Aleppo's Karm Al-Jabal neighborhood, as light enters through a wall peppered by shrapnel. Both rebel and regime forces deployed snipers, and the national army made use of heavy artillery and air power to bombard occupied areas. Facing page: Civilians take shelter after a government jet had bombed and gunned several targets, including a bakery where civilians were queuing, on 20 September. (continues)

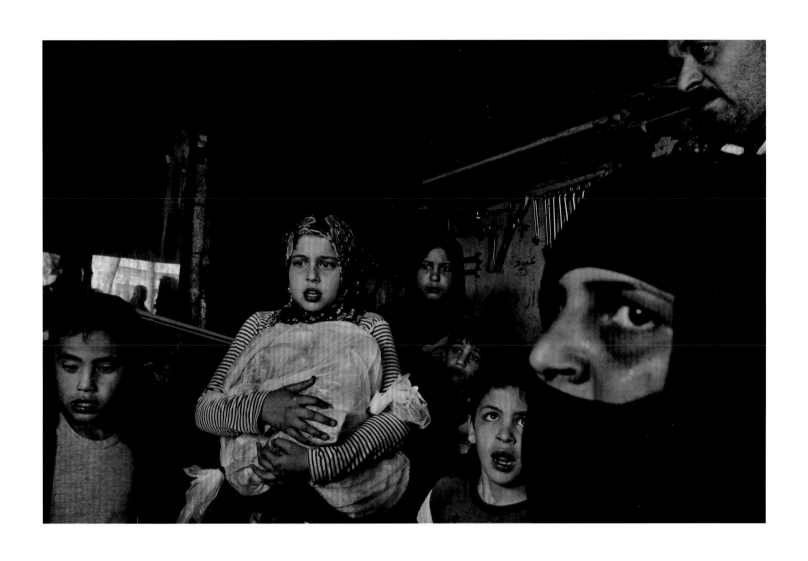

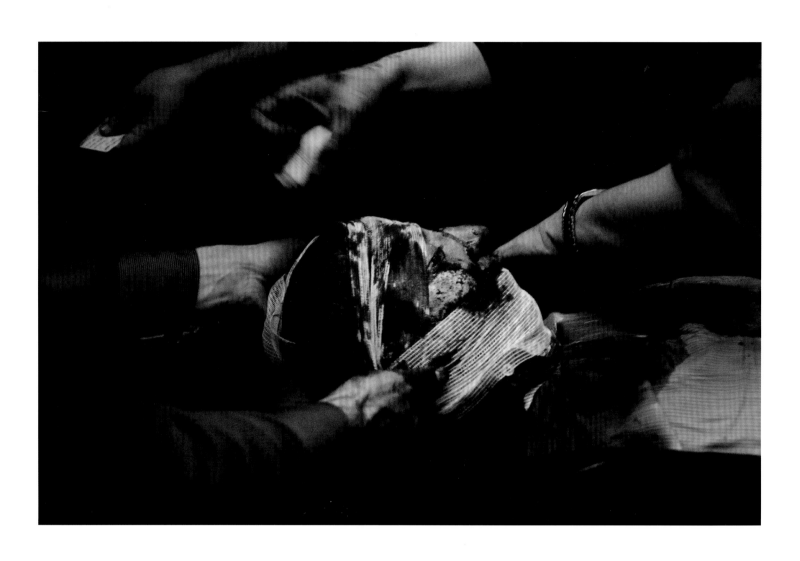

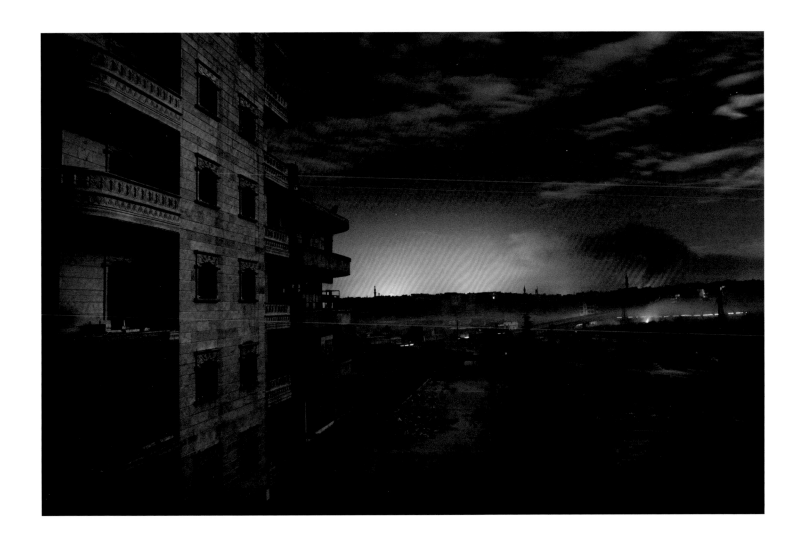

(continued) Rebel-held neighborhoods, initially in southwest Aleppo and later through-out the city, became battlefields, as government forces attempted to regain control. Facing page: The victim of a mortar bombardment is treated in a clandestine hospital in the southwestern Bustan al-Qasr district, in December, after most city hospitals had been destroyed. Above: Smoke rises over the Masaken Hanano and Bustan al-Basha neighborhoods, north of the Old City.

The Syrian commercial hub of Aleppo was the scene of some of the bloodiest clashes in the ongoing uprising against the regime of President Bashar al-Assad. Above: A Free Syrian Army (FSA) fighter prepares to fire a rocket-propelled grenade against government forces, in Aleppo's Old City. Below: A casualty is taken to hospital in a makeshift ambulance. (continues)

(continued) Both government and opposition forces considered control of Aleppo to be strategically important. The FSA first seized parts of the city in July. In the months that followed, government forces battled to recapture it, with limited success. Below: An FSA fighter takes up position in the Sulemain Halabi district, a rebel stronghold, during clashes with government forces. (continues)

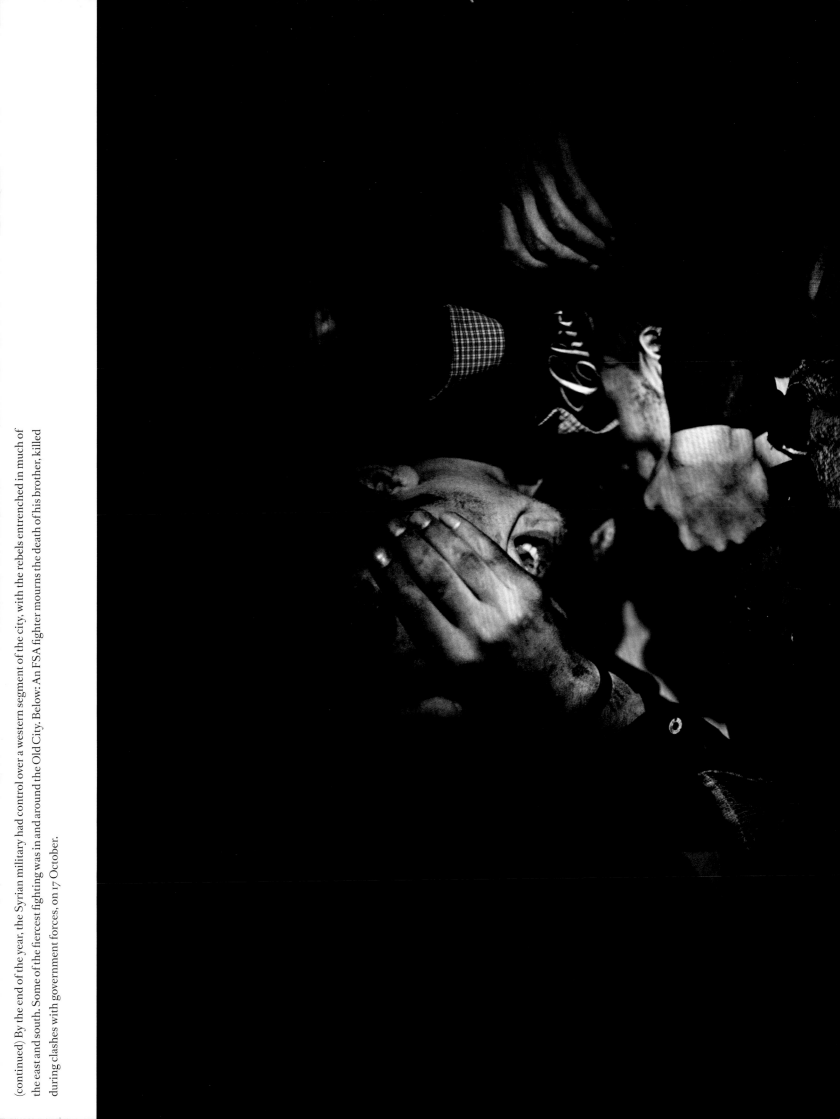

(continued) By the end of the year, the Syrian military had control over a western segment of the city, with the rebels entrenched in much of the east and south. Some of the fiercest fighting was in and around the Old City. Below: An FSA fighter mourns the death of his brother, killed during clashes with government forces, on 17 October.

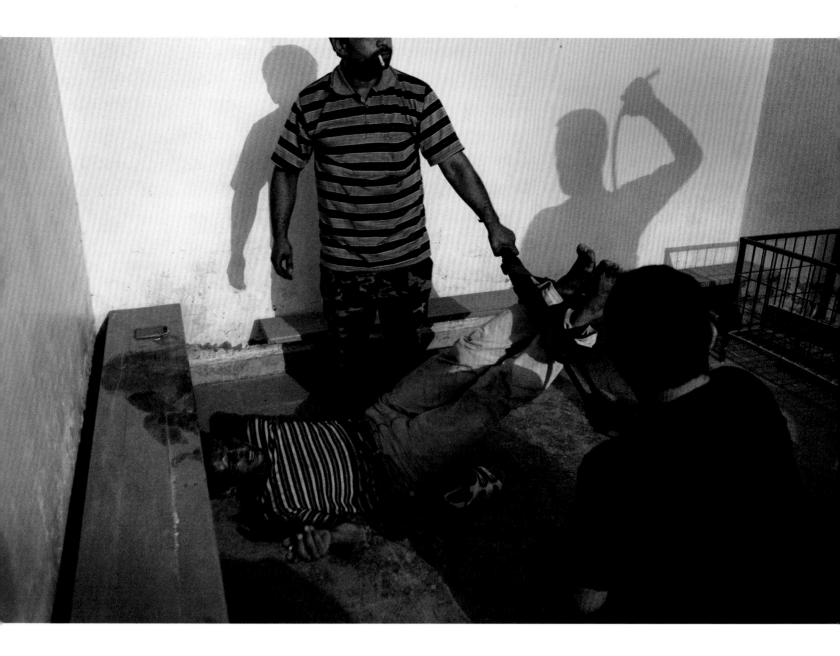

A man suspected of giving money to government informants is held at a school occupied by the dissident Free Syrian Army (FSA), in the northern city of Aleppo. He was one of two captives believed to be members of the pro-government Shabiha militia who were held and interrogated for 48 hours before having the money that was on them confiscated. The men were then released.

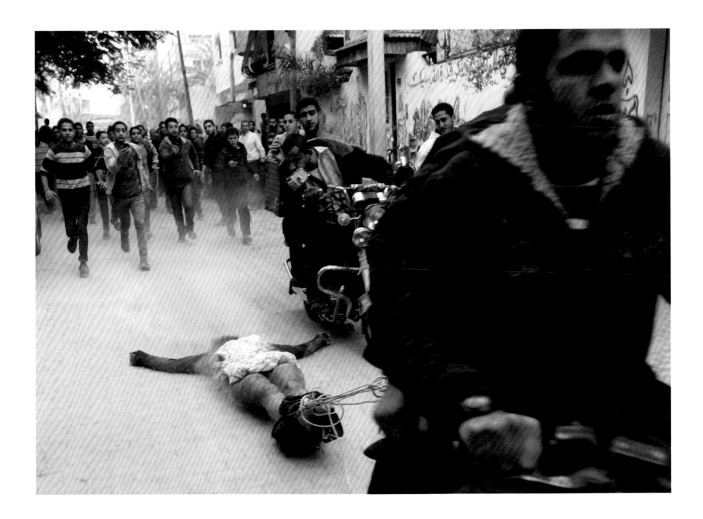

Palestinians drag the body of a suspected collaborator with Israel through the streets of Gaza City, on 20 November. That week had seen heavy bombardment of Gaza by Israel, in what was known as Operation Pillar of Defense. The dead man was one of six alleged collaborators killed at a city intersection by masked men, who forced them to lie on the ground, and shot them in the head. The military wing of the ruling Hamas organization claimed responsibility for the deaths.

GENERAL NEWS

SINGLES
1st Prize / **Rodrigo Abd**
2nd Prize / **Sebastiano Tomada**
3rd Prize / **Dominic Nahr**
Honorable Mention / **Ammar Awad**
STORIES
1st Prize / **Alessio Romenzi**
2nd Prize / **Paolo Pellegrin**
3rd Prize / **Daniel Berehulak**

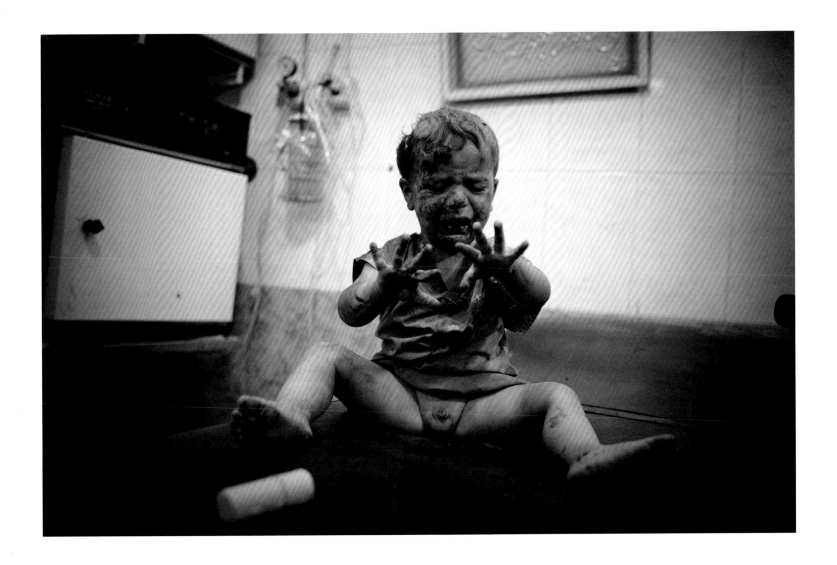

A wounded child awaits treatment in one of the few hospitals left standing in the northern Syrian city of Aleppo, in October. Battle had been raging since July between government forces and insurgents of the Free Syrian Army (FSA) for control of the city. Medical centers treating casualties in rebel-held districts appear to have been specifically targeted by the military, forcing doctors to work from an undercover network of clinics and small field hospitals.

Ongoing conflict in Syria between troops and militia loyal to President Bashar al-Assad, and dissidents of the Free Syrian Army (FSA) and other rebel groups, led to escalating fatalities and a massive exodus of refugees. Government forces were accused of deliberate mass targeting and indiscriminate use of airpower, particularly in battles for the cities of Homs and Aleppo. A peace plan drafted by UN envoy Kofi Annan in March failed, and a further UN-brokered ceasefire during the Islamic holiday of Eid al-Adha in October also collapsed. By November, an estimated 2.5 million people had been displaced, with tens of thousands crossing borders into neighboring Turkey, Lebanon, and Jordan. A UN survey at the end of the year held the death toll nationwide to be at least 60,000. Facing page, top: Rebel fighters help a wounded comrade during clashes with government troops in the Old City of Aleppo, in September. Below: A mother, comforted by a surviving son, grieves the loss of two sons in a mortar attack, in Homs province. Following spread, top left: A member of the FSA takes cover from sniper fire, on the roof of the captured Syrian intelligence services building, in Al-Qusayr, western Syria, on 10 February. Right: A girl mourns her father, killed by pro-government Shabiha militia and left on the street, in Al-Qusayr. Below, left: A rebel fighter displays a captive believed to be a member of the Shabiha militia, in Aleppo. Right: Displaced people attempt to cross the border into Turkey.

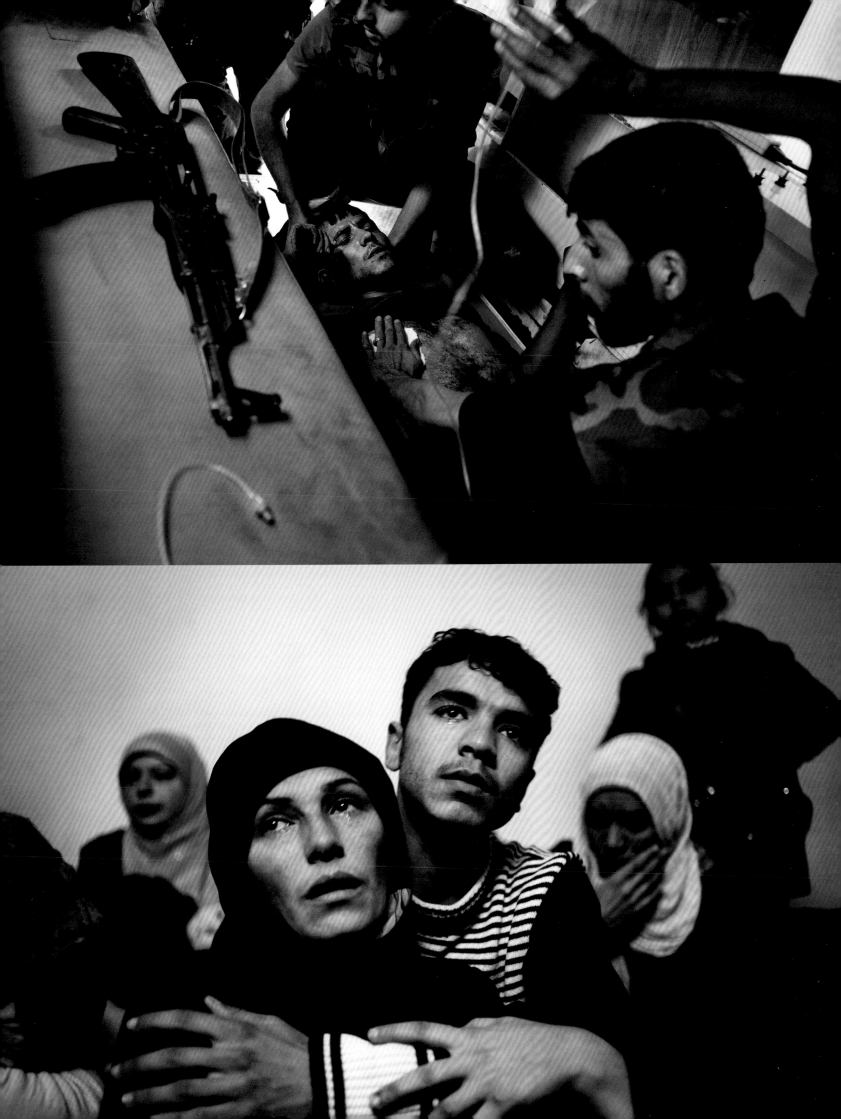

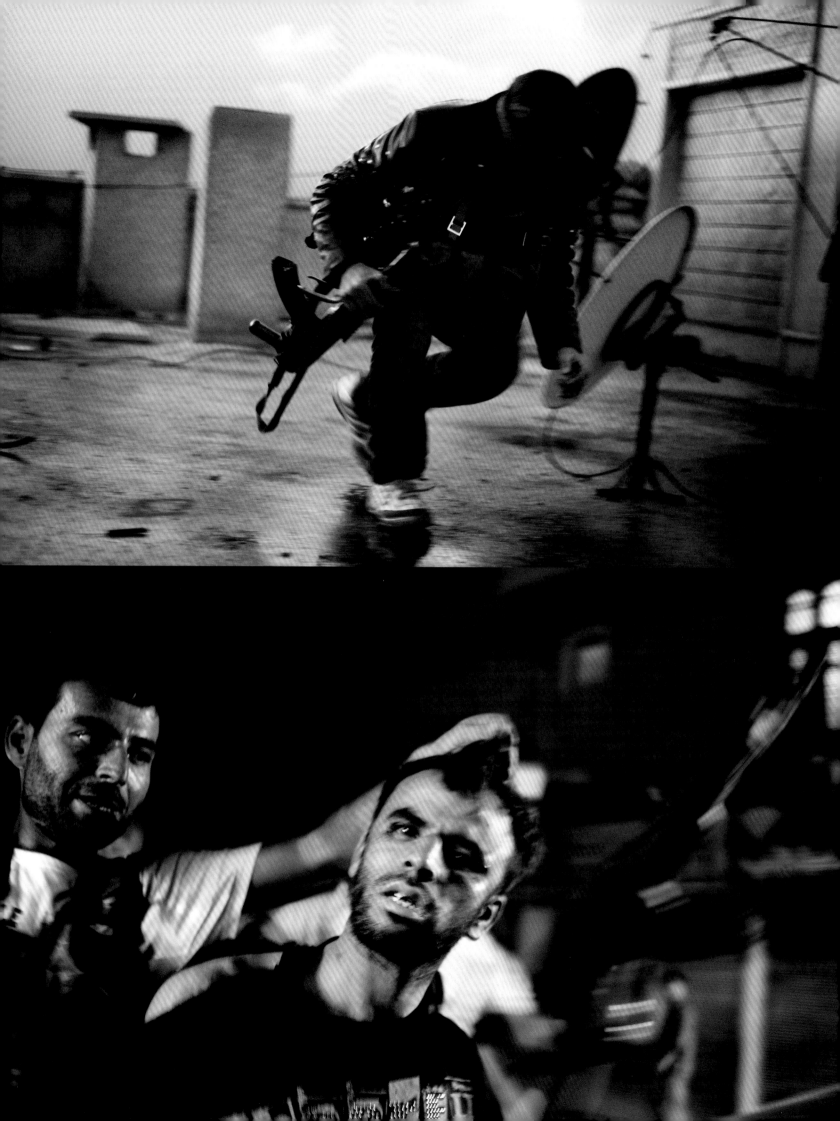

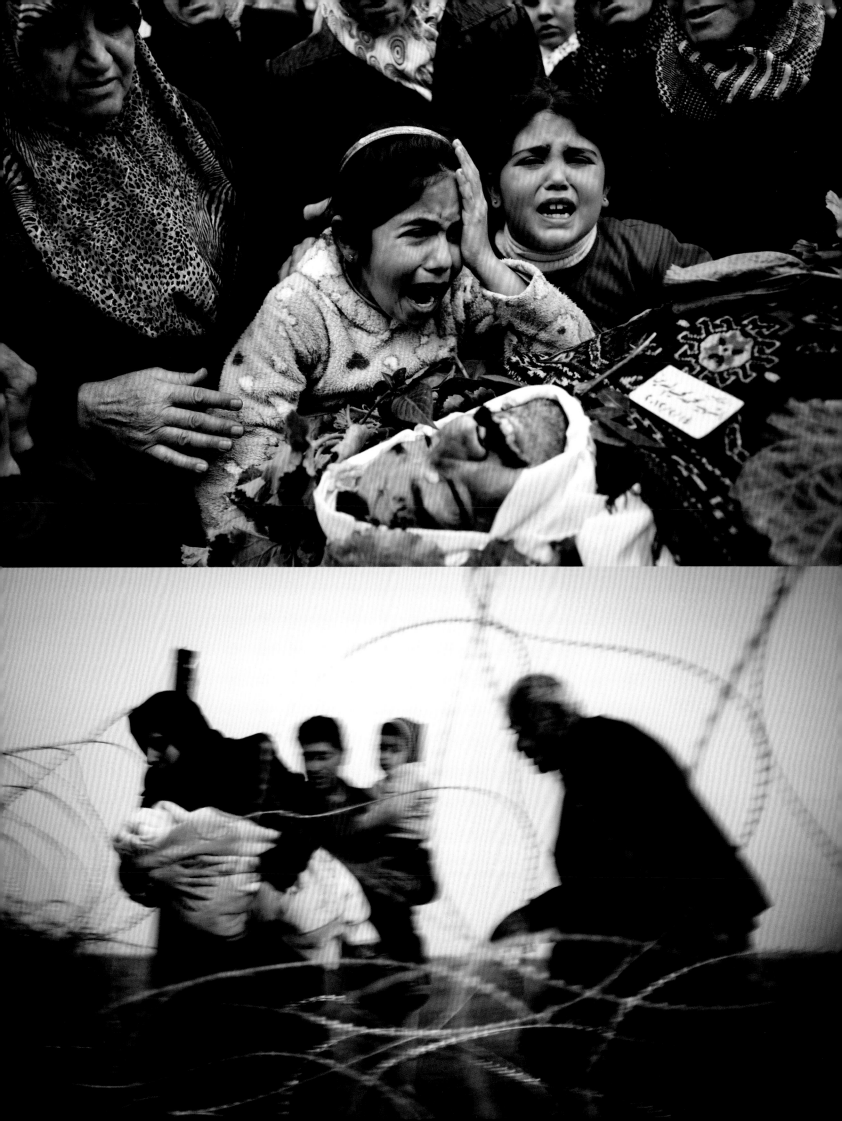

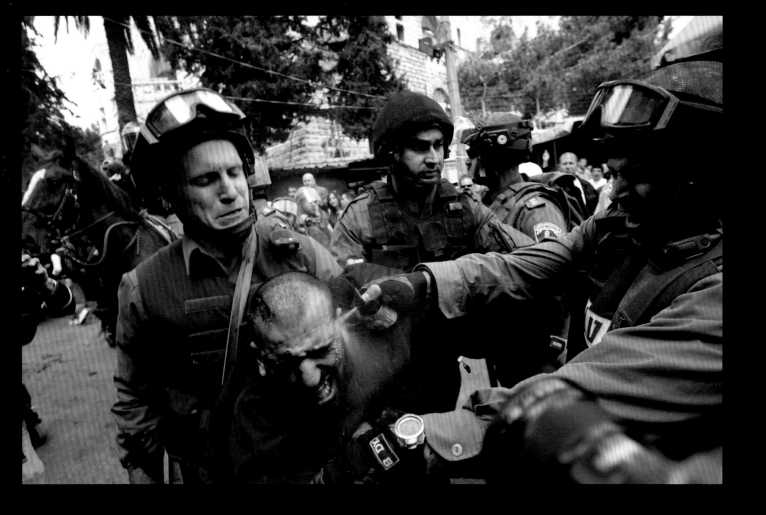

Israeli border police officers use pepper spray as they detain a Palestinian protestor, during clashes after Friday prayers on Land Day, outside Damascus Gate in Jerusalem's Old City. Land Day commemorates the killing of six Arabs by security forces on 30 March 1976, amid protests against land appropriation in Galilee. A number of the annual rallies marking the event in Jerusalem, Gaza, and the West Bank turned violent, with demonstrators throwing stones while security forces fired rubber bullets, tear gas, and stun grenades to disperse the protests.

>

Aida cries as she recovers from severe injuries sustained during a Syrian military bombardment of her home, in the northern city of Idlib. Her husband and two children were killed in the attack. Syrian troops launched a vigorous assault on Idlib, a center of the uprising against the rule of President Bashar al-Assad. The shelling of Idlib began just hours after UN envoy Kofi Annan had arrived in Damascus, on a high-profile international mission aiming to mediate an end to the conflict.

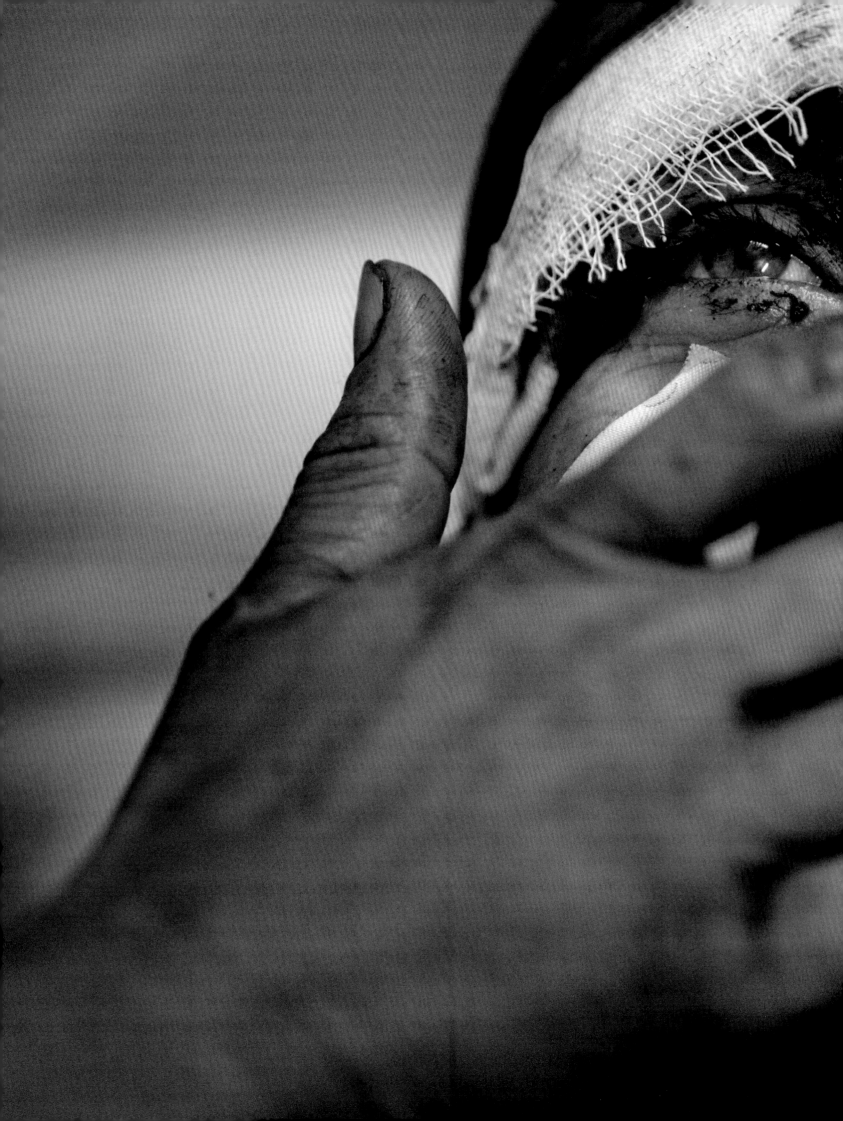

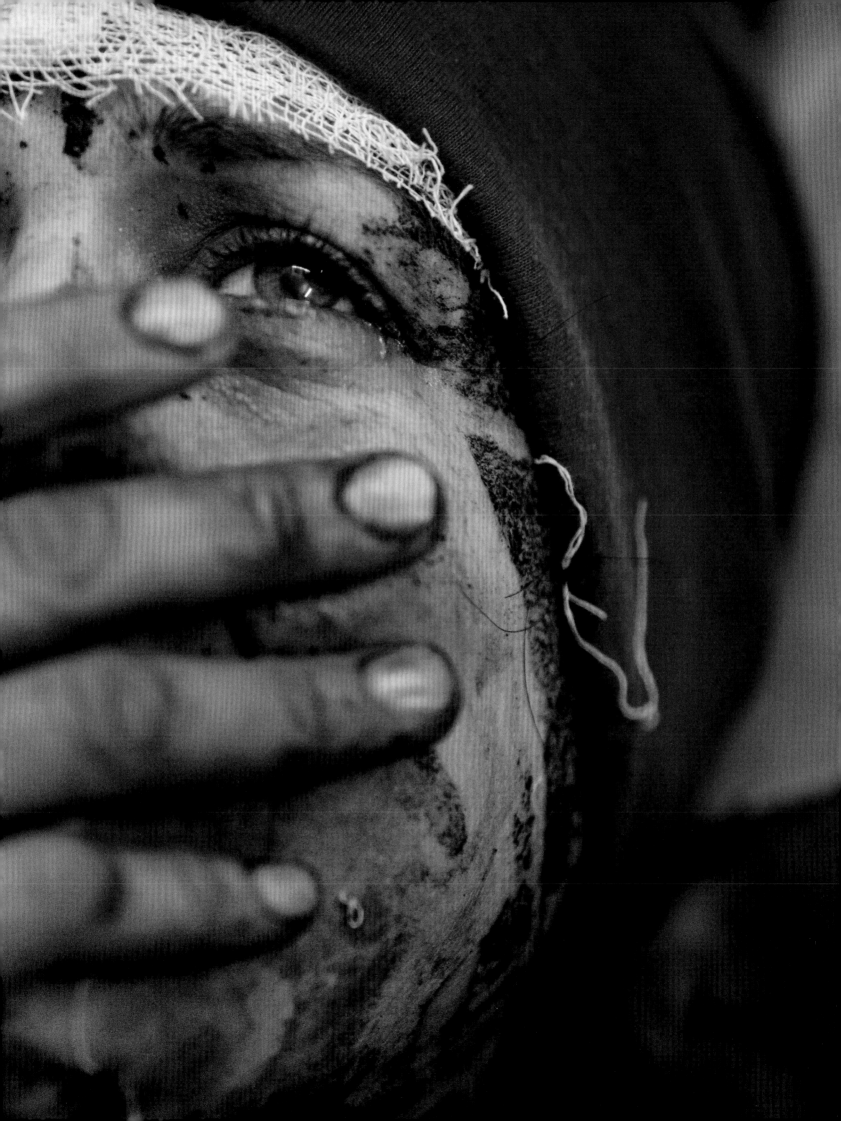

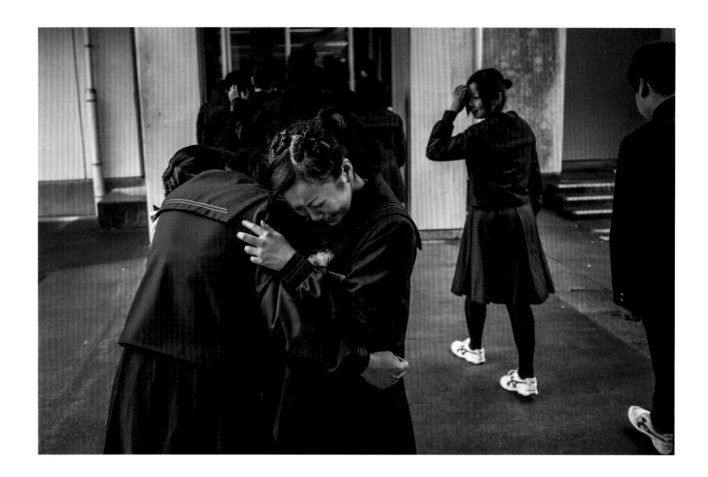

A year after the March 2011 earthquake and subsequent tsunami that devastated large areas of northeastern Japan, thousands of people remained without homes, and the Japanese government was still struggling to dispose of rubble and help rebuild livelihoods. Above: Mihaya Sato (15) cries on the shoulder of a school friend at the first graduation ceremony after the tsunami, at the Shizukawa Junior High School, in the town of Minamisanriku, Miyagi—one of the worst-hit prefectures. Facing page, top: Children walk home from school as workers clear the rubble of a damaged house, in Kesennuma, Miyagi. Below: Uprooted pine trees still lie strewn over a beach in Rikuzentakata, Iwate prefecture. Rikuzentakata was almost completely destroyed by the tsunami, and lost up to 40 percent of its population of over 23,000.

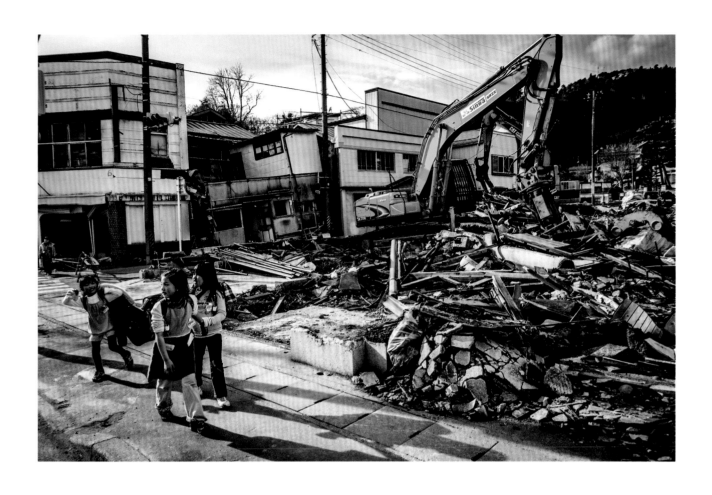

The group of deprived neighborhoods known as the 'Crescent', around the northern edge of downtown Rochester, New York State, USA, is renowned for its high crime and murder rates. Reasons given for these include a depressed local economy and the large number of empty houses, prone to becoming locations for drug-dealing. Facing page, top: Police officers search a house for an armed suspect in northeast Rochester. Below: A man is arrested after having assaulted his father with a samurai sword. Following pages, top left: Youths run away as a police car approaches a corner known as a drug-dealing spot. Right: A crime scene in the Crescent area. Below left: The funeral of Max King (15), who was shot in the head in August. His was the 25th murder in Rochester since the beginning of 2012. Right: A family in the Crescent.

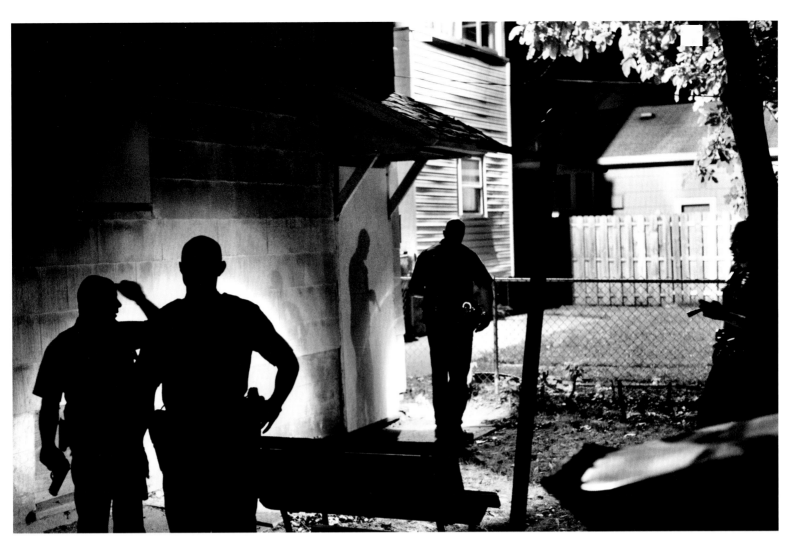

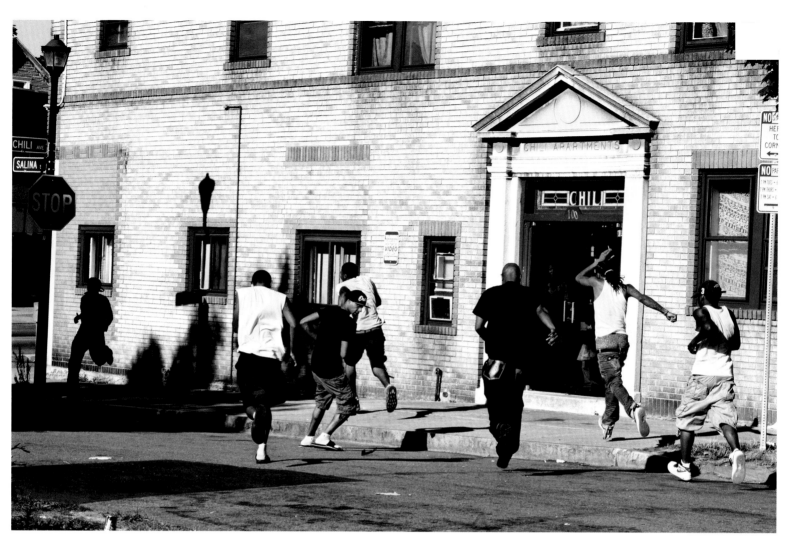

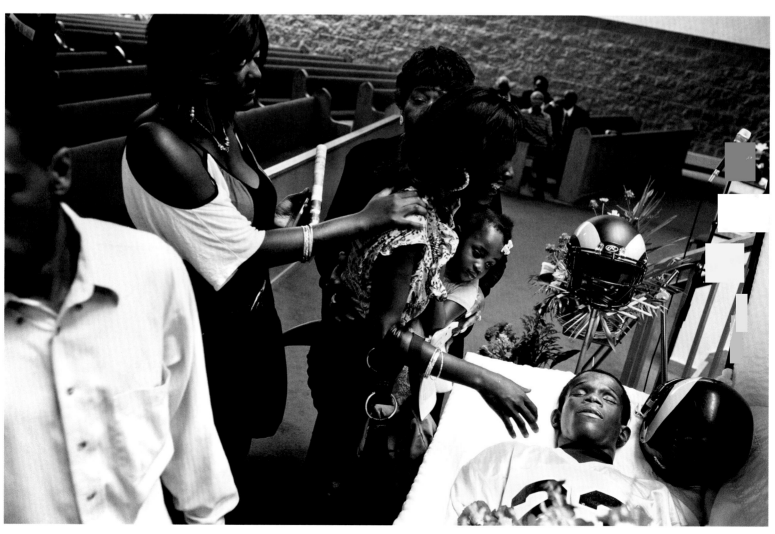

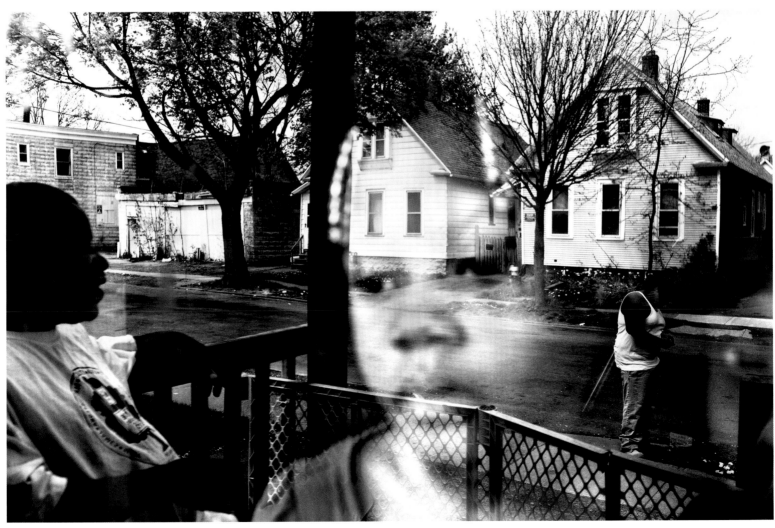

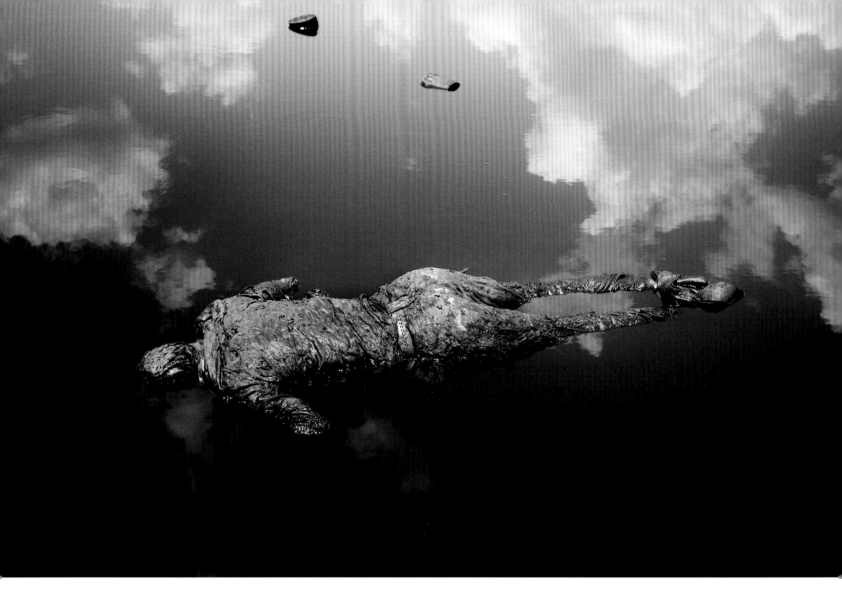

A Sudan Armed Forces (SAF) soldier lies dead in a pool of oil next to a leaking oil facility in the town of Heglig, after a clash with the Sudan People's Liberation Army (SPLA). The SPLA is the army of the Republic of South Sudan. For more than half a century Sudan's northern regime in Khartoum fought the south, in a conflict that cost two million lives. South Sudan gained its independence from the north in 2011, but the exact demarcation of the border was not settled, and some areas remained contested. In April, a battle broke out between Sudan and South Sudan over disputed oilfields, with the area around Heglig—officially in the north but claimed by the south—seeing some of the fiercest fighting. In September, the presidents of Sudan and South Sudan agreed trade, oil and security deals, and planned to set up a demilitarized buffer zone, but border disputes remained unresolved.

CONTEMPORARY ISSUES

SINGLES
1st Prize / **Micah Albert**
2nd Prize / **Esteban Felix**
3rd Prize / **Emilio Morenatti**
Honorable Mention / **Felipe Dana**
STORIES
1st Prize / **Maika Elan**
2nd Prize / **Majid Saeedi**
3rd Prize / **Aaron Huey**
Honorable Mention / **Altaf Qadri**

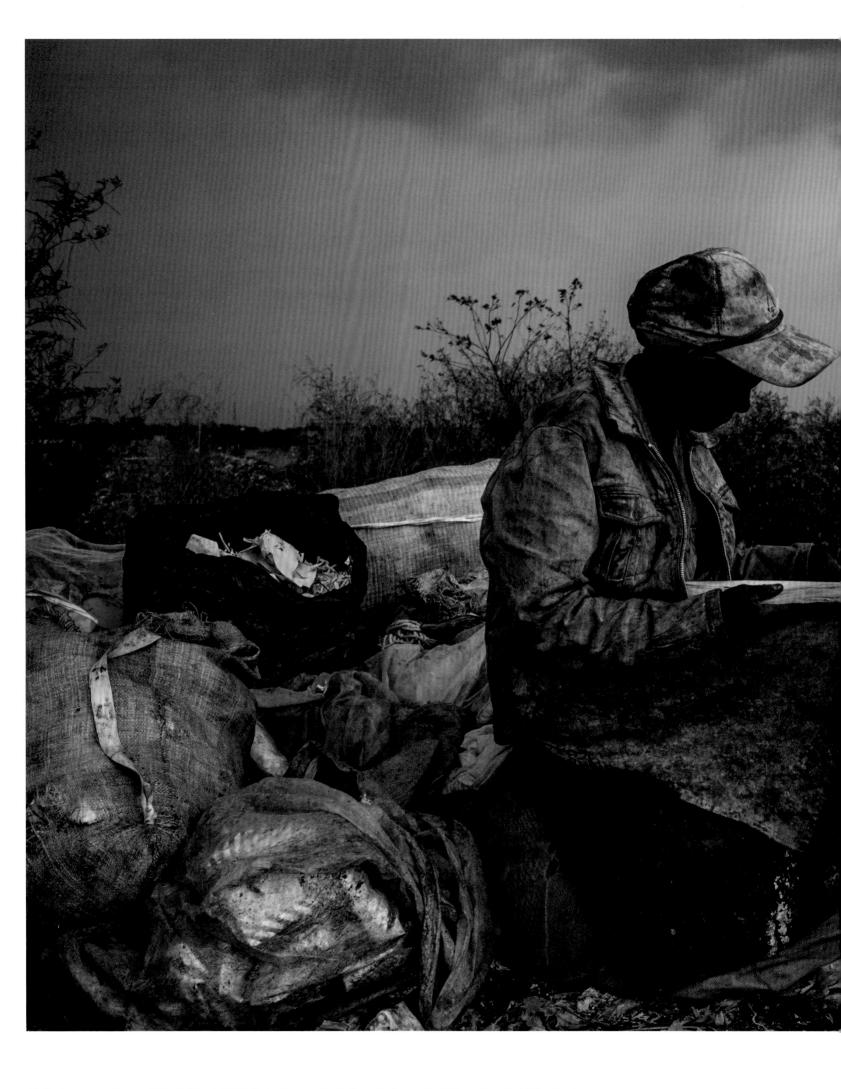

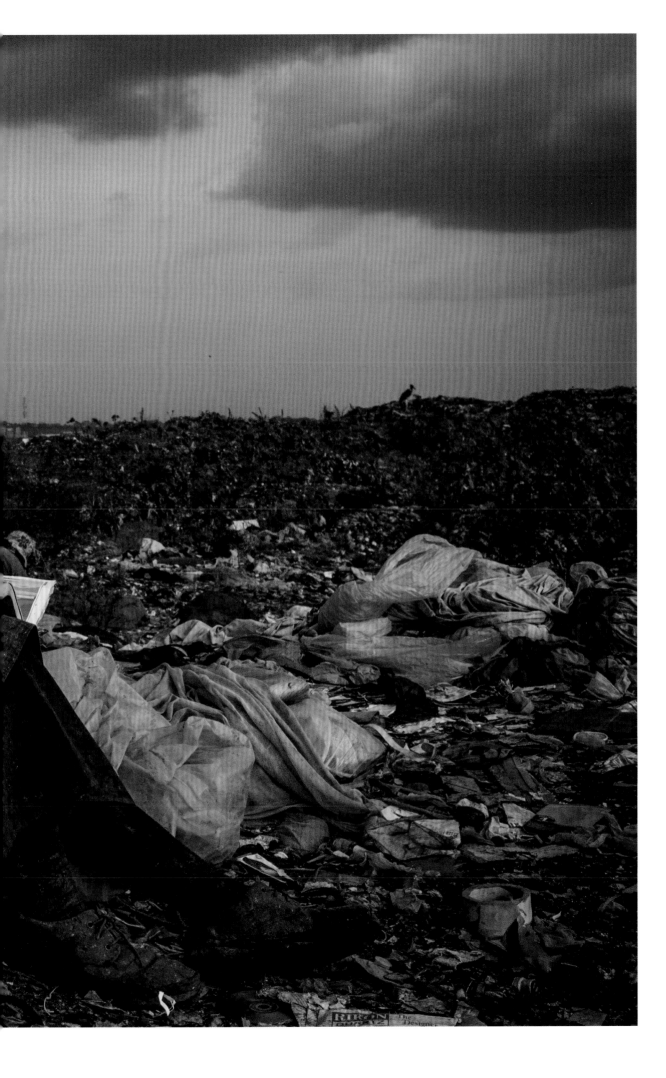

A woman sits on bags of waste she has salvaged, at the Dandora municipal dump, outside Nairobi, Kenya. She said that she enjoys looking at books, even industrial catalogues, as a break from picking up garbage. The dumpsite, some 8 km from the center of the Kenyan capital, is one of the largest rubbish dumps in Africa. People living in the slum area around the site have been found to suffer from increased levels of lead in their blood, as well as above-normal incidence of kidney diseases, and cancer. Gases rising from decomposing waste lead to high rates of respiratory disease. Despite the health risks, between 6,000 and 10,000 people earn a living from the dumpsite, seeking food waste, scavenging goods for resale, or separating materials for recycling. Informal cartels run the recycling operation, paying pickers around €2 a day. Opened in 1975, the dump should—under international environmental laws—have been closed after 15 years. It remains in use, despite being declared full in 2001.

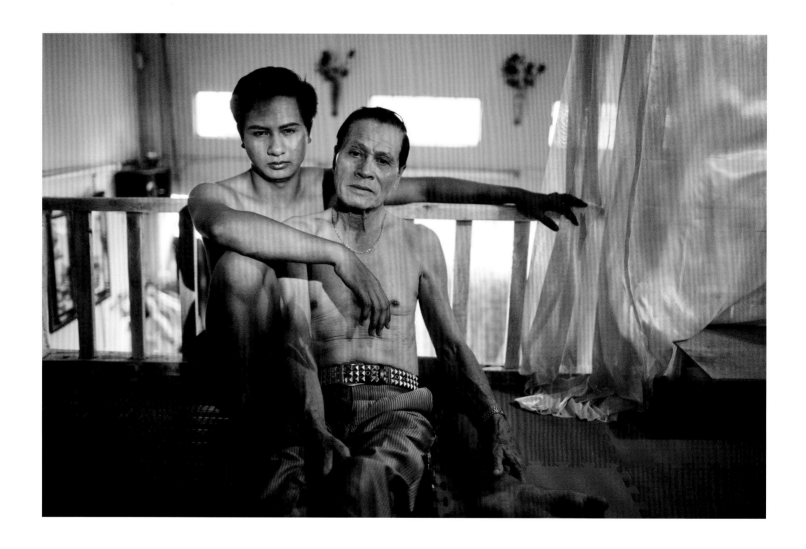

Vietnam has historically been unwelcoming to same-sex couples, but in 2012 the Vietnamese government announced it was considering recognizing same-sex marriage. Above: Vu Trong Hung (52) and Tran Van Tin (28) have been together for two years. Facing page: Ngan (20) teases Isabelle (21) about the sort of underwear she likes. Both are students, and they have been in a relationship for four years. (continues)

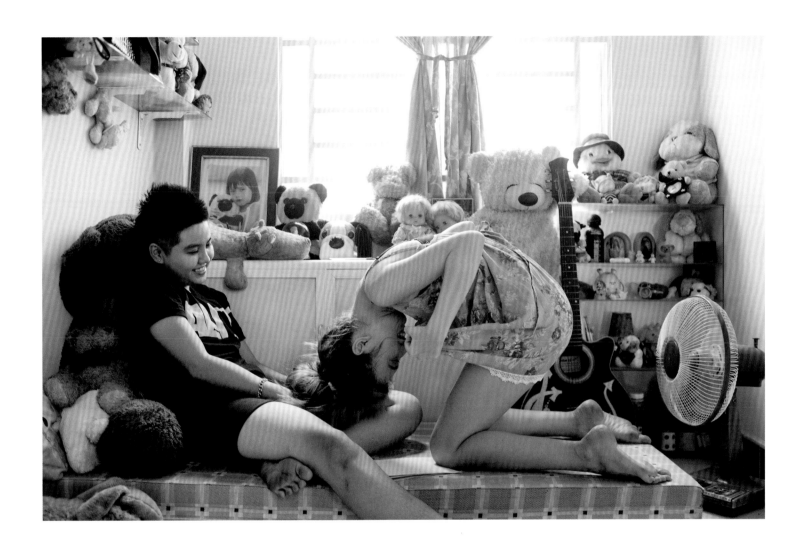

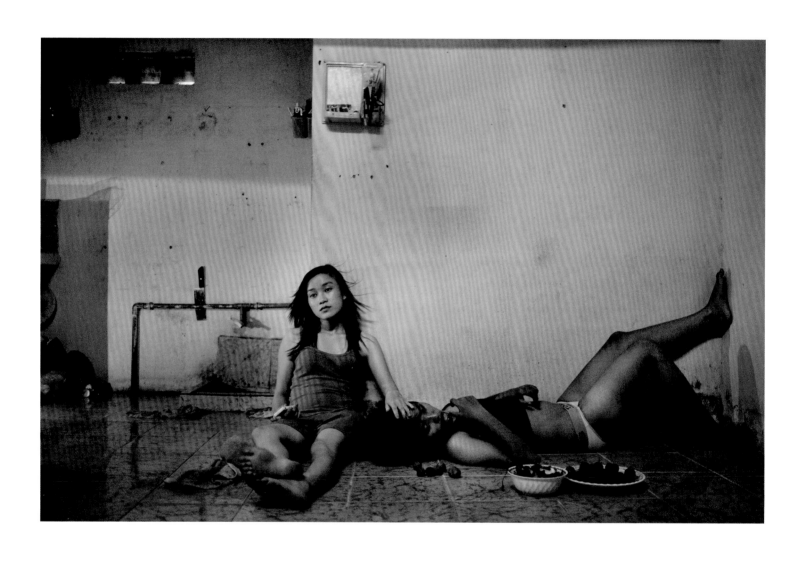

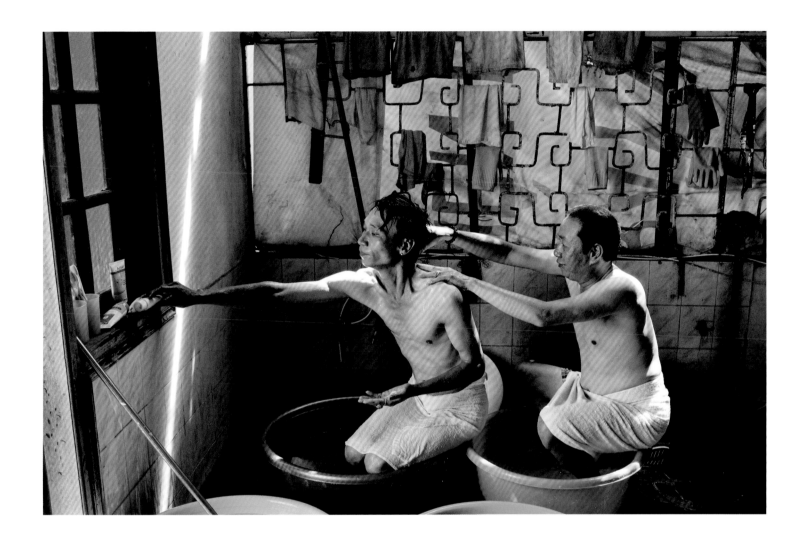

(continued) Despite the announcement of parliamentary debate on the issue, polls showed that public opinion remained generally opposed to same-sex marriage. Facing page: Phan Thi Thuy Vy (20) and Dang Thi Bich Bay (20), both students, relax watching television at the end of the day. They have been together for a year. Above: Businessman Hieu (58) takes a bath with Thang (62), a social worker. They have been partners for eight years.

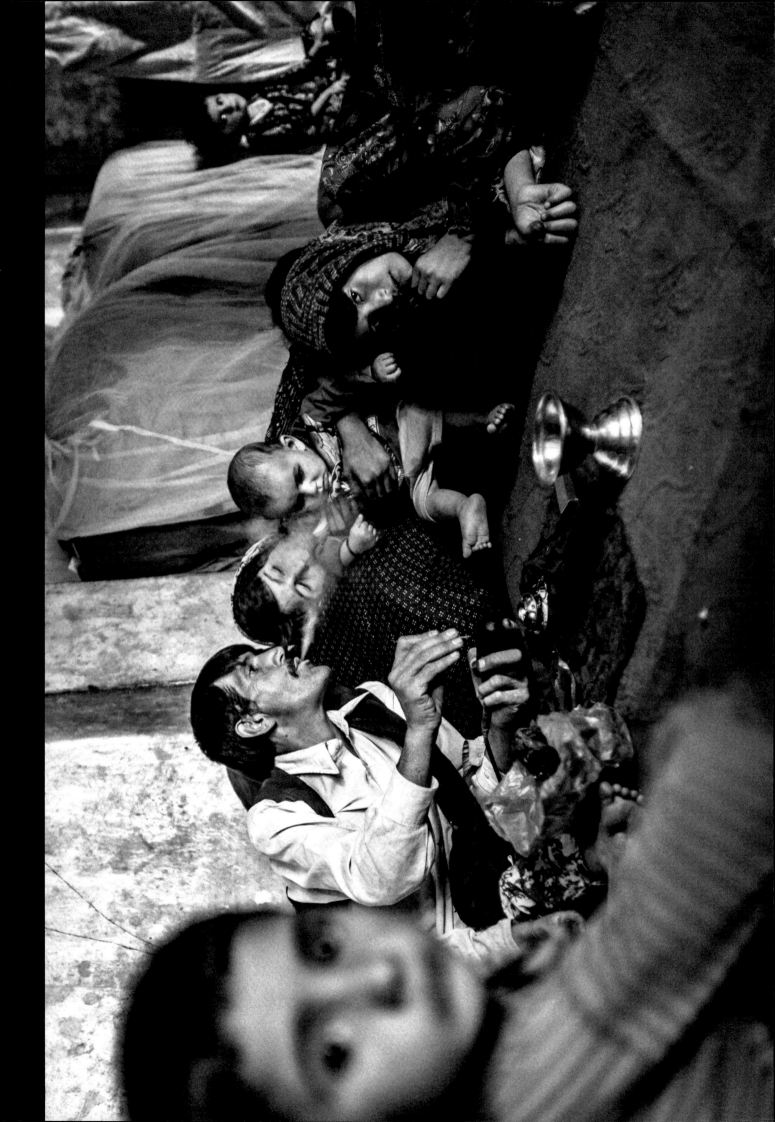

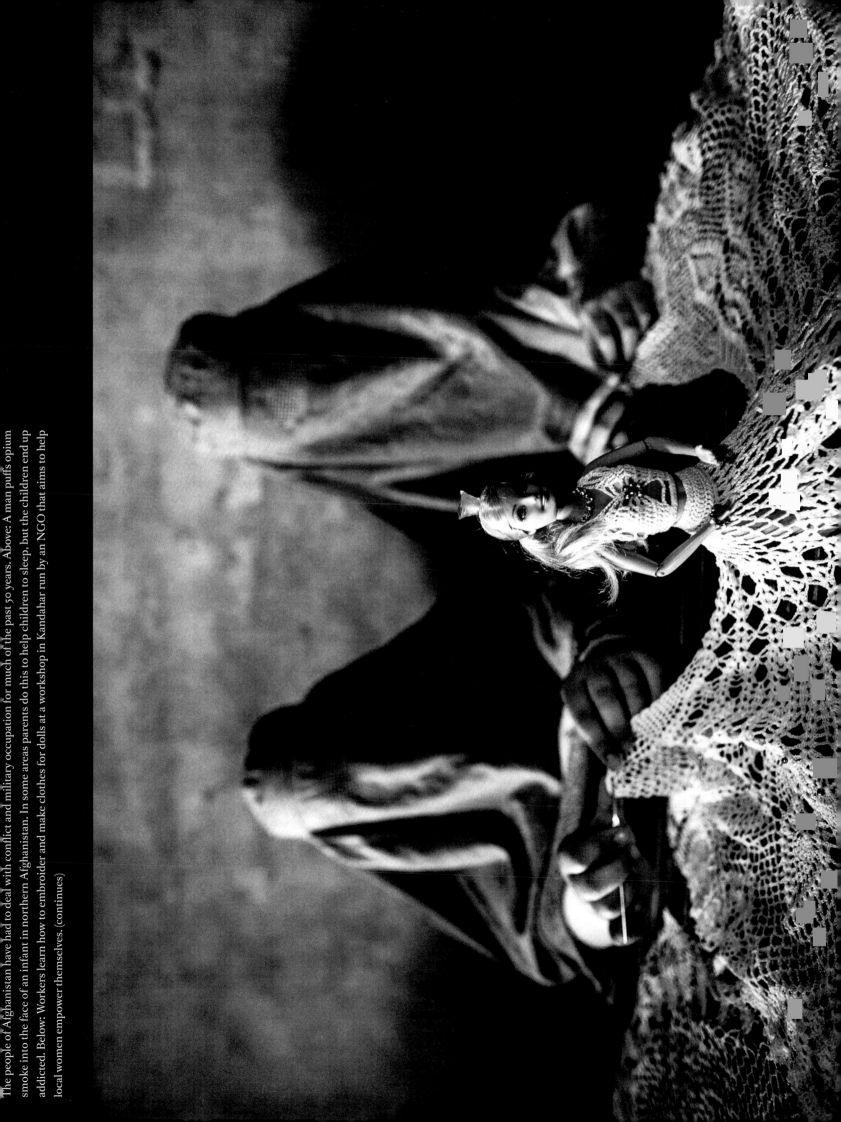

The people of Afghanistan have had to deal with conflict and military occupation for much of the past 50 years. Above: A man puffs opium smoke into the face of an infant in northern Afghanistan. In some areas parents do this to help children to sleep, but the children end up addicted. Below: Workers learn how to embroider and make clothes for dolls at a workshop in Kandahar run by an NGO that aims to help local women empower themselves. (continues)

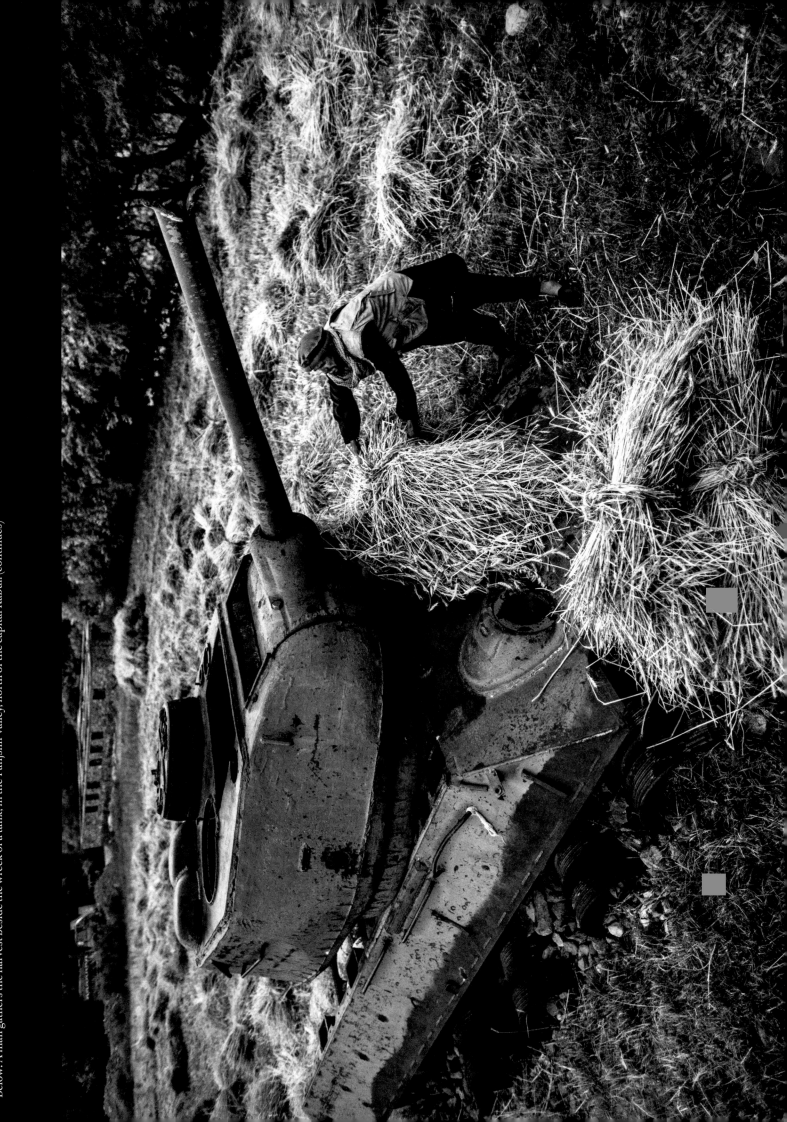

(continued) Conflict and long-term instability in Afghanistan have led to personal trauma, and severe economic and infrastructural damage.

Below: A man gathers the harvest beside the wreck of a tank, in the Panjshir valley, north of the capital Kabul. (continues)

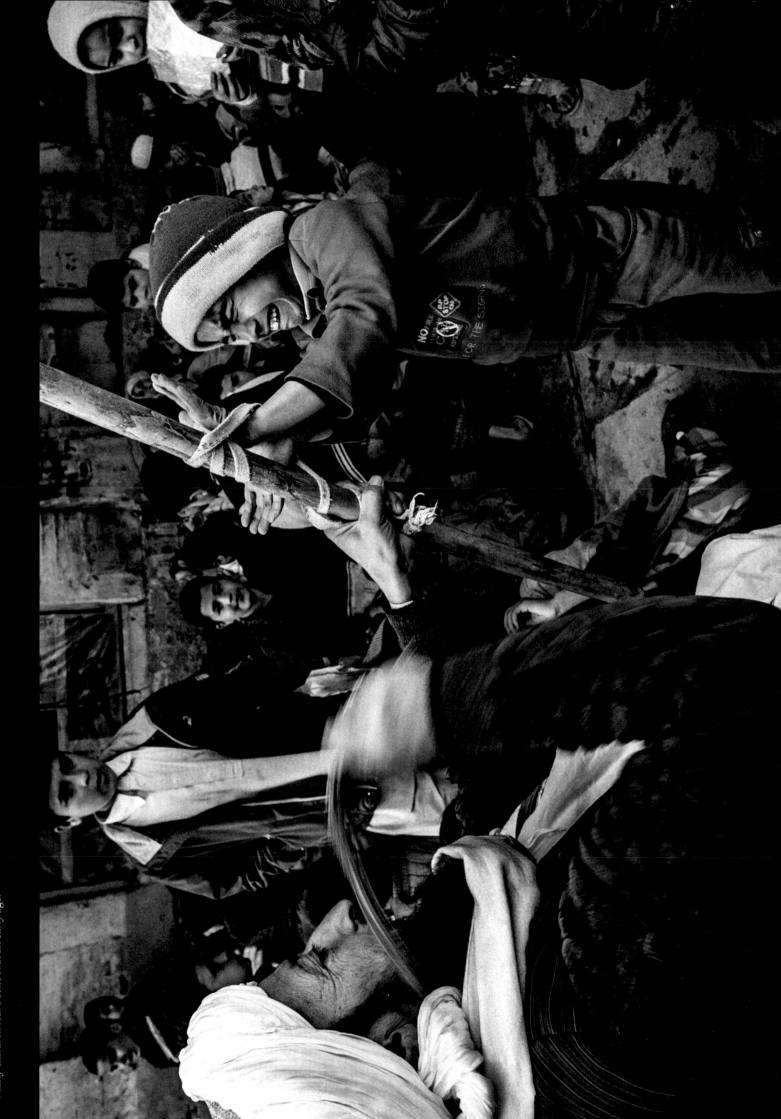

(Continued) Foreign aid has helped support various initiatives to improve infrastructure and education. But as occupation forces withdraw and Western economies face their own difficulties, funds to NGOs are being cut. Below: A child is punished at a religious school in Herat. Many children leave school at an early age.

The Oglala Lakota people of the Pine Ridge Reservation in South Dakota, USA, live near the site of the massacre of over 250 Lakota Sioux, at Wounded Knee Creek in 1890. They recount a long history of violated treaties and broken promises on the part of successive US governments. Pine Ridge is seeing an upsurge in resistance movements, and a revival of traditional spiritual ways. The sun dance—a tradition nearly forgotten—has returned and people are teaching traditional language, horse skills, and ceremonies to the youth. Facing page, top: Oglala youths hold an inverted flag as a symbol of defiance to commemorate a 1975 shoot-out between American Indian Movement (AIM) activists and the FBI, in which two agents and one AIM member died. Below: Stanley Good Voice Elk burns sage to purify his surroundings. He is a *heyoka*, a recipient of sacred visions. Following pages, top left: Three-year-old C.J. Shot bathes in the sink, in a three-bedroom house that is home to 22 people. Right: Oglala men carry a felled cottonwood tree to the center of a sun dance circle. Below, left: A passenger barely has room for the journey home after collecting used clothing donated by a charity. Right: Wakinyan Two Bulls (9) places prayer flags in a tree near Mato Tipila (Devil's Tower), a place of Oglala ceremony in Wyoming.

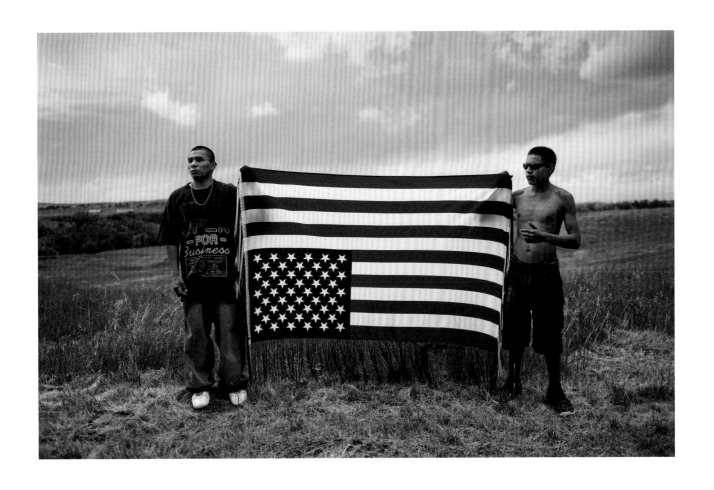

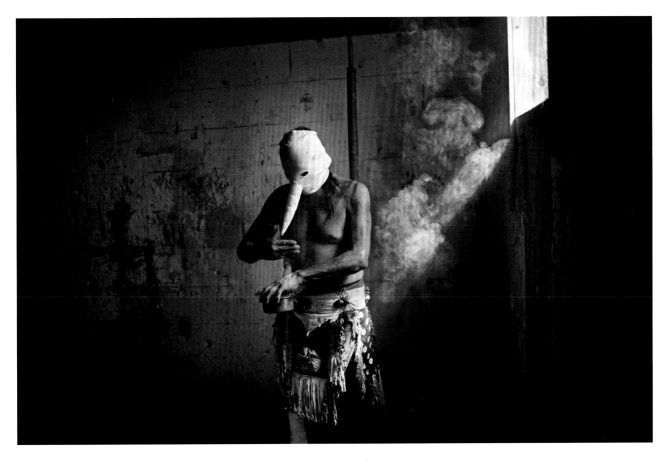

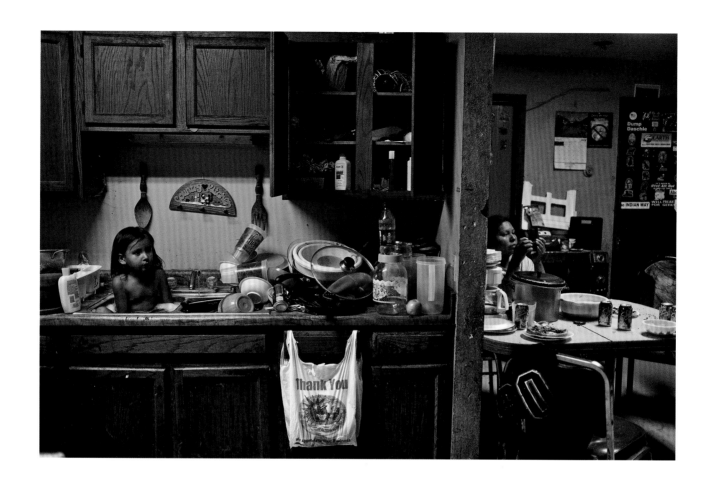

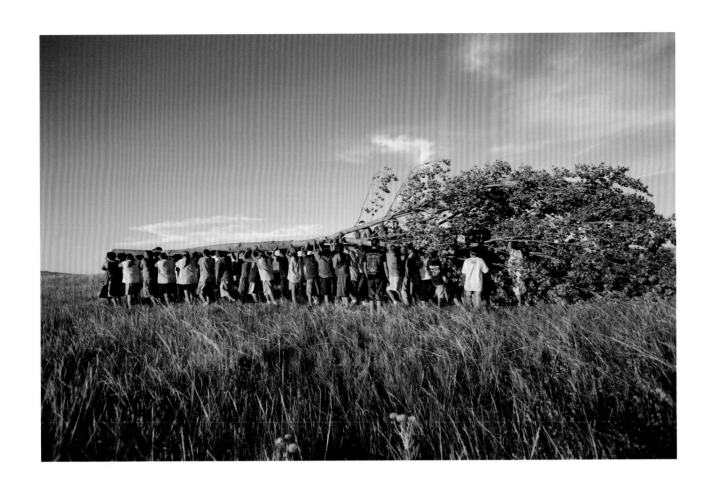

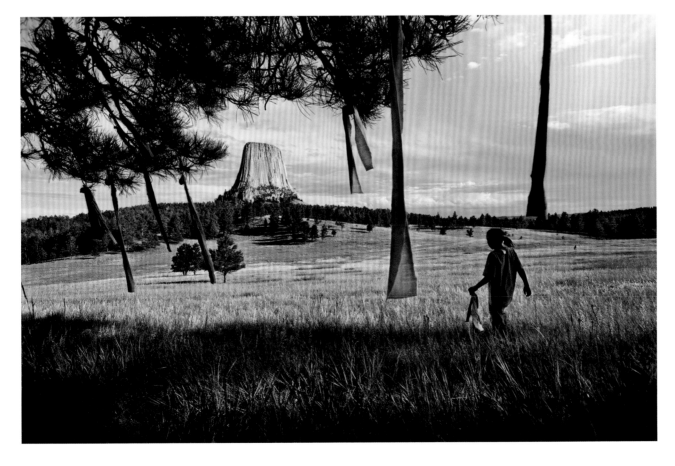

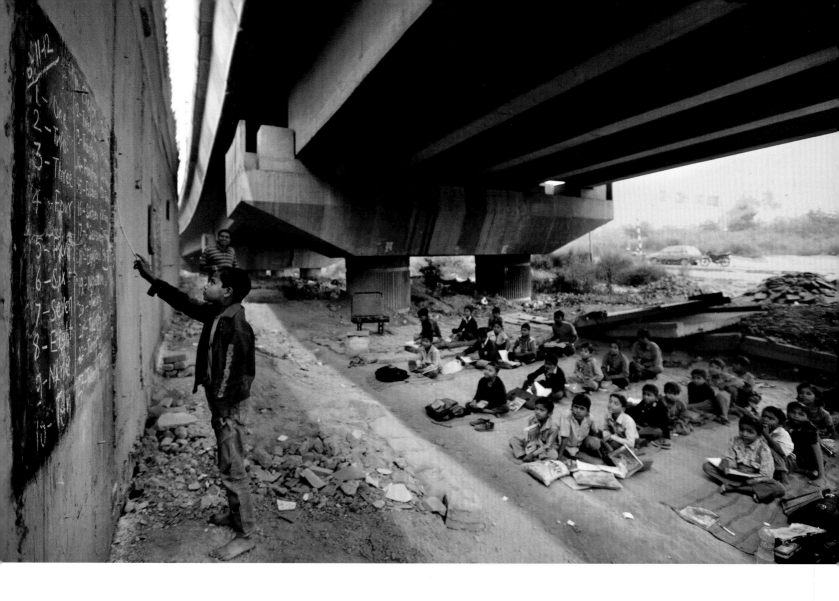

Children of local laborers attend a free school under a metro rail bridge, in New Delhi, India. The school was founded by Rajesh Kumar Sharma (40), himself unable to complete a college education because of financial difficulties. Every day he leaves his general store for two hours to teach, while his brother replaces him at work. Together with an assistant, Laxmi Chandra, Sharma gives lessons to around 45 children daily, having persuaded their families to free them from working to earn money. He aims to prepare his students for admission to government schools, and to equip them for overcoming poverty. Above: A boy writes on a blackboard painted onto the wall of a building. Facing page, top: Babar Ali (9) stands as Laxmi Chandra checks his work. Below: A student clears chairs and a bag of mats after classes.

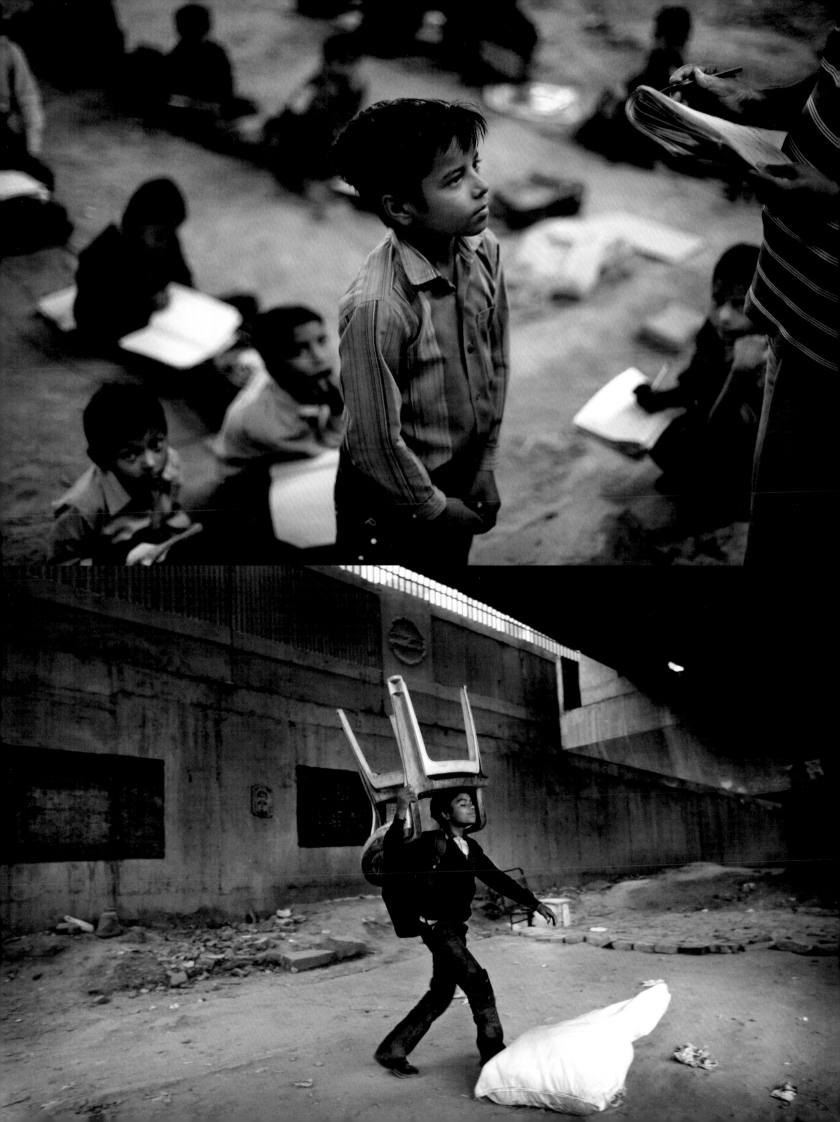

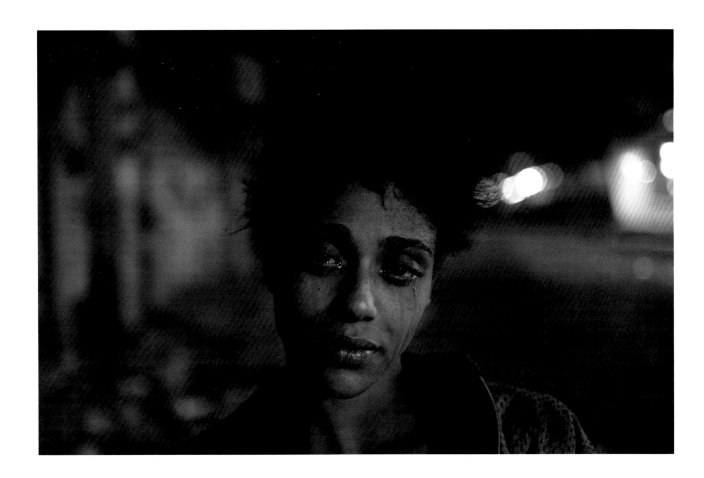

Natalia Gonzales, 15 years old and a crack user, lives in the Manguinhos slum in Rio de Janeiro, Brazil. Once, blatant sale of crack at outdoor drug markets led to areas of Manguinhos and surrounding shantytowns being dubbed 'Crackland', but the drug seems to be disappearing from the streets. Certain drug bosses say they have stopped selling crack because it destabilizes their territories, making them harder to control. City authorities also take credit for the change, saying it is the result of a police offensive to retake slum areas long abandoned by the government.

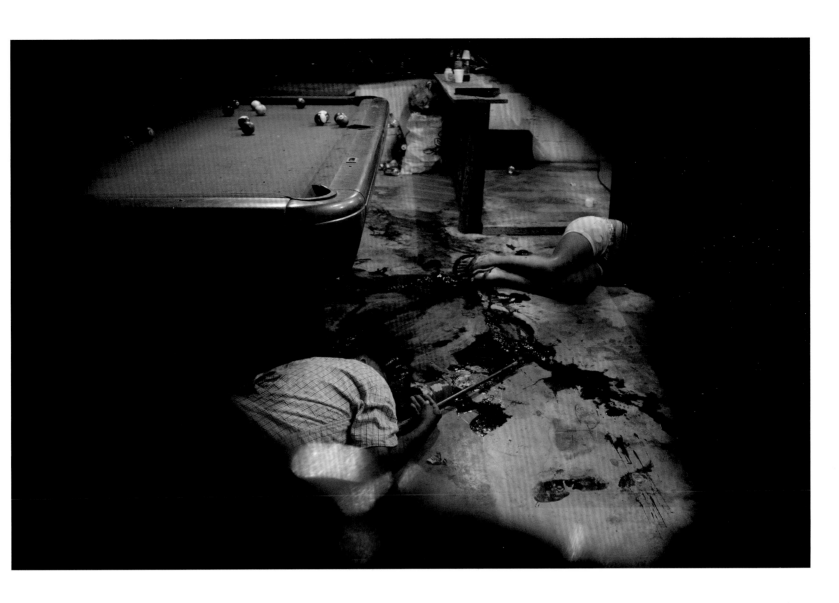

Bodies lie on the floor of a poolhall, after an attack by unidentified masked assailants, in Choloma, on the outskirts of San Pedro Sula, Honduras. A wave of violence has made Honduras one of the most dangerous places on Earth, with an annual rate of 86 murders per 100,000 inhabitants. San Pedro Sula, often cited as Honduras's most violent city, has a murder rate double the national average. Criminal gangs operate almost with impunity, imposing reigns of extortion, murder, and drug trafficking.

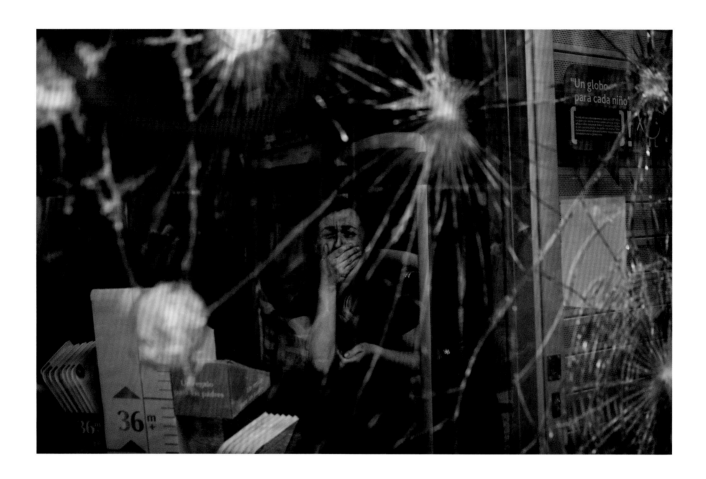

Mireia Arnau (39) looks out from behind the broken glass of her shop, which was stormed by demonstrators clashing with police in Barcelona, during a general strike on 29 March. The strike was called in protest against the government's labor reforms. In an ongoing climate of economic difficulty, parliament was proposing stringent cuts, as well as measures aimed at making it easier for businesses to fire employees. Spain's unemployment was running at over 24 percent, the highest in the European Union, with half of under 25s out of work. Most protests across the country were peaceful, but in Barcelona some demonstrators hurled rocks at banks and shopfronts.

DAILY LIFE

SINGLES
1st Prize / **Daniel Rodrigues**
2nd Prize / **Søren Bidstrup**
3rd Prize / **Jacob Ehrbahn**
STORIES
1st Prize / **Fausto Podavini**
2nd Prize / **Paolo Patrizi**
3rd Prize / **Tomás Munita**
Honorable Mention / **Frederik Buyckx**

Youths play football on a field that was once part of a military barracks, in the village of Dulombi, Galomaro, Guinea-Bissau. Before Guinea-Bissau gained its independence in 1974, the barracks housed members of the Portuguese military. Football is the most popular amateur sport in the world, and some of Africa's stars began their careers in just such informal settings.

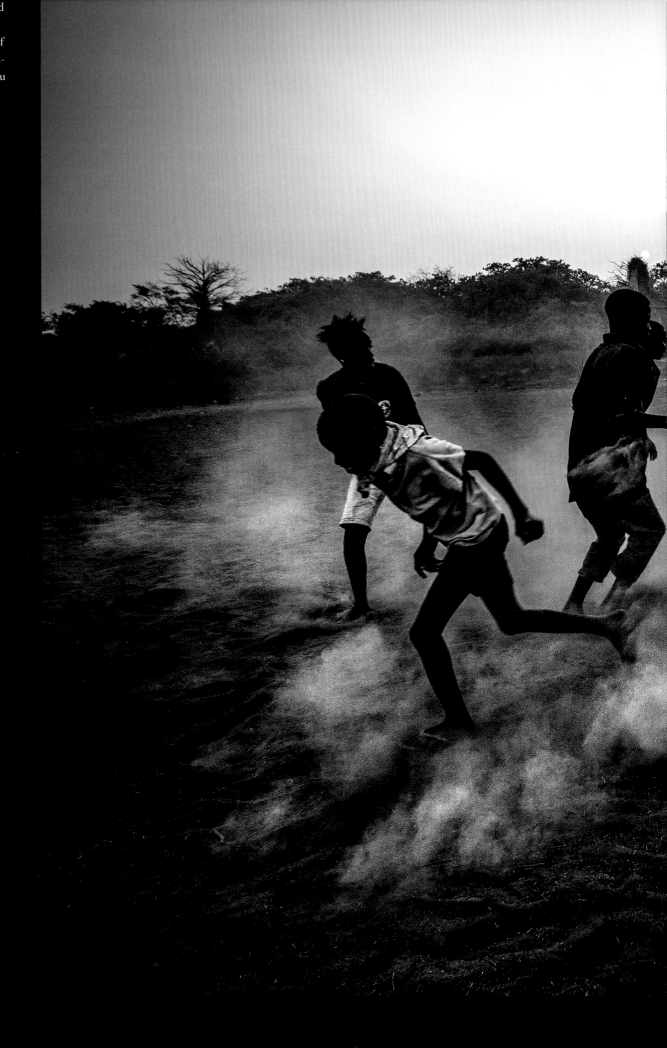

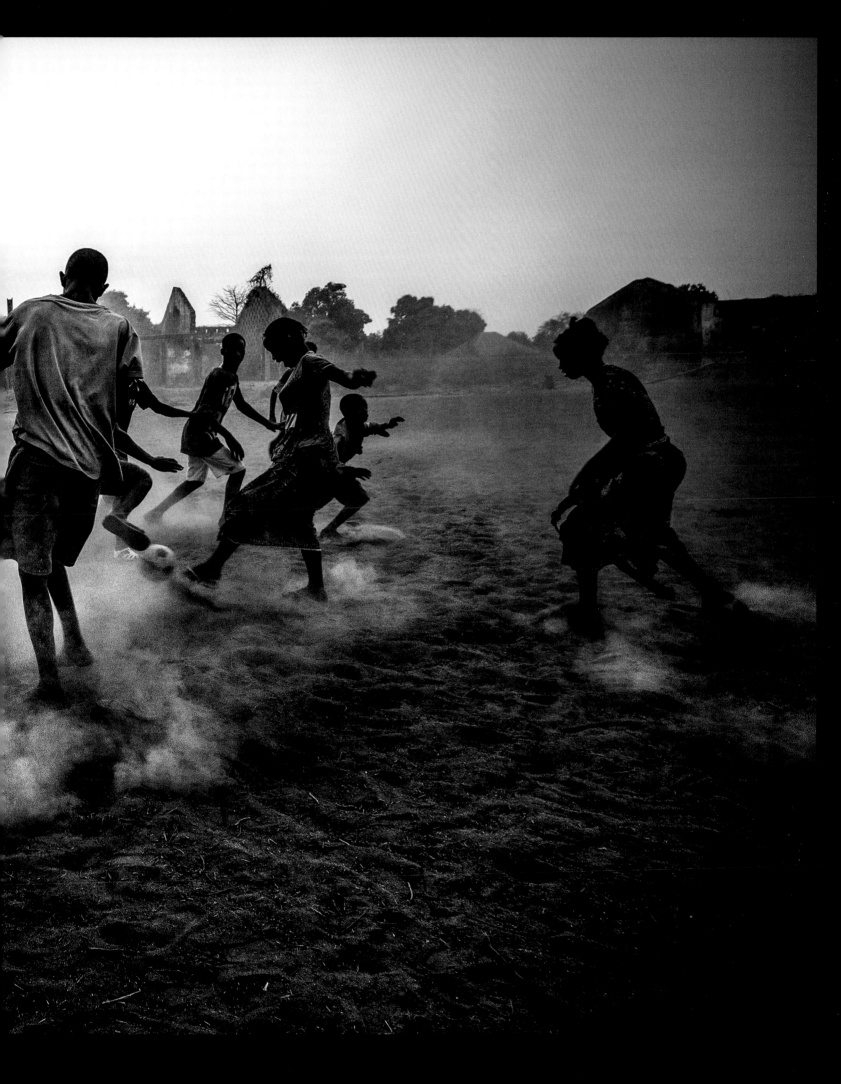

Mirella was married to her husband Luigi for over 40 years. At the age of 65, Luigi began to show symptoms of Alzheimer's disease. For six years, Mirella cared for Luigi herself, at home in Rome. Alzheimer's is a progressive degenerative illness that can affect memory, thinking, behavior, and emotion, and is the most common type of dementia. Over 36 million people worldwide live with dementia, and numbers are increasing as populations age. For Mirella, it meant that everyday tasks became long and difficult operations involving both of them. At one point Luigi seemed no longer to understand what the cutlery and food set before him were for, and stopped eating. He appeared to be unable to distinguish between day and night, and his confused body clock–sleeping during the day, and staying awake at night–disrupted Mirella's daily rhythm, too. After five years of the disease, Luigi no longer recognized his wife. He died in May 2011, with Mirella and their family at his bedside.

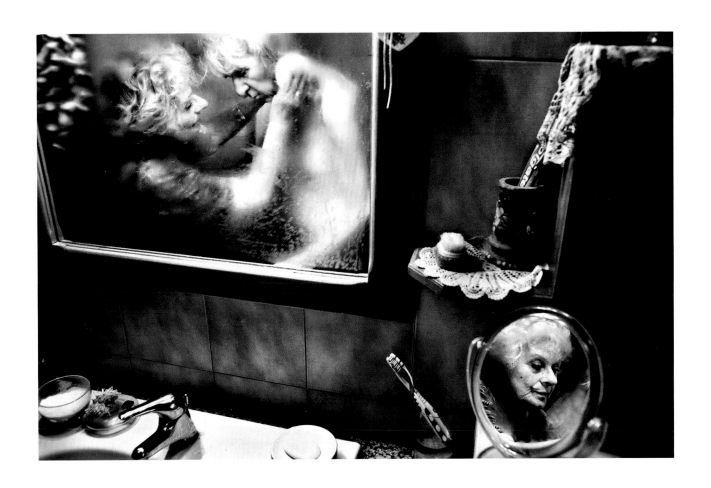

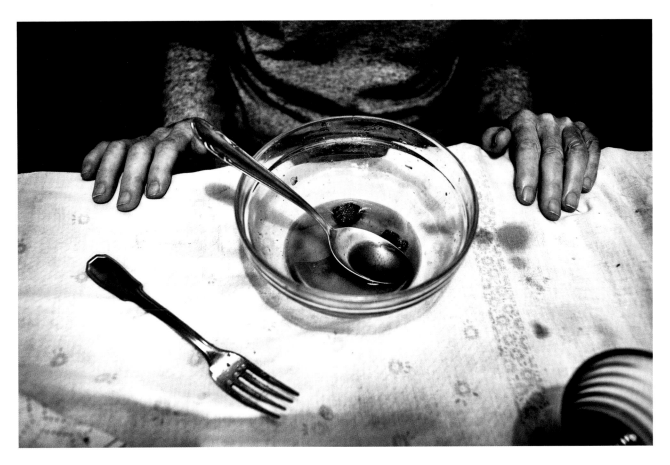

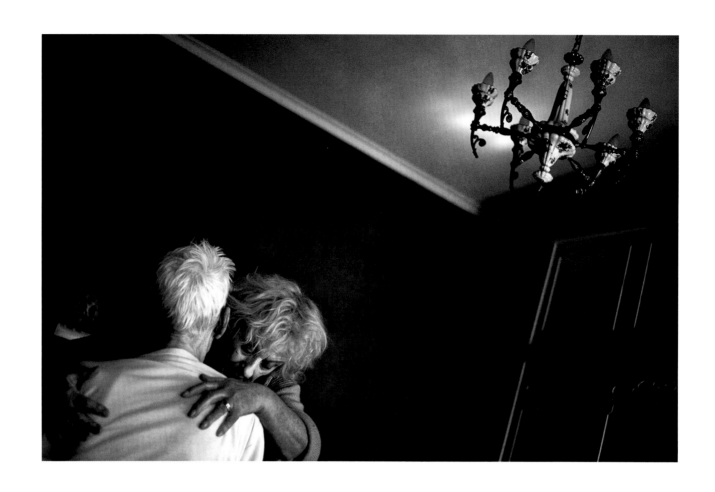

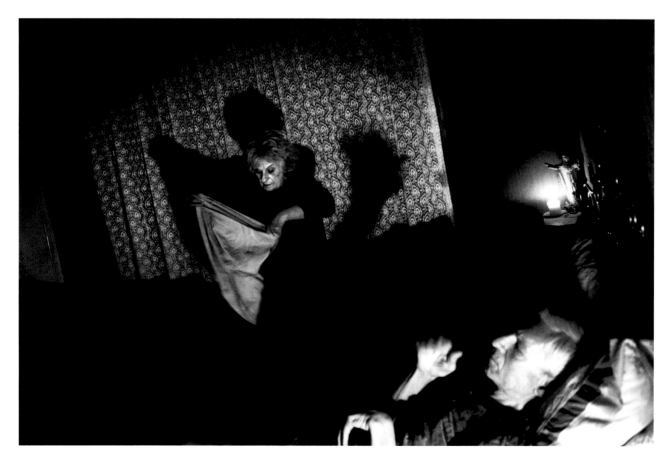

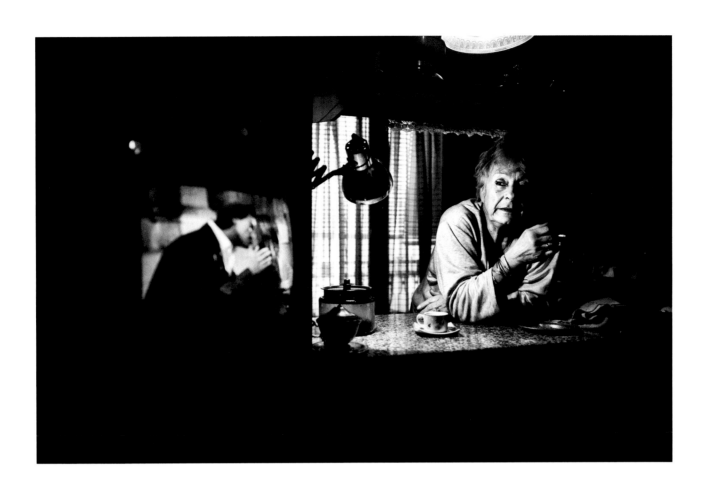

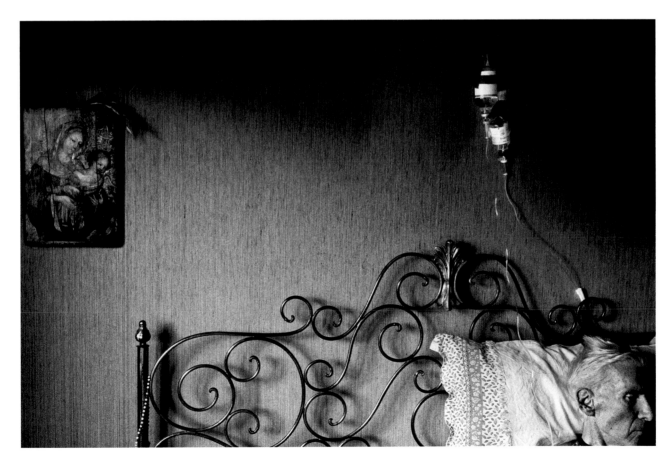

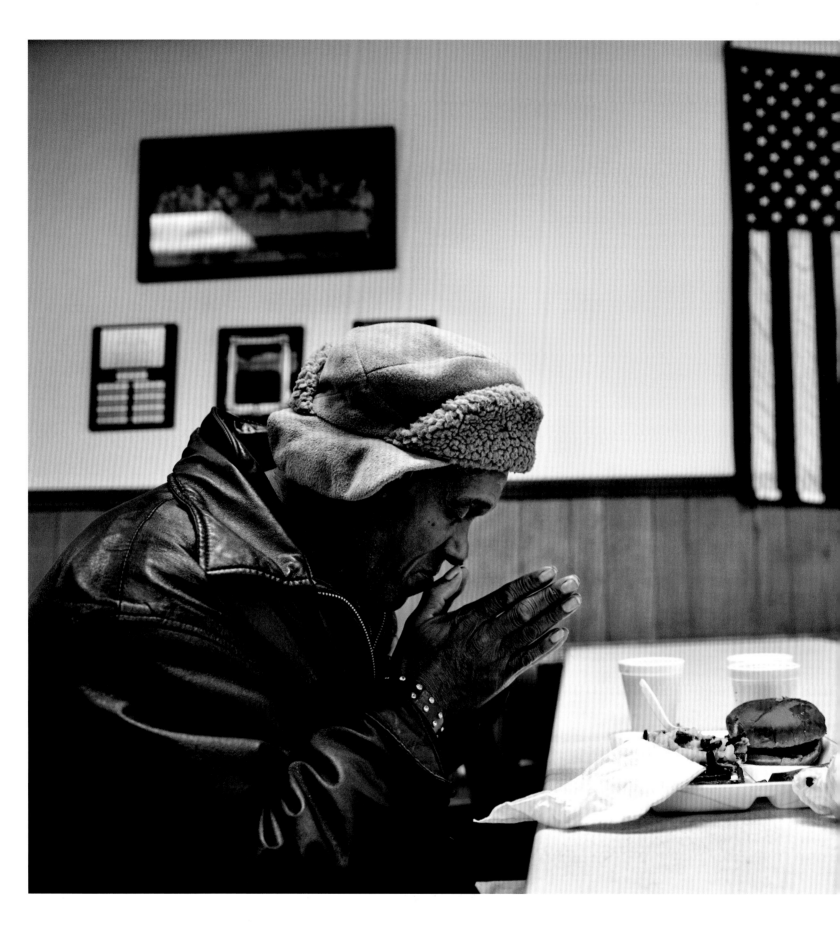

Every day, John McLean (65), visits the St Vincent de Paul Society Dining Hall, in Youngstown, Ohio. People who are homeless or in financial difficulty can go to the hall for warmth, a good meal, and to socialize. Youngstown, which is struggling from the loss of steel industry jobs, is one of the poorest major cities in the US, with more than one in three citizens living below the poverty line, and half the inhabitants living in areas characterized by extreme poverty.

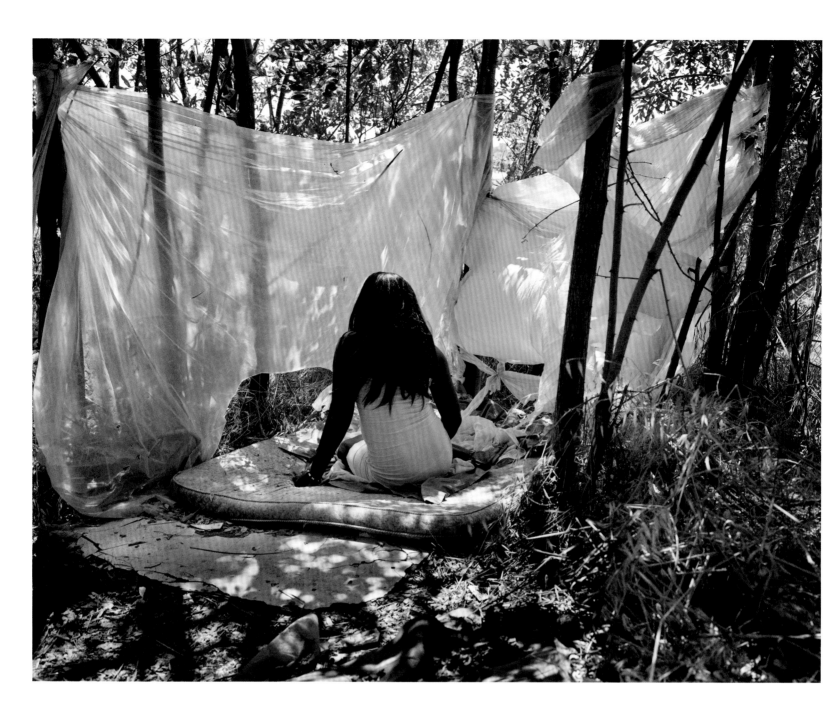

Roadside prostitution in Italy is conducted primarily by migrant sex workers. Some of the women are victims of trafficking—they have been deceived by criminal gangs into coming to Italy, lured by promises of legitimate jobs. Others have willingly been smuggled into the country, but find prostitution the only way that they can earn enough money to send back to their families, or to pay back the thousands of euros they owe to smugglers. Above: Deborah, a Nigerian sex worker, sits on her makeshift bed. Facing page: A mat used by sex workers, in a wooded area on the outskirts of Rome. (continues)

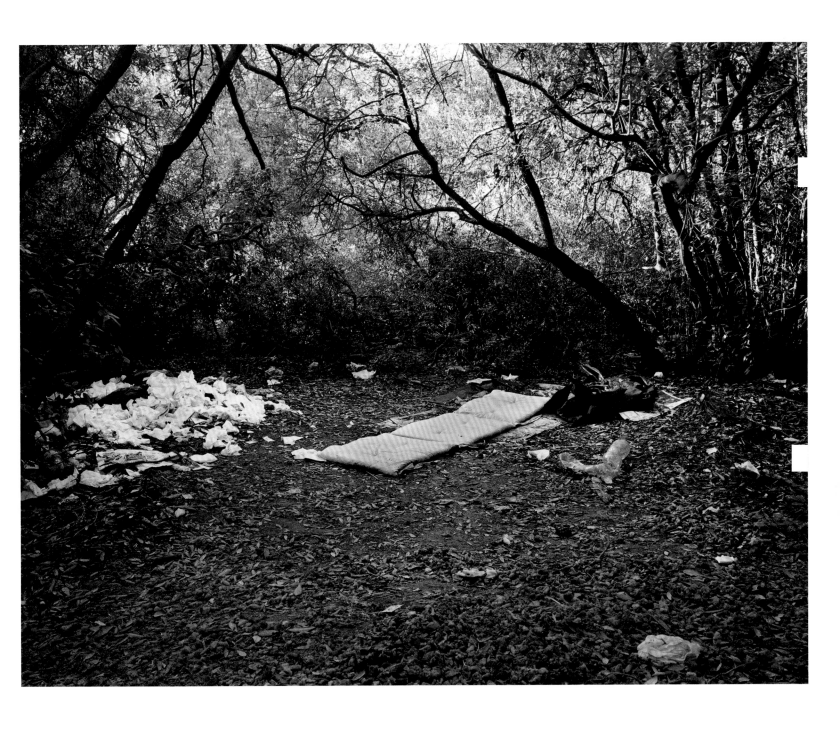

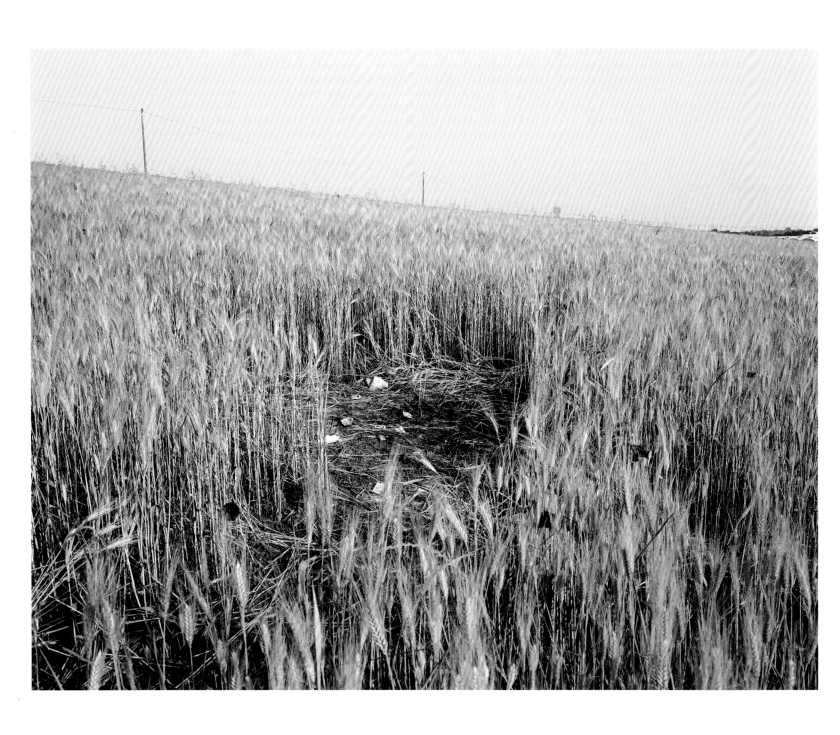

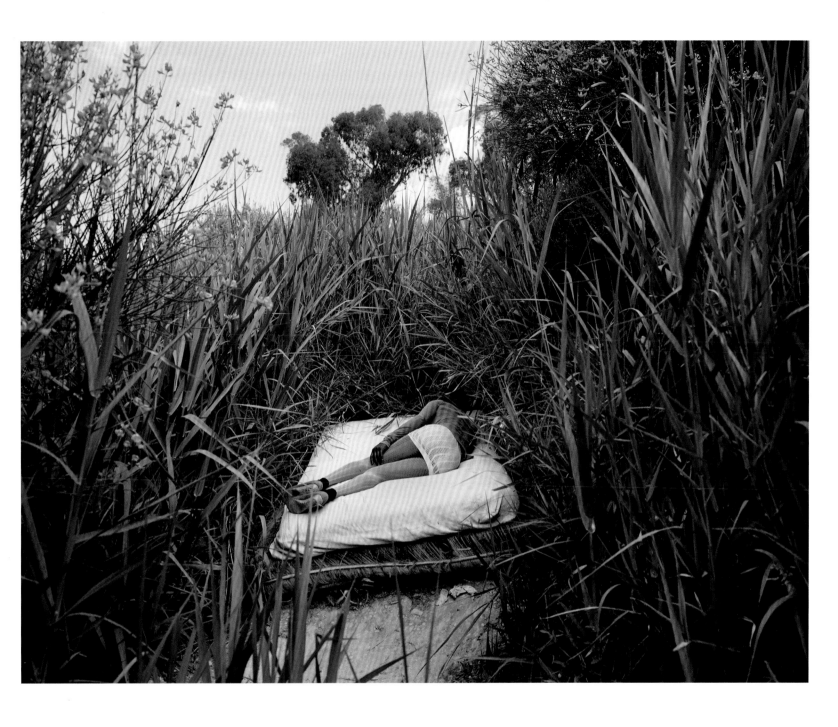

(continued) For nearly twenty years, women from Benin City, in the state of Edo in Nigeria, have been going to Italy to earn money as sex workers, hoping to ensure a better future for their families. The women organize the operation among themselves, and are ostensibly released from obligation once they have paid off their debt, but still find it difficult to secure work that is unrelated to sex. Facing page: A wheat field used by sex workers beside a country road. Above: Anna, a Nigerian sex worker, near Rome.

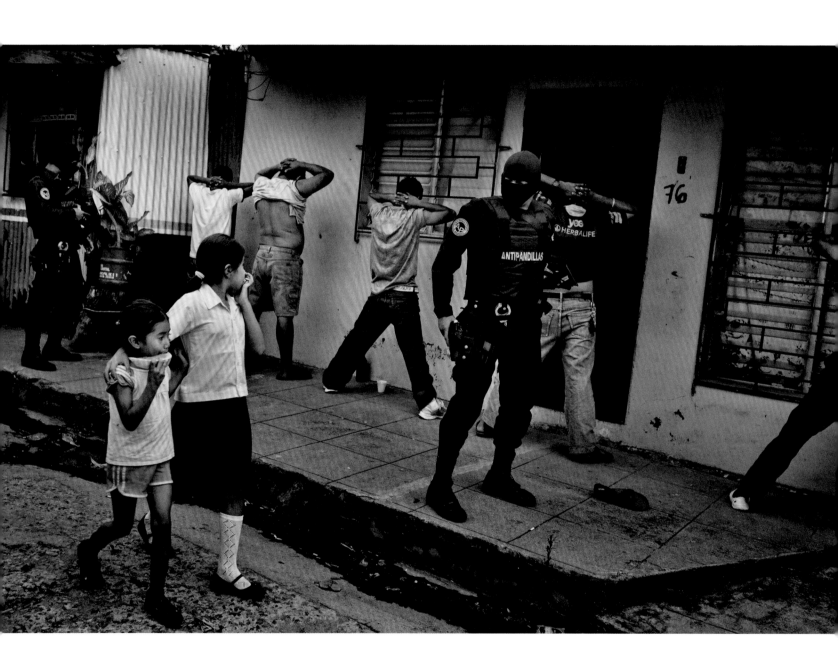

Large-scale gang warfare has made El Salvador one of the most violent countries in the Americas. However, a truce agreed between major gang leaders on 9 March appeared to have some success. Homicides in the first part of the year were down 32 percent, and kidnappings dropped by half. Above: Anti-gang police conduct a raid in the capital San Salvador. Facing page: A member of Barrio 18 wears gang tattoos to show commitment for life.

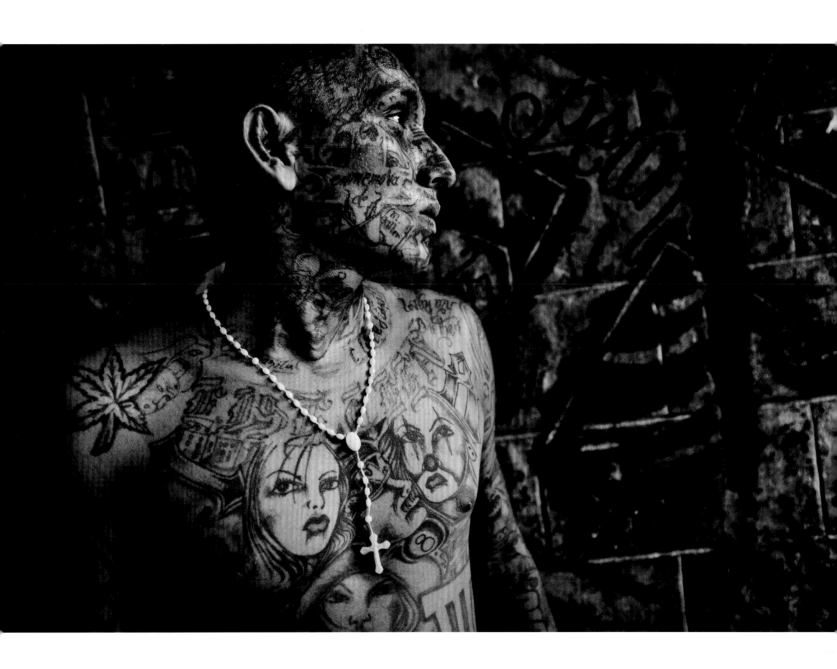

The favelas (slum quarters) of Rio de Janeiro, Brazil—many just a street away from rich neighborhoods—have for decades been no-go areas ruled by drug lords and vigilante militia. With the football World Cup coming to Rio in 2014, and the Olympics in 2016, authorities have made a concerted effort to clean up the favelas. The Unidade de Polícia Pacificadora ('Pacifying Police Unit', or UPP) was set up in 2009 to see this through. The approach is twofold. The first stage, UPP Policing, sees elite forces storming a favela, and establishing a permanent police presence there. Then UPP Social is supposed to follow up with an improvement of services and infrastructure, such as in education and electricity supply. The initiative has met with partial success. Police units have been established—often for the very first time—in a number of communities, with positive results. But critics say that the UPP has concentrated on favelas closest to rich areas, that the social follow-up has not been effective, and that a true tackling of the problems in favelas needs a broader approach to the reduction of poverty.

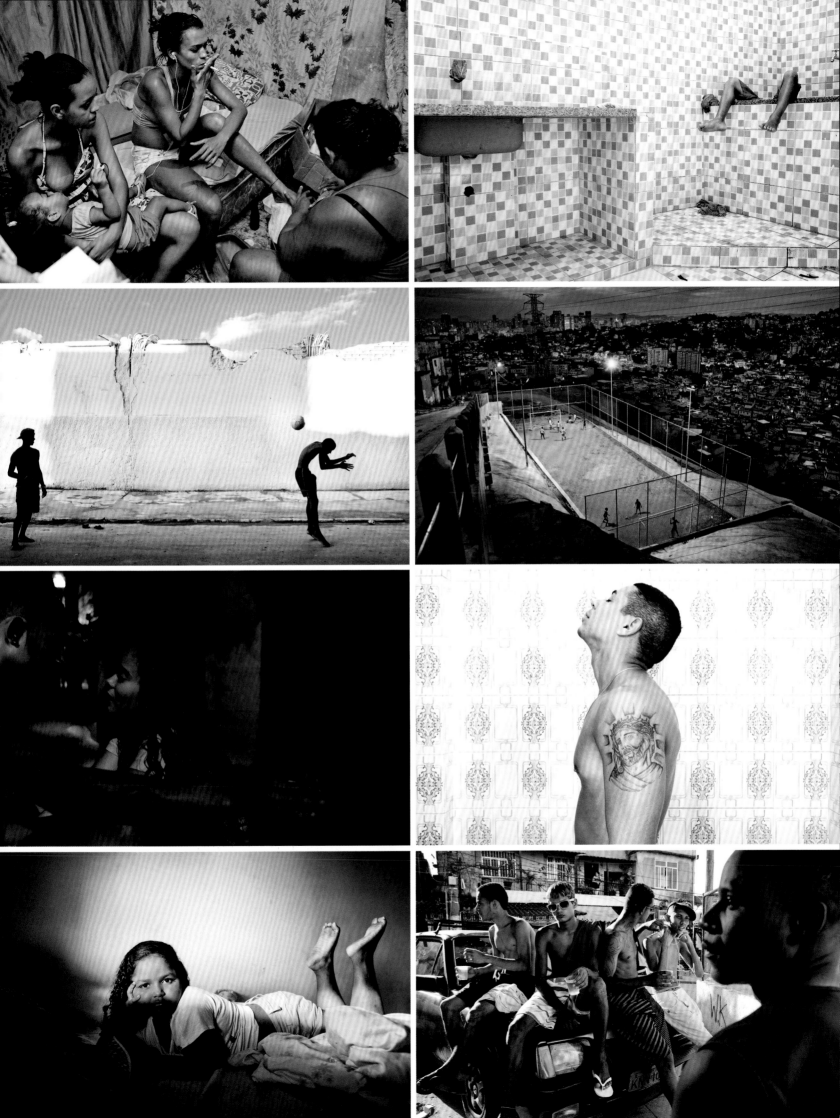

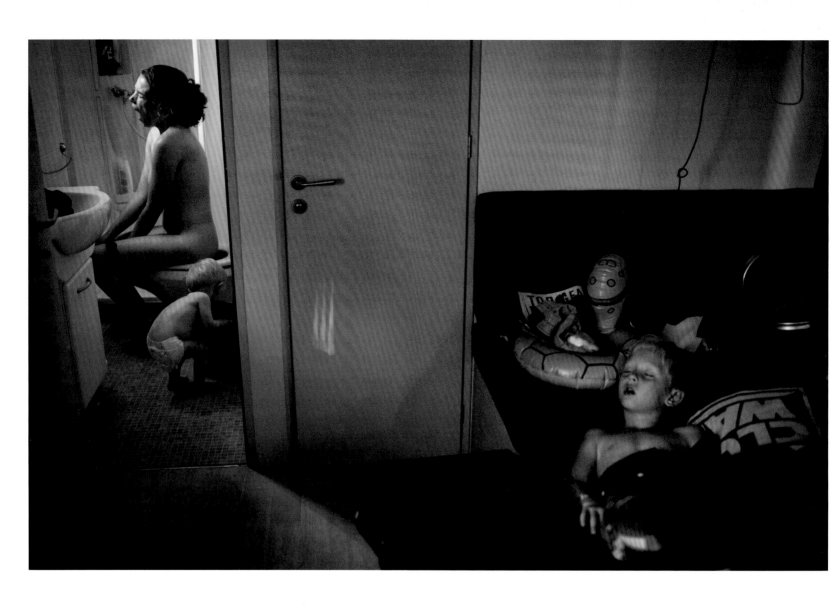

The photographer's family, early one morning on summer holiday in northern Italy.

PEOPLE
OBSERVED
PORTRAITS

SINGLES
1st Prize / **Nemanja Pancic**
2nd Prize / **Marie Hald**
3rd Prize / **Ilona Szwarc**
STORIES
1st Prize / **Ebrahim Noroozi**
2nd Prize / **Daniel Ochoa de Olza**
3rd Prize / **Ananda van der Pluijm**

Milan (4) leaves hospital on 27 February, three months after surviving a family suicide attempt, in which both his father and mother died. All three jumped from a sixth-floor balcony, in Belgrade, Serbia. Milan's parents had been experiencing financial difficulties in the midst of a struggling national economy.

Somayeh Mehri (29) and Rana Afghanipour (3) are a mother and daughter living in Bam, southern Iran. They were attacked with acid by Somayeh's husband Amir. Somayeh had frequently been beaten and locked up by her husband, and finally found the courage to ask for a divorce. Amir warned her that if she persisted in her attempts to leave him, she would not live out life with the face she had. One night in June 2011, he poured acid on Somayeh and Rana as they slept. Above: Somayeh before she was attacked. Facing page, top: Somayeh and Rana kiss each other. Since their disfigurement, they say, others don't like to kiss them. Below: Rana looks at herself in a mirror. (continues)

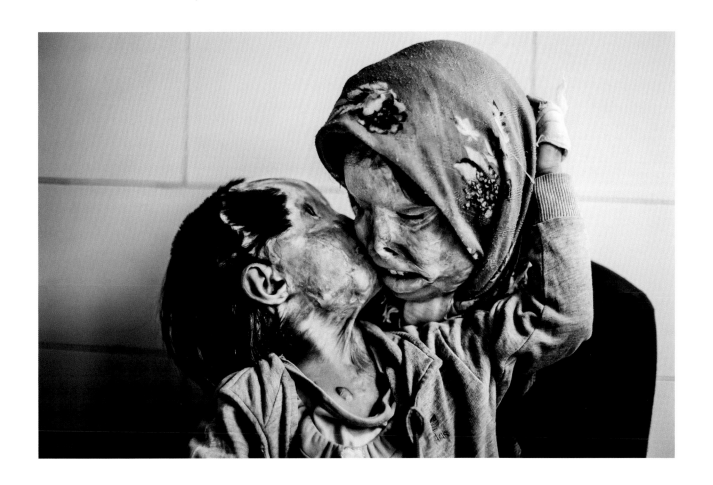

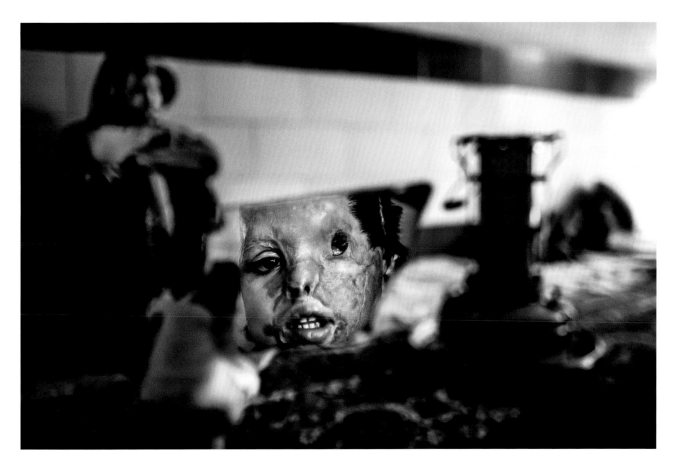

People Observed Portraits 83

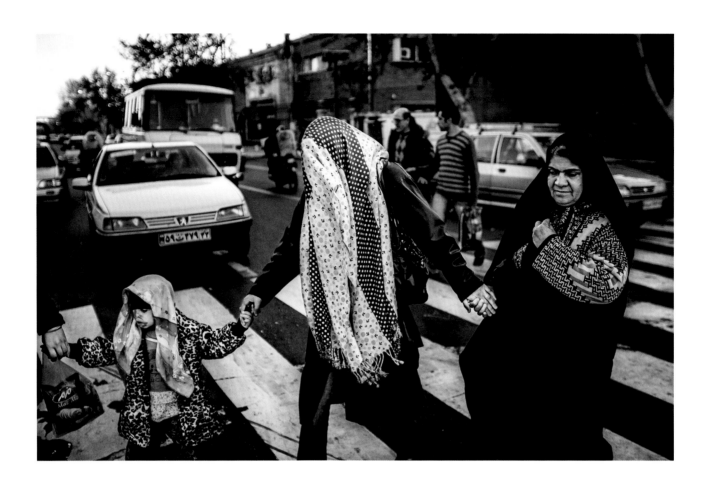

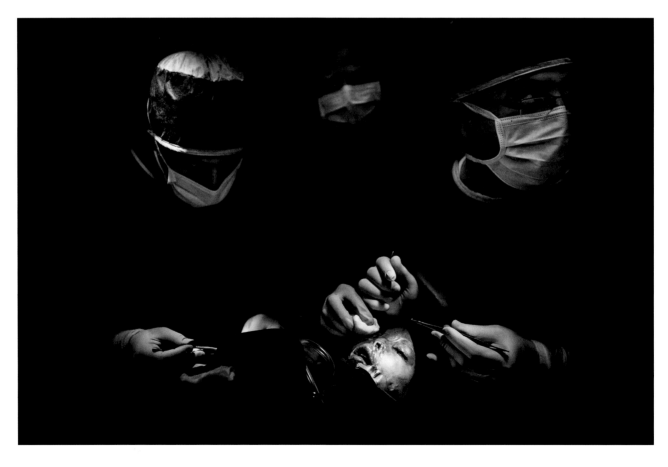

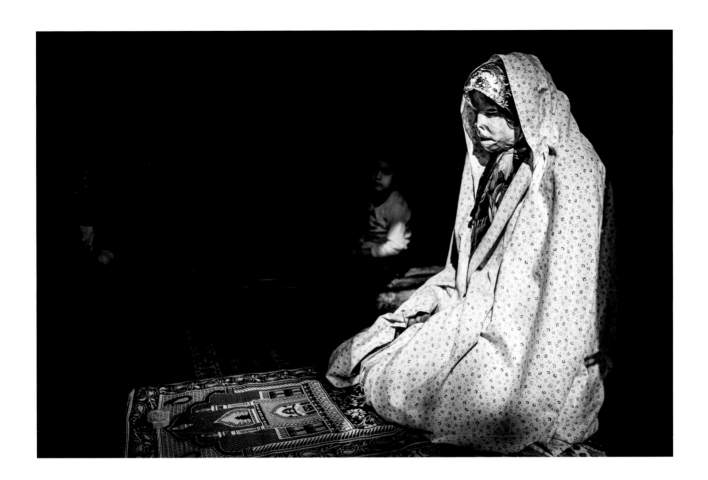

(continued) Somayeh's and Rana's faces, hands, and, in places, their bodies were severely burned. Somayeh was blinded, and Rana lost one of her eyes. Fellow villagers have helped pay their medical expenses, and Somayeh's father sold his land in order to raise money. Facing page, top: Mother and daughter go for medical treatment in Tehran. Somayeh now prefers to keep her face entirely covered in public. Below: Doctors fit Rana with a glass eye. Above: Somayeh doesn't like socializing any more and spends much of her time praying.

Kayla stands with her American Girl doll, in front of a portrait of her ancestors, in Boston, Massachusetts, USA. The dolls come in a range of different 'characters', with varying skin tones and hairstyles that customers can choose from.

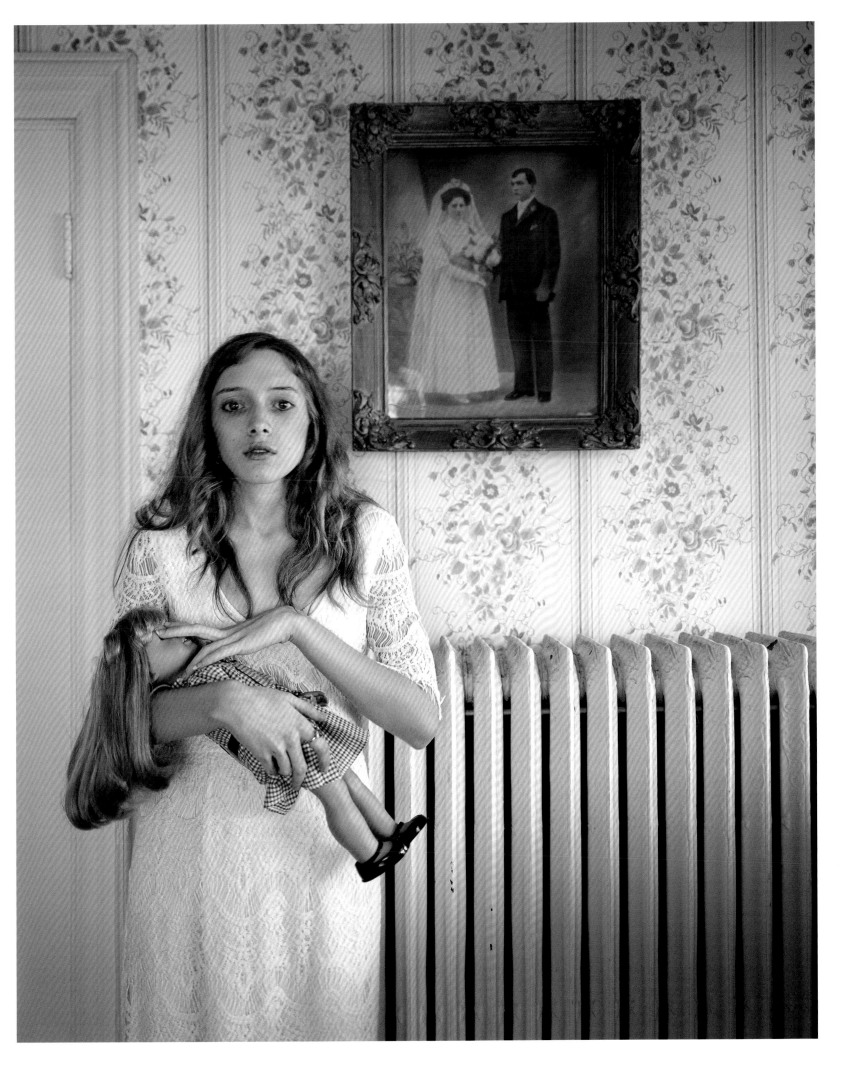

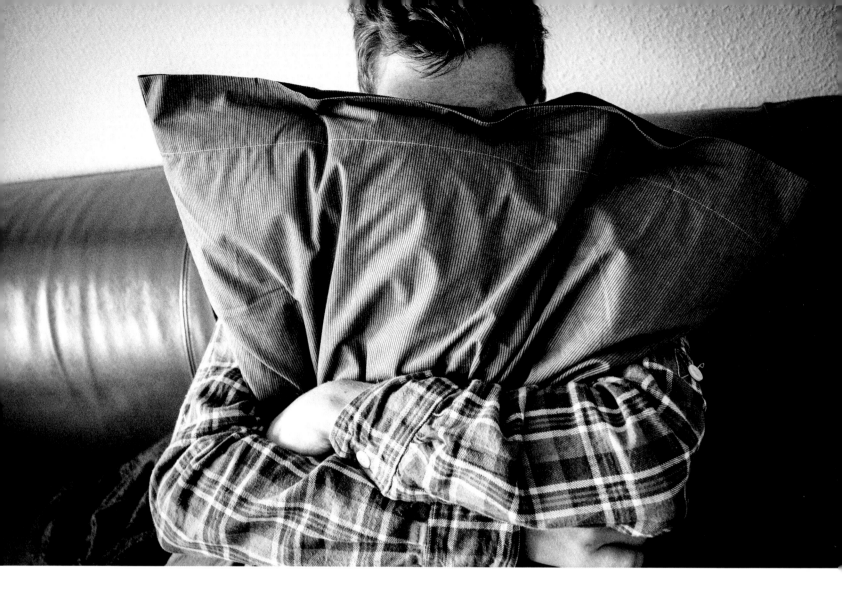

Martin (18) is the photographer's half-brother. He returned to stay with their mother after living with his father for ten years. He was jobless, had no qualifications, and had spent time in a youth shelter. The photographer, who had had no contact with Martin over the previous decade, decided to use her camera to help get to know him again.

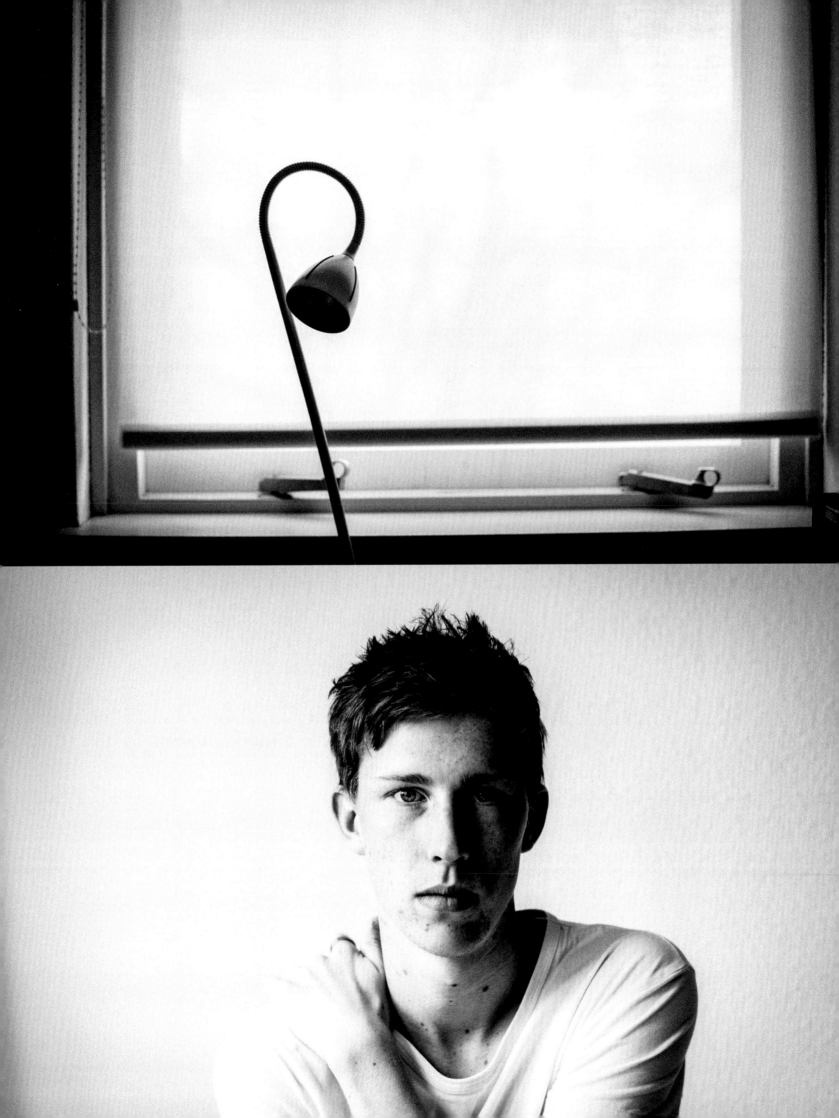

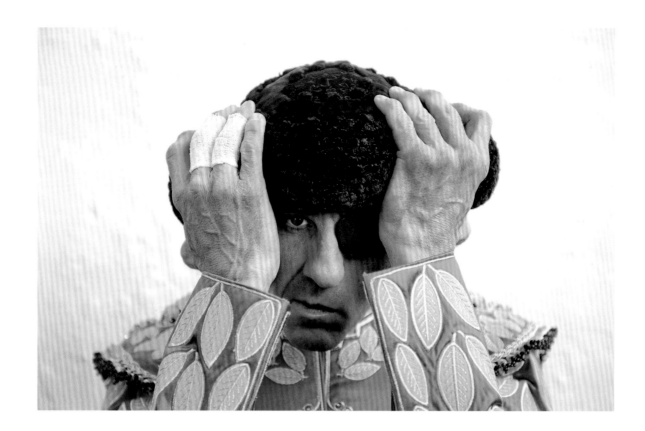

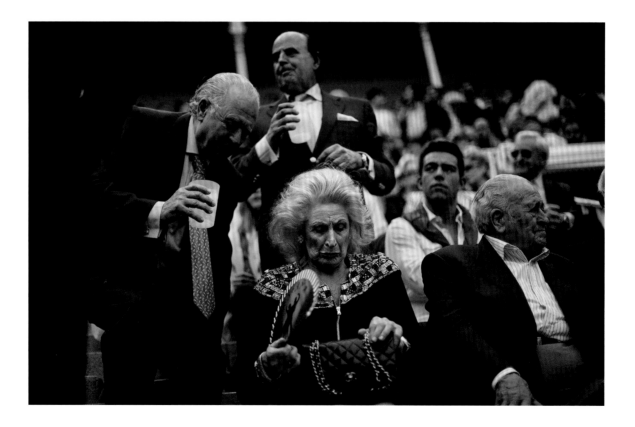

Spanish bullfighter Juan José Padilla (38), known as the 'Cyclone of Jerez', lost the sight in one eye and has partial paralysis of the face after being gored by a bull in October 2011. Five months later he made a comeback. Above: Padilla adjusts his *montera* (bullfighter's hat) before going into the ring. Below: The crowd gathers for a bullfight.

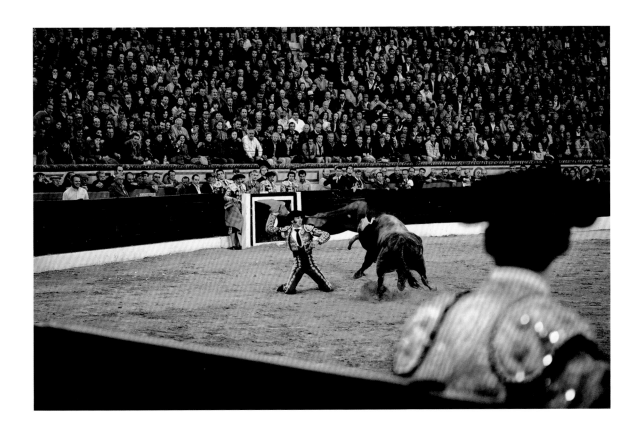

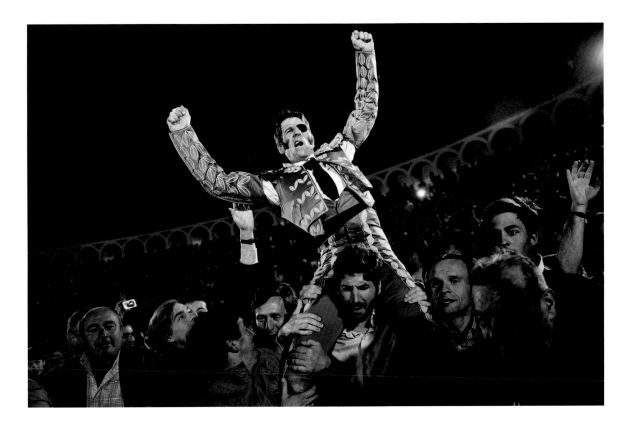

Padilla made his comeback on 4 March, in the southwestern town of Olivenza. After the fight, he was carried from the ring on the shoulders of a fellow bullfighter, an honor reserved for the very best performers.

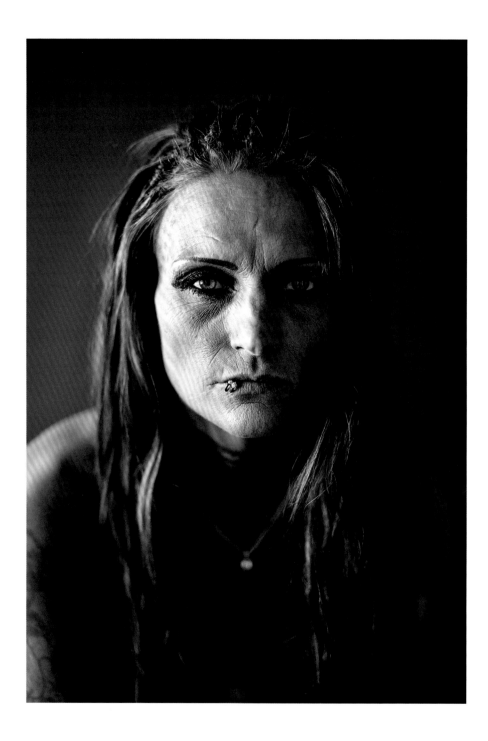

Bonnie Cleo Andersen (38), mother of three, has been a sex worker in Denmark since the age of 18. Prostitution is legal in Denmark. Bonnie works during the day in a small house in a village in the east of the country, then picks her children up after school to take them home to another village, 15 km away. Her hope is that they will have better lives than hers.

PEOPLE
STAGED
PORTRAITS

SINGLES
1st Prize / **Nadav Kander**
2nd Prize / **Stefen Chow**
3rd Prize / **Anna Bedyńska**
STORIES
1st Prize / **Stephan Vanfleteren**
2nd Prize / **Ebrahim Noroozi**
3rd Prize / **Fu Yongjun**

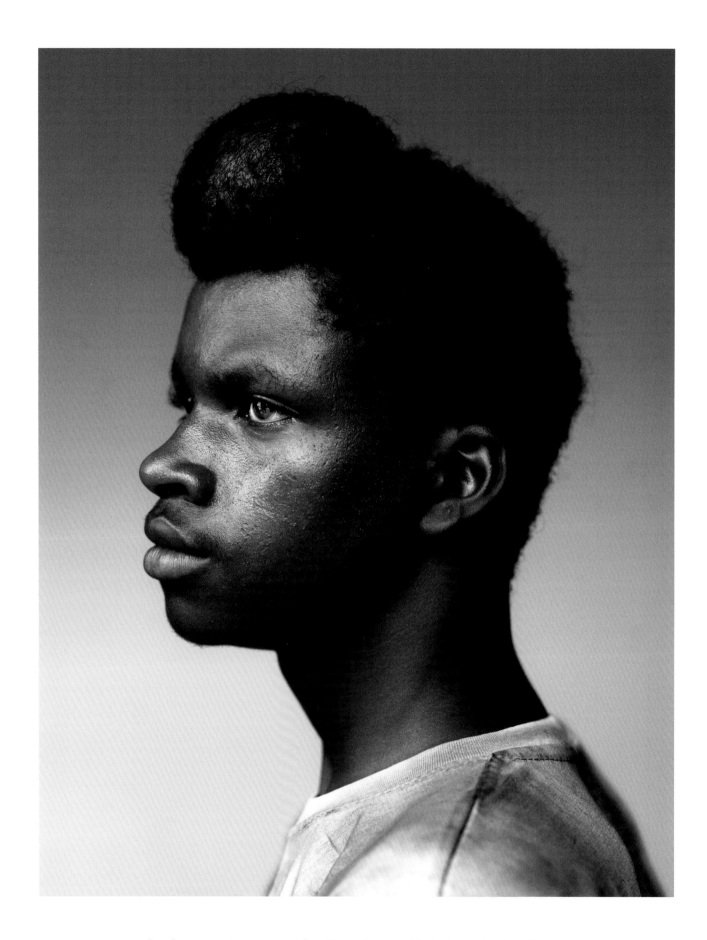

People receiving treatment on *Africa Mercy*, a hospital ship docked at Conakry, Guinea. Boubacour Diallo (18). "I was born like this. It is God's will. People sometimes laugh at me, but that doesn't bother me. I am an honest Muslim. I don't fear death."

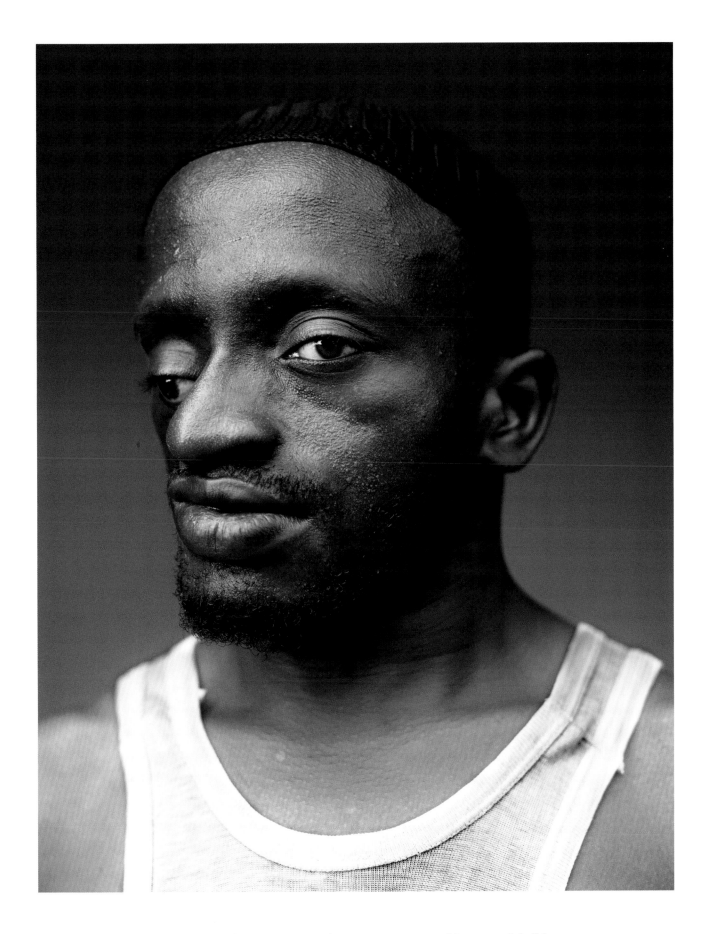

Ansman Danshuku (29). "Years ago they cut away a tumor as big as a tennis ball from my face, and now there is a hole. I am a teacher. It is hard to stand in the classroom with a face like this."

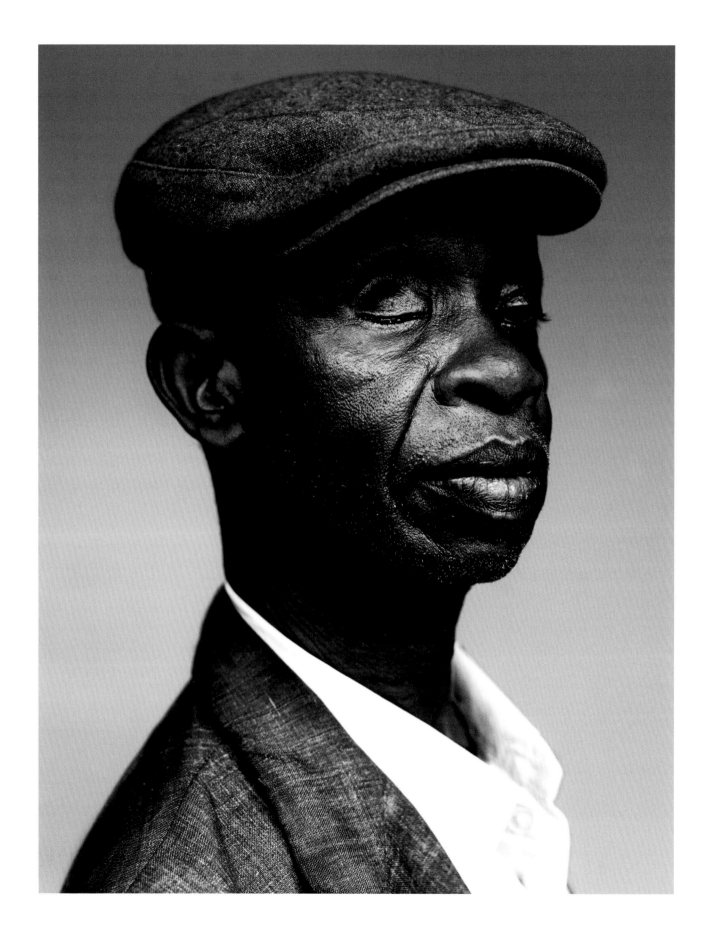

Mohamed Diabatis (61). "Two years ago I lost my right eye, and have only 50 percent vision in my left. I am a positive man, but how can I work if I go completely blind? I fight to survive."

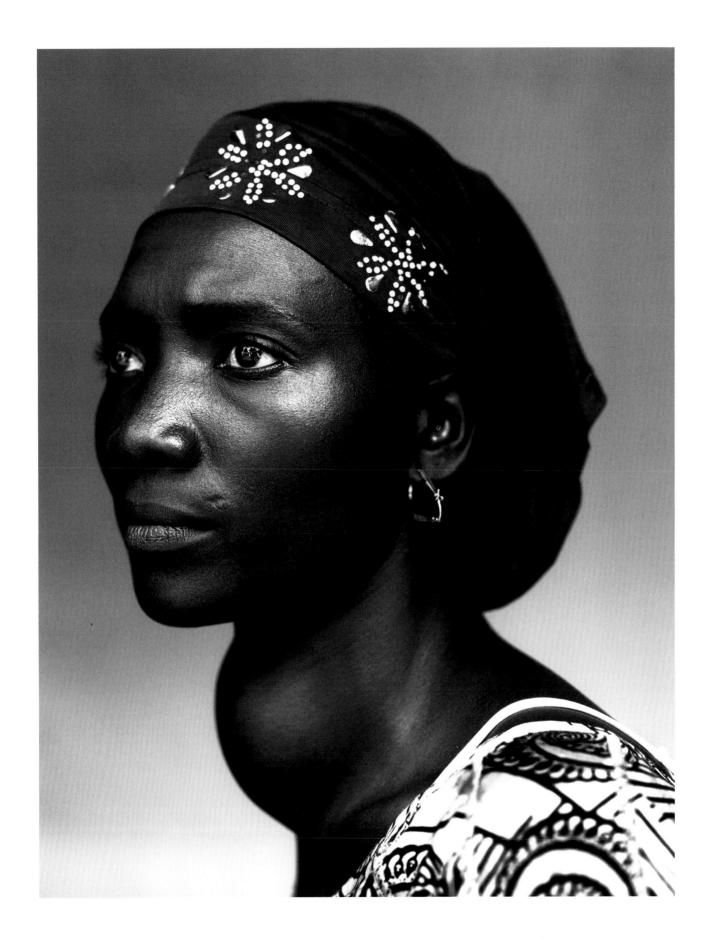

Makone Soumaoro (30). "My neck doesn't hurt, but I worry that it swells so much. I hope it is not a tumor, because I'm a housewife and my husband and children need me."

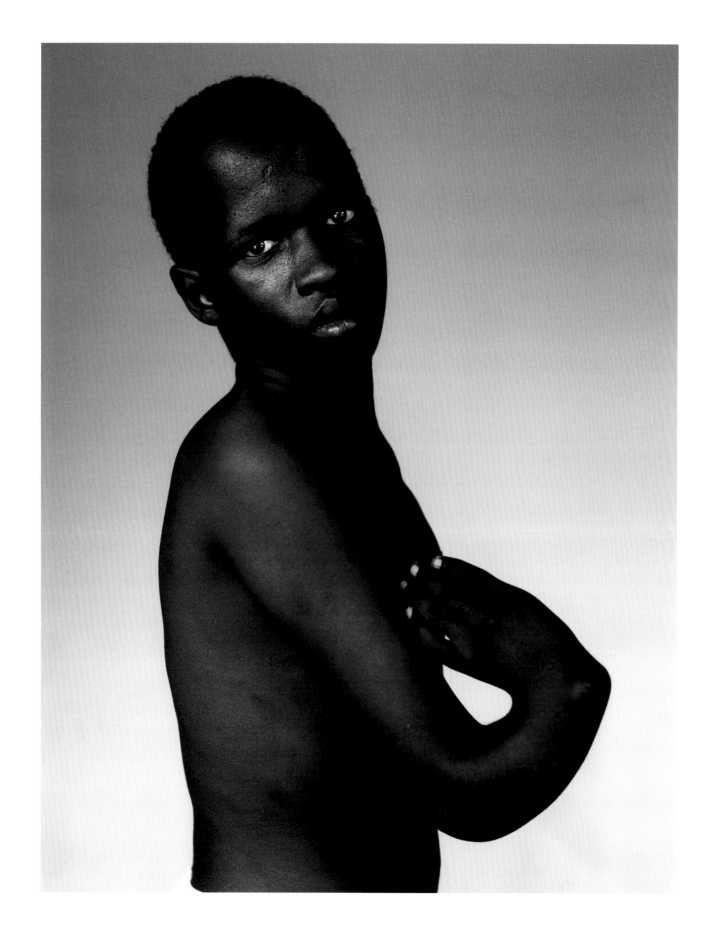

Barry Mamadou Djoulde (16). "I dream of starting my own business to support my family. I was born with radial club hands and underdeveloped elbows."

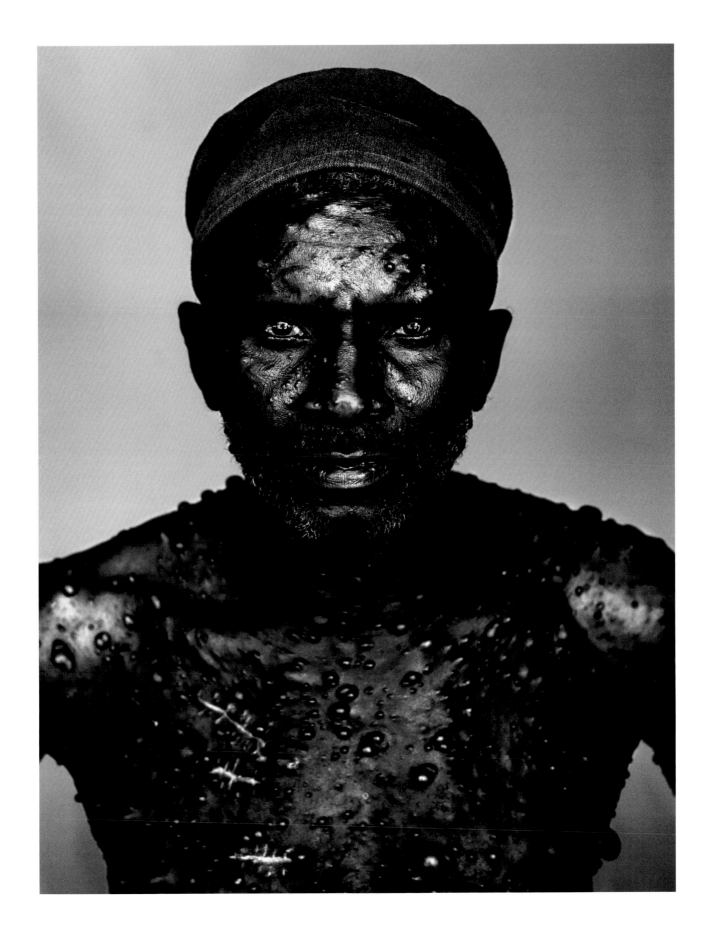

Fofana Mamadou (52). "It doesn't hurt, but it's not a beautiful sight. People laugh. I can cover my body, but not my face. My wife left me, because she could not live with a man like me."

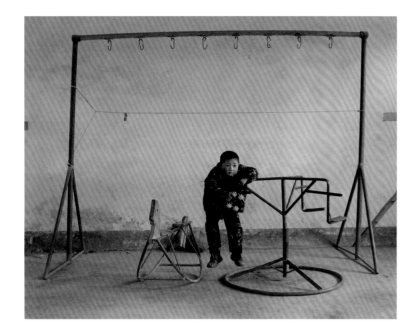

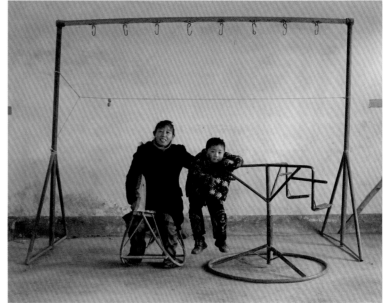

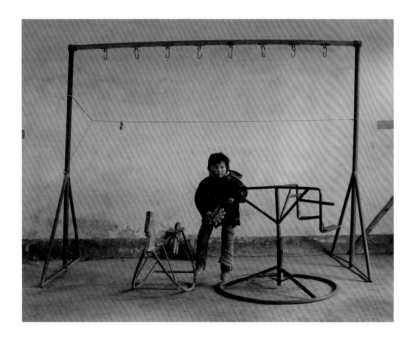

China has some 220 million migrant workers. Young couples moving from rural areas to work in the cities often have to leave their children behind while they earn money to support the family. Many who meet and marry far from home need to remain working, and so take their children to be looked after back in their villages by grandparents. The portraits depict children in the village of Zhangmu, Chongqing, in southwest China, both alone and with a much-loved teacher Fu Huaying. This page, top: Wu Mingjie (4), whose parents are working in Guangdong Province, nearly 1,000 km away. Below: Huang Qi (4), whose parents are working 700 km away, in Yunnan Province. Facing page, top: WuCan (4), whose parents are working in Zhejiang Province, some 1,400 km distant. Below: Fu Huaying, who has been a teacher in Zhangmu for over 20 years.

 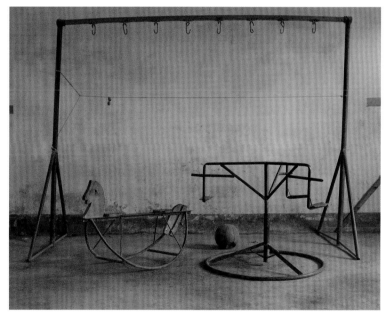

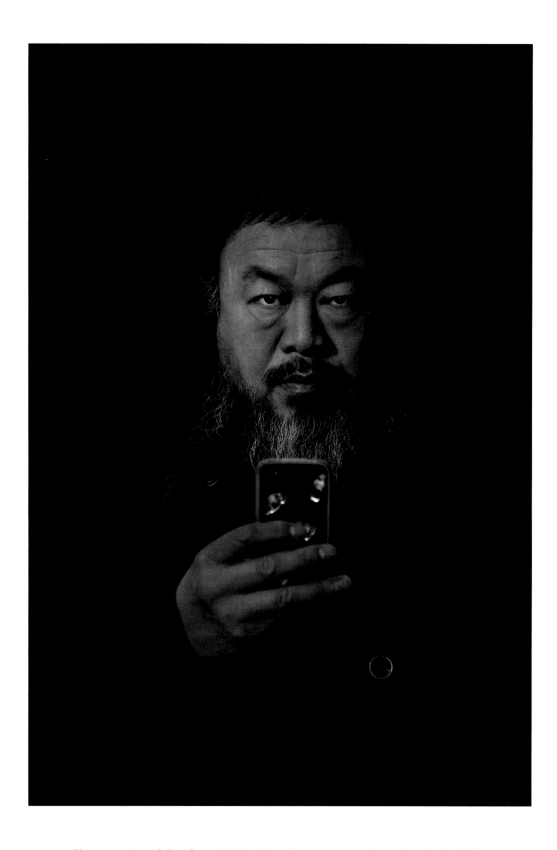

Chinese artist and dissident Ai Weiwei is active across a number of media, including sculpture, installation, architecture, photography and film. He is highly vocal in his criticism of the Chinese government's record on democracy and human rights, and in his investigations of corruption and cover-up. In 2011, Ai was detained by the authorities, accused of tax evasion. He spent time in jail and under house arrest, and he cannot travel without government permission. In May, Ai was a recipient of the inaugural Václav Havel Prize for Creative Dissent, awarded by the Human Rights Foundation.

Zuzia is a girl with albinism, and attends a school for partially sighted children in Warsaw, Poland. She dreams of meeting someone like herself. Albinism is caused by a recessive gene (passed to a child by both parents) that deprives the skin, hair, and eyes of pigment. This can cause serious eye problems. Because pigment plays a role in protecting the skin from ultraviolet radiation, people with albinism are highly susceptible to the adverse effects of overexposure to sunlight.

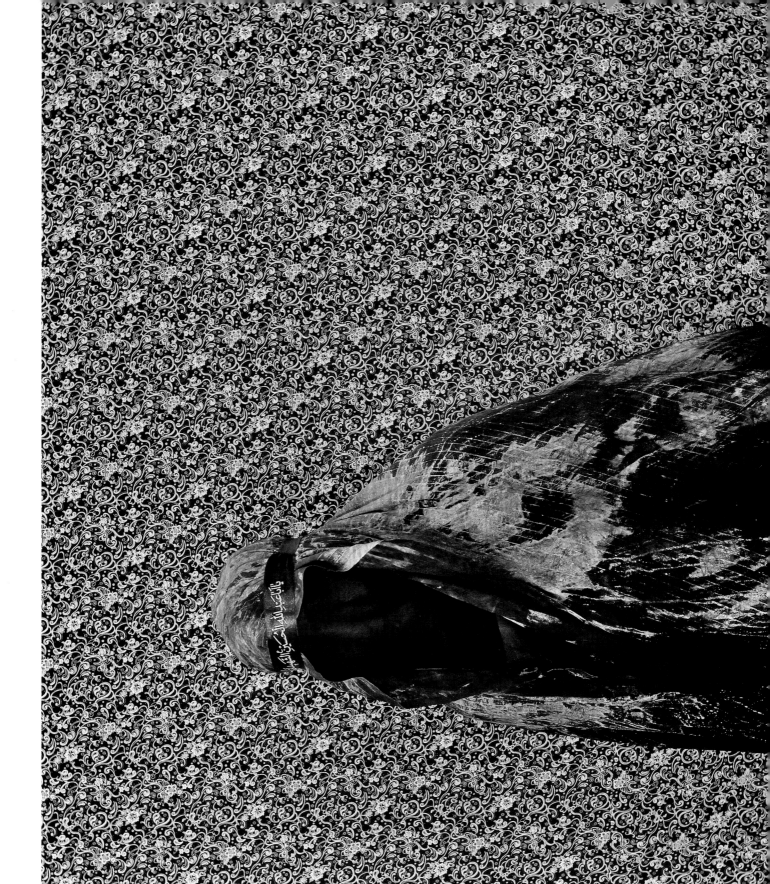

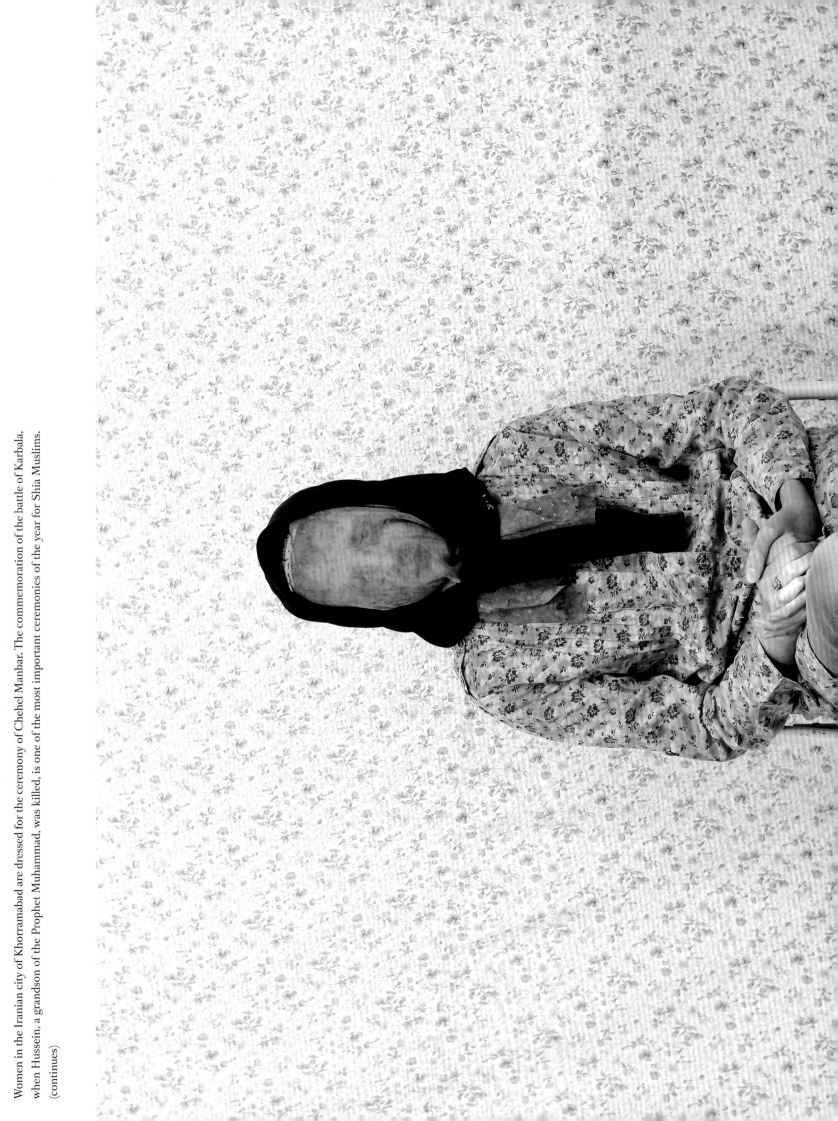

Women in the Iranian city of Khorramabad are dressed for the ceremony of Chehel Manbar. The commemoration of the battle of Karbala, when Hussein, a grandson of the Prophet Muhammad, was killed, is one of the most important ceremonies of the year for Shia Muslims.

(continues)

(continued) On the ninth day of the Muslim month of Muharram—on the eve of the climactic Day of Ashura—women in some regions participate in Chehel Manbar. In an act of mourning for Hussein they go veiled and barefoot to light candles at 40 different locations. (continues)

(continued) Ceremonies differ from city to city, according to regional traditions. In Khorramabad, women light candles in the doorways of houses and offer cookies to the occupants. They may also cover their head and shoulders with clay, in an act of mourning.

Daniel Kaluuya (23) is a British actor, comedian, and writer, best known for his role in the TV drama *Skins* and as Special Agent Tucker in the 2011 Rowan Atkinson film *Johnny English Reborn*. In 2010, Kaluuya shed nearly 20 kg to take on the role of a boxer in the stage play *Sucker Punch*, for which he won both an Evening Standard Award, and the Critics' Circle Theatre Award for Most Promising Newcomer.

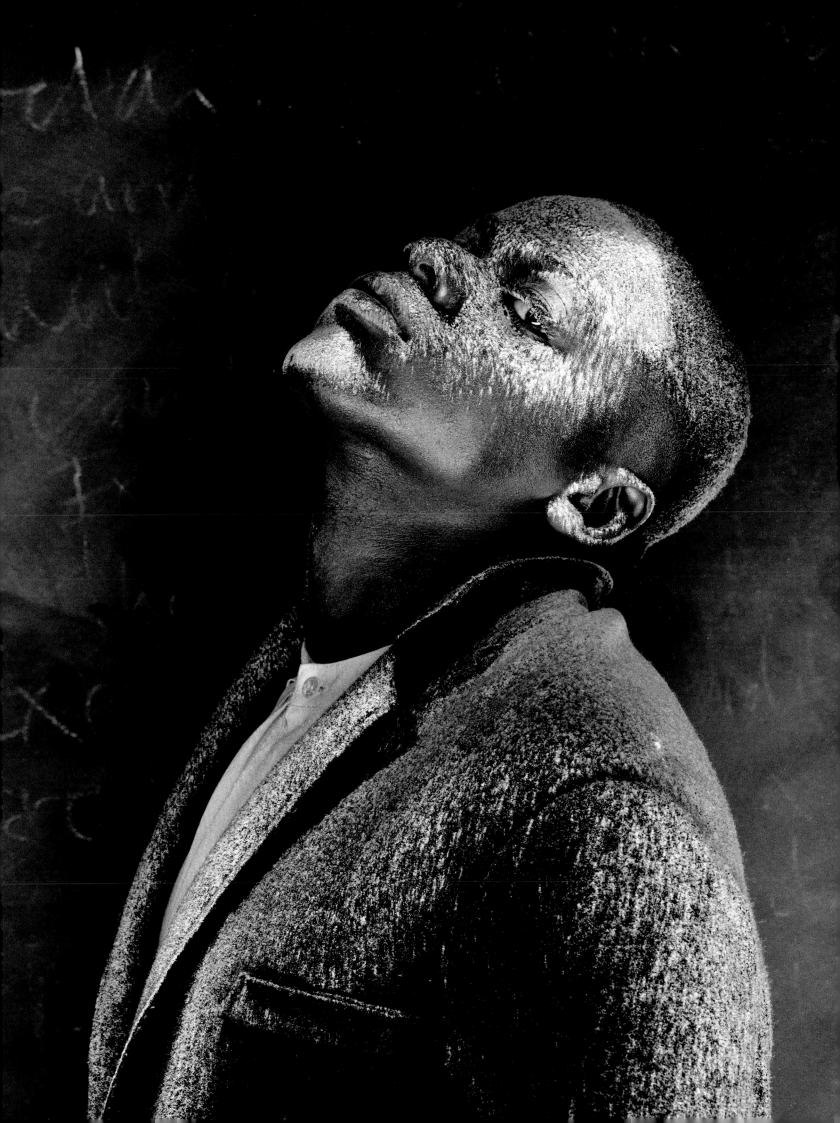

NATURE

SINGLES
1st Prize / **Christian Ziegler**
2nd Prize / **Ali Lutfi**
3rd Prize / **Randall Benton**
STORIES
1st Prize / **Paul Nicklen**
2nd Prize / **Xiaoqun Zheng**
3rd Prize / **Thomas P. Peschak**

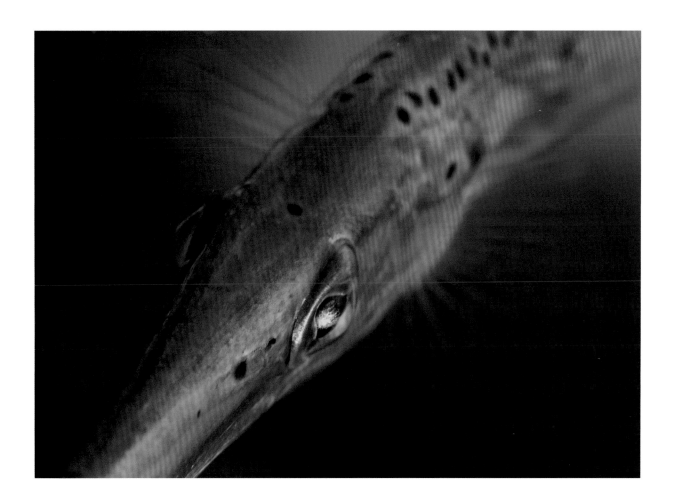

A Caribbean trumpetfish (*Aulostomus maculatus*), off the coast of Bonaire, in the Lesser Antilles. Trumpetfish are named for their elongated snouts and bodies, and can open their mouths widely to suck up the small fish and crustaceans they feed on. They are able to change skin color to blend with surroundings, and often use large herbivorous fish as camouflage, shadowing them until the moment is right to strike out at smaller prey.

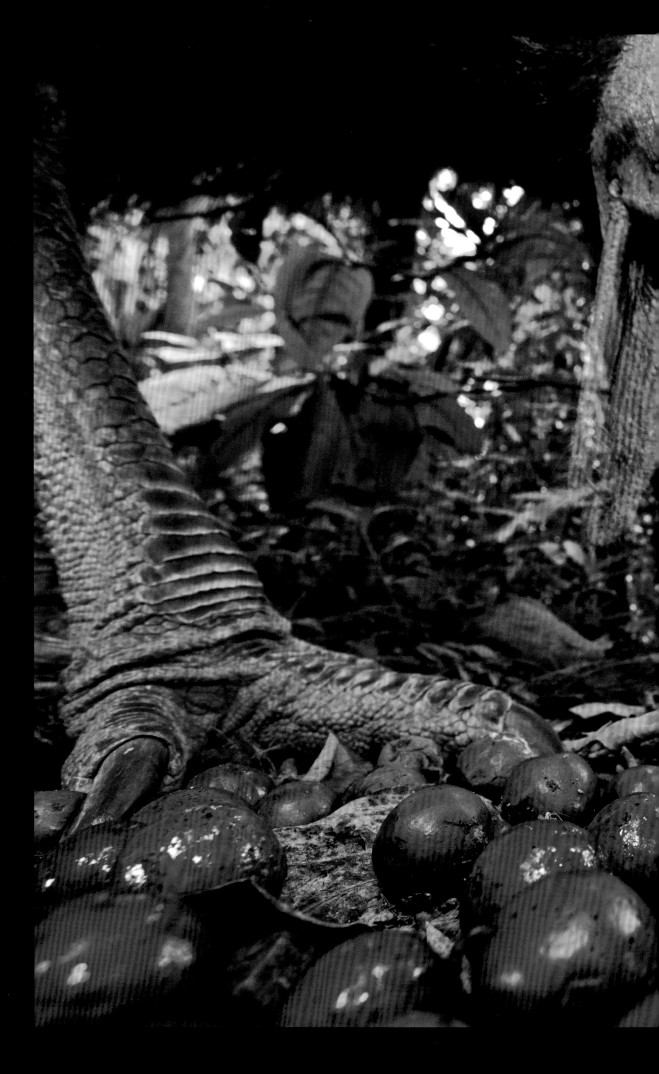

A southern cassowary (*Casuarius casuarius*) feeds on the fruit of the blue quandong tree, in Queensland, Australia. The flightless birds grow up to two meters in height, with males weighing some 55 kg, and females 76 kg. Cassowaries are an endangered species, with around only 1,500 left in the wild. The birds are crucial to the ancient rainforest of northern Queensland because they carry large seeds in their stomachs for long distances. Several dozen tree species appear to rely on cassowaries alone to disperse their seeds. The birds are under threat from habitat loss resulting from agricultural and housing development, killings by domestic dogs, and collisions with vehicles.

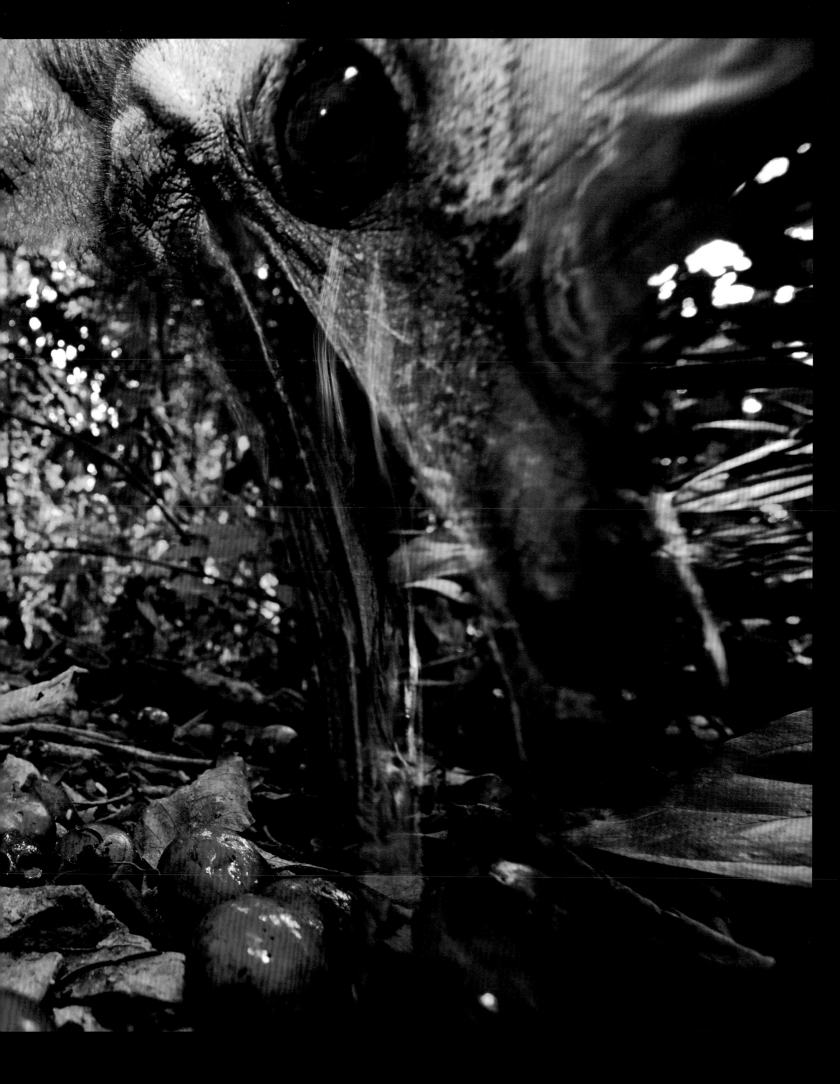

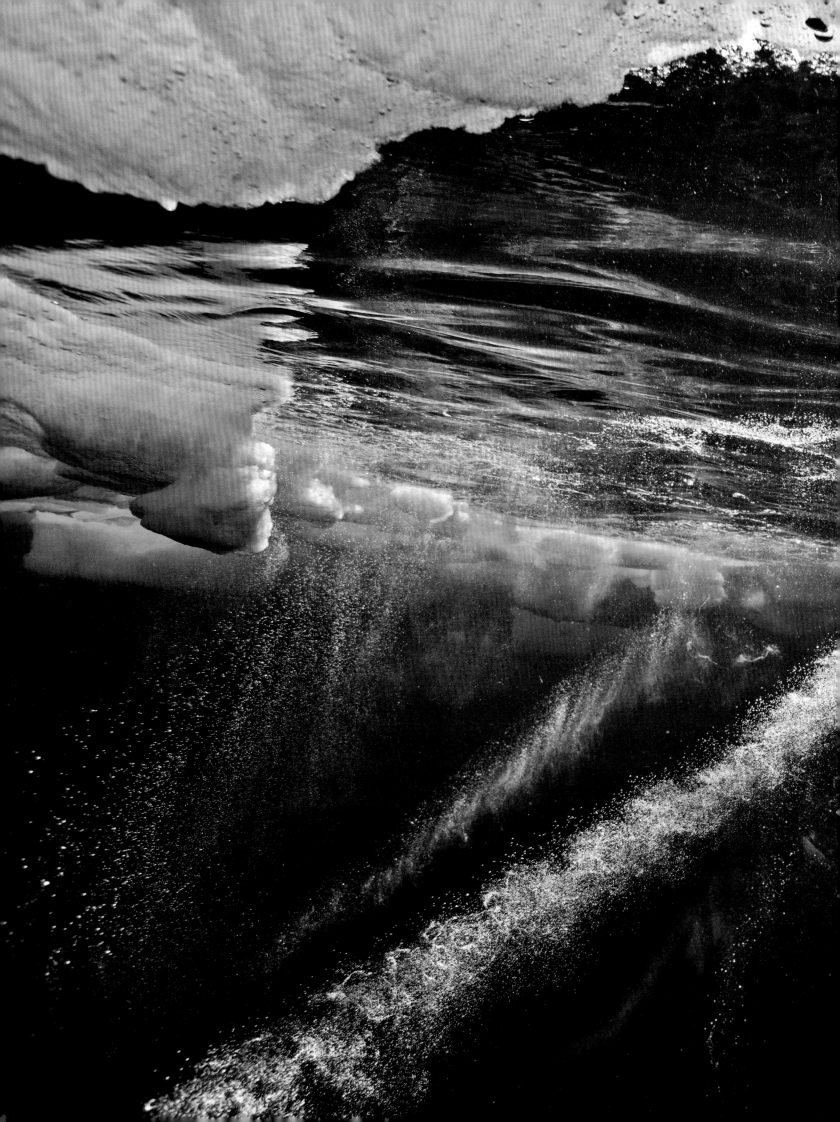

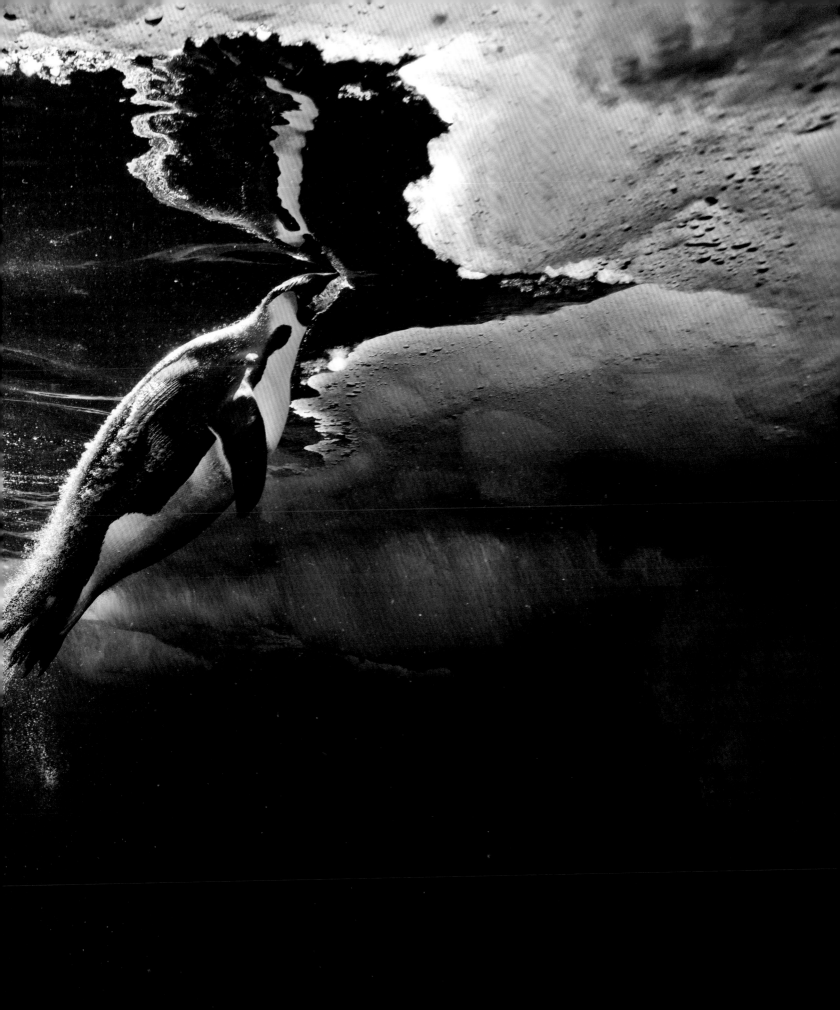

Emperor penguins' body shape and poor climbing ability make it difficult for the birds to haul themselves ashore, especially onto icy or rocky coasts. It is also a moment when they are especially vulnerable to attacks by predators, such as the leopard seal. But the flightless emperor penguin is capable of becoming airborne by swimming at up to three times its normal speed, and launching itself from the water to clear the edge of a shoreline. Recent research shows that the penguins do this by releasing air from their feathers, in the form of tiny bubbles. The bubbles act as a lubricant, cutting drag, and enabling the birds to achieve bursts of speeds that would otherwise be impossible. Previous spread: An emperor penguin shoots toward the surface, in the Ross Sea, Antarctica. Facing page, top: With a leopard seal in pursuit, penguins launch themselves from the water onto sea ice. Below: After being at sea for three weeks, adult penguins, bellies full of krill and fish, begin the long walk back to the colony to feed their chicks. Following spread: The cloud of bubbles the penguins create may help confuse predators.

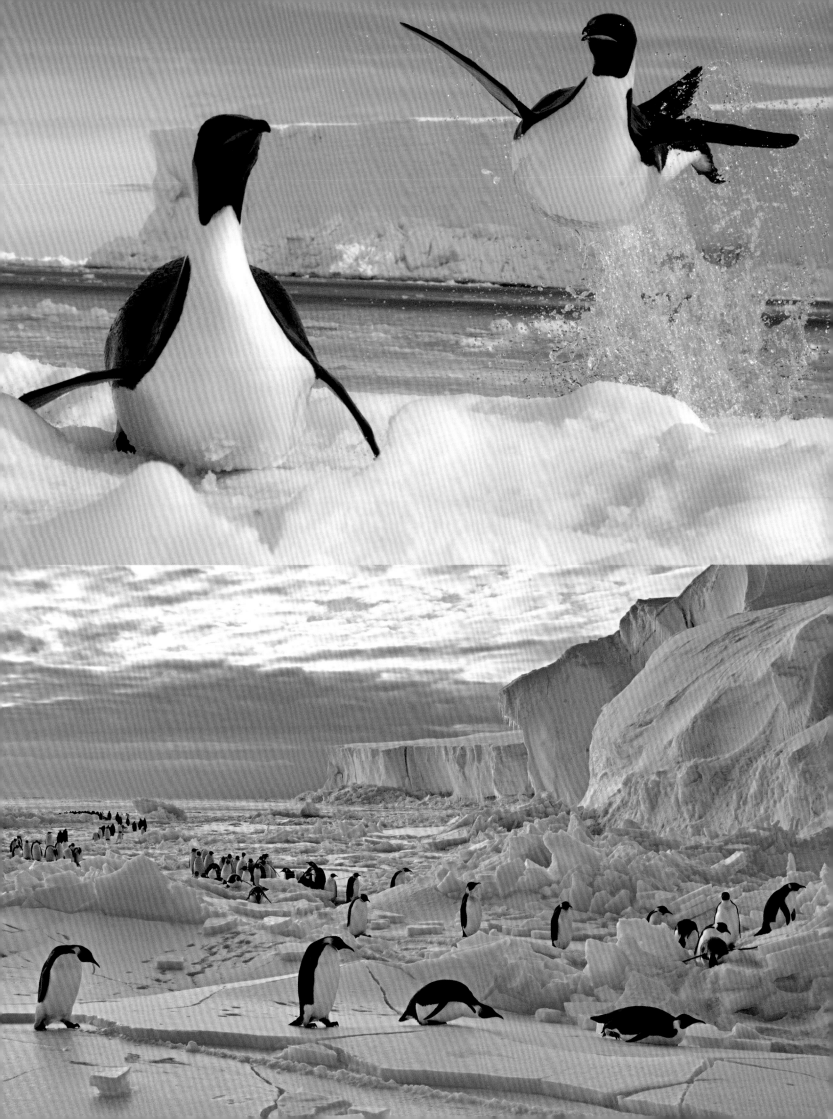

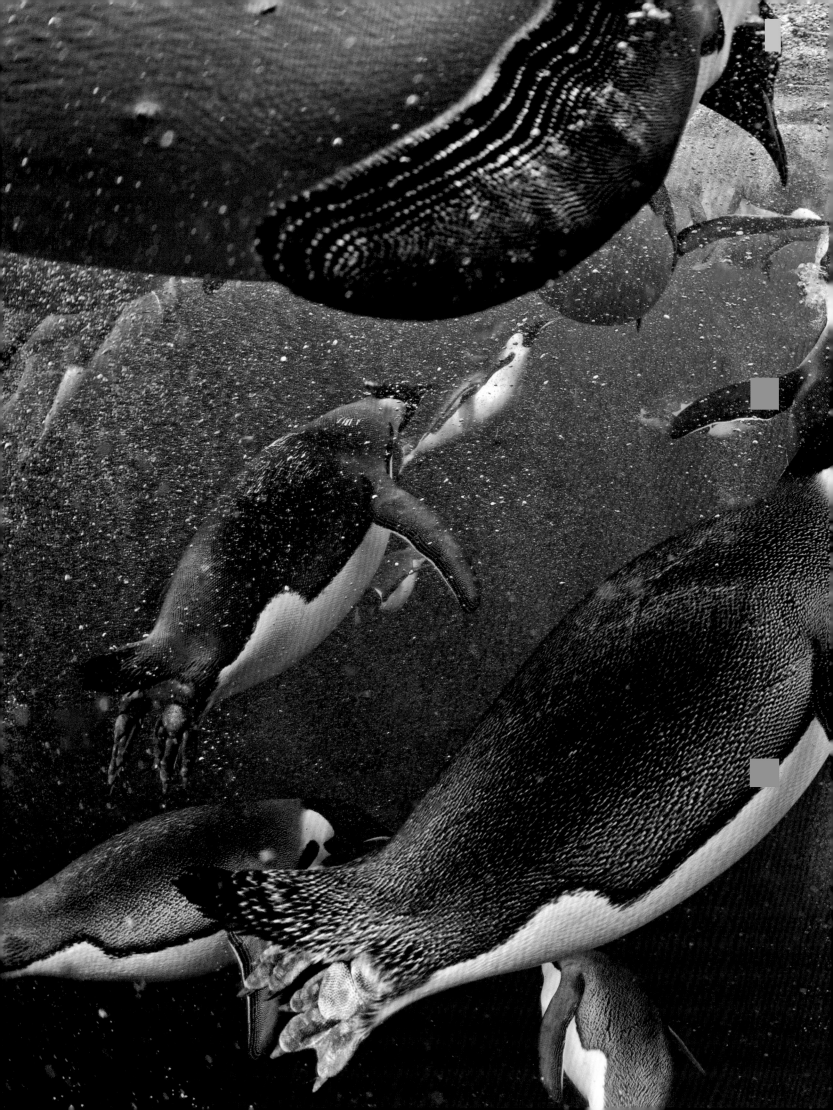

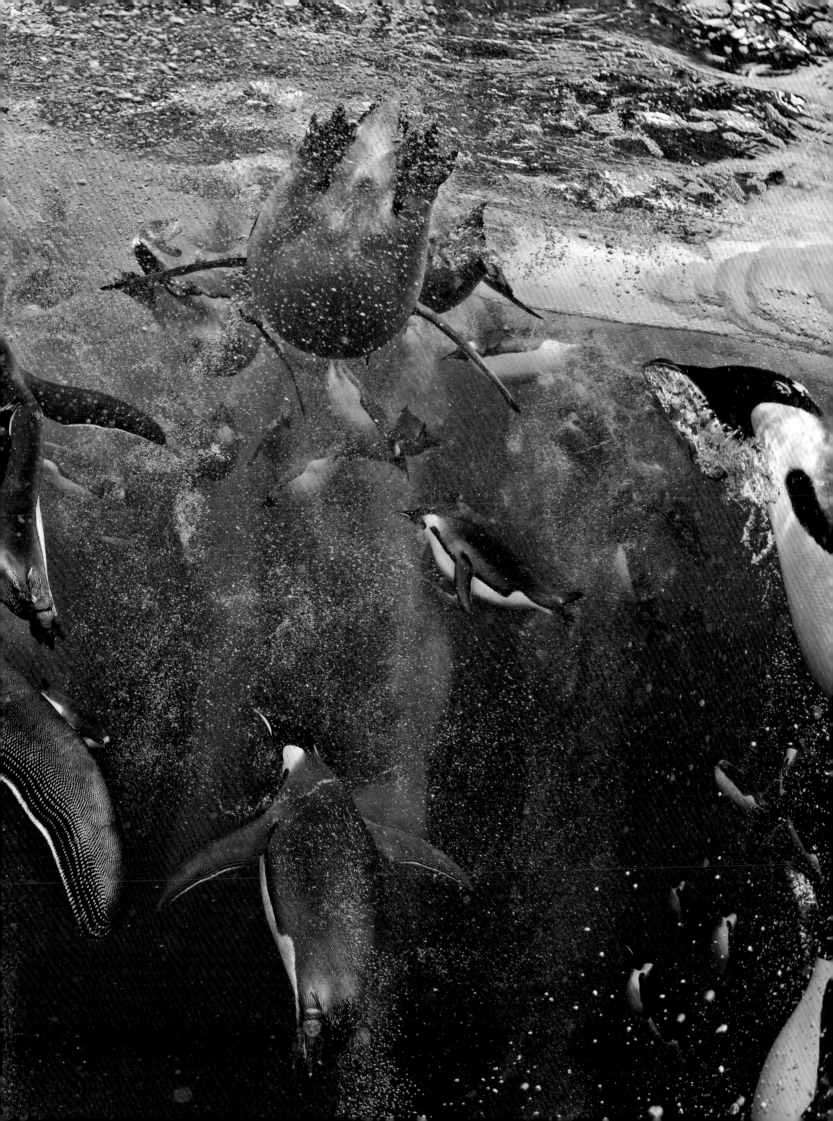

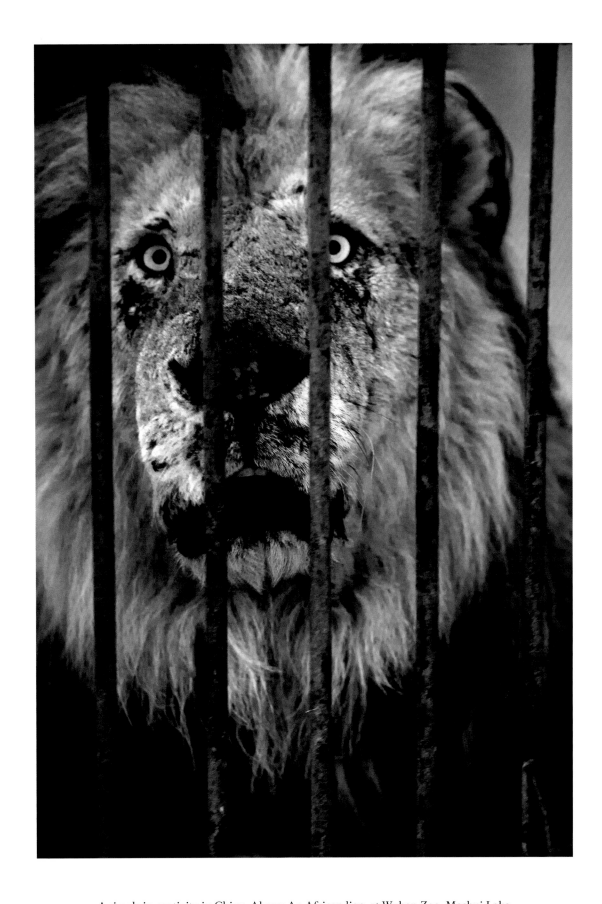

Animals in captivity in China. Above: An African lion, at Wuhan Zoo, Moshui Lake, Hanyang. Facing page, top: Magellanic penguins, at Whenzou Zoo, Jingshan Park, Zhejiang. Below: A mandrill, at Fuzhou Zoo, Fuzhou City, Fujian.

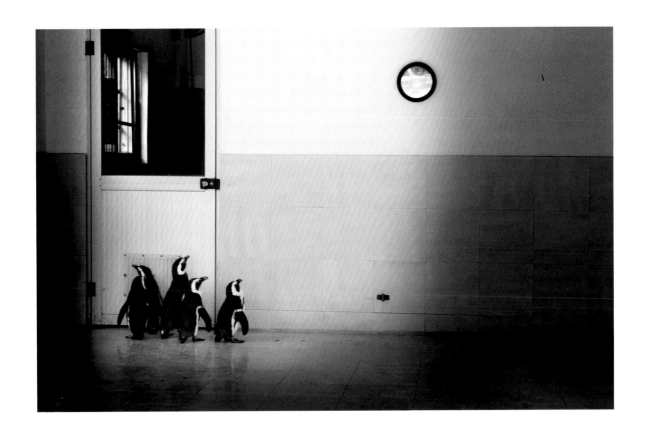

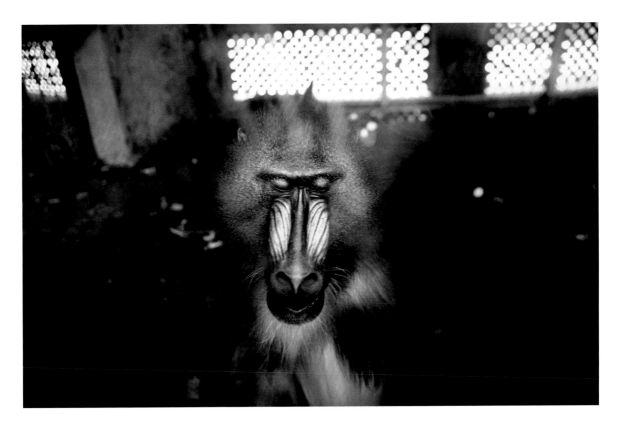

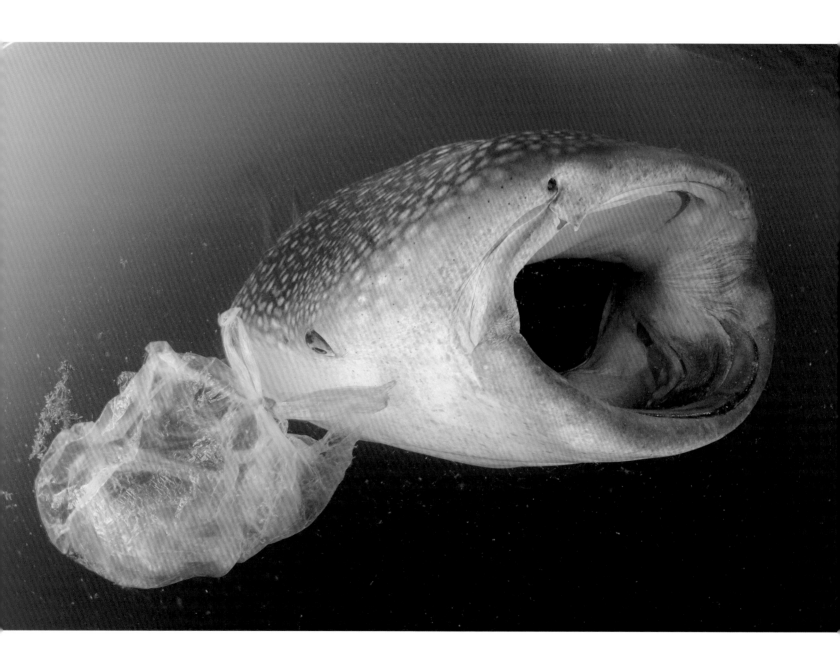

Whale sharks (*Rhincodon typus*) are slow-moving, filter-feeding sharks found in tropical and warm oceans, and are the largest non-mammalian vertebrates on the planet. They are currently listed as a vulnerable species, and come under particular threat from pollution and strikes by boat propellers. The sharks feed by drifting with their capacious mouths open, drawing in plankton, fish, and small crustaceans. Foreign objects, such as plastic, can also be drawn into the shark's digestive system, causing harm.

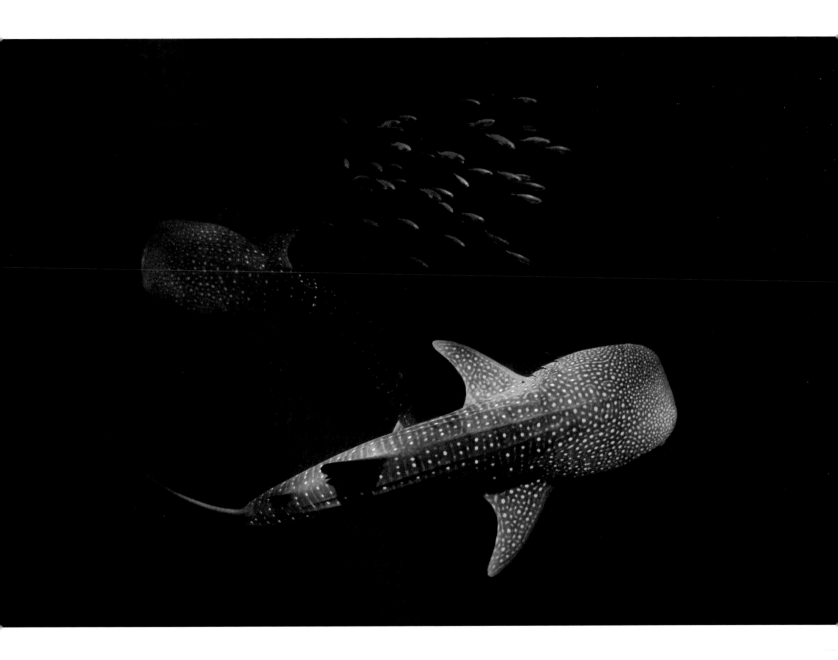

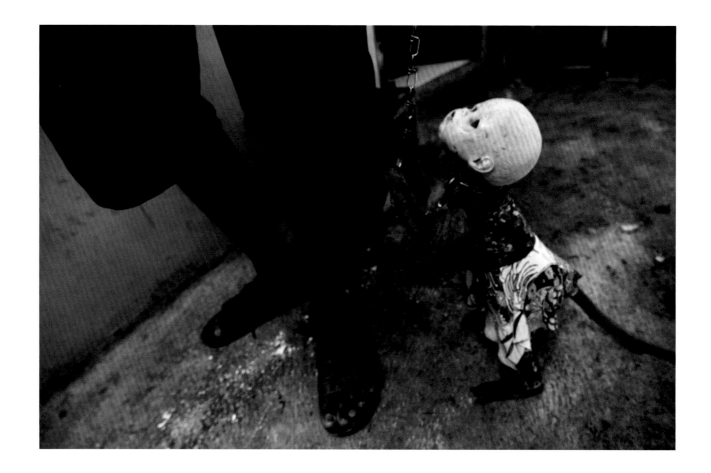

A long-tailed macaque, wearing patchwork clothing and a doll's head, performs in Solo, Central Java, Indonesia. The monkeys are generally purchased at an animal market and trained to carry out such activities as walking on stilts, riding bicycles, or simply begging. Once a popular children's entertainment in villages, performing monkeys are increasingly becoming a feature of life in the city, where their minders use them to earn money from waiting motorists at traffic intersections. A monkey can bring in around €4 a day. Macaques are not endangered, but concerns have been raised about the welfare of performing animals, particularly as numbers in cities increase.

SPORTS

SPORTS ACTION

SINGLES

1st Prize / **Wei Seng Chen**

2nd Prize / **Yongzhi Chu**

3rd Prize / **Wei Zheng**

STORIES

1st Prize / **Roman Vondrous**

2nd Prize / **Sergei Ilnitsky**

3rd Prize / **Chris McGrath**

SPORTS FEATURE

STORIES

1st Prize / **Jan Grarup**

2nd Prize / **Denis Rouvre**

3rd Prize / **Vittore Buzzi**

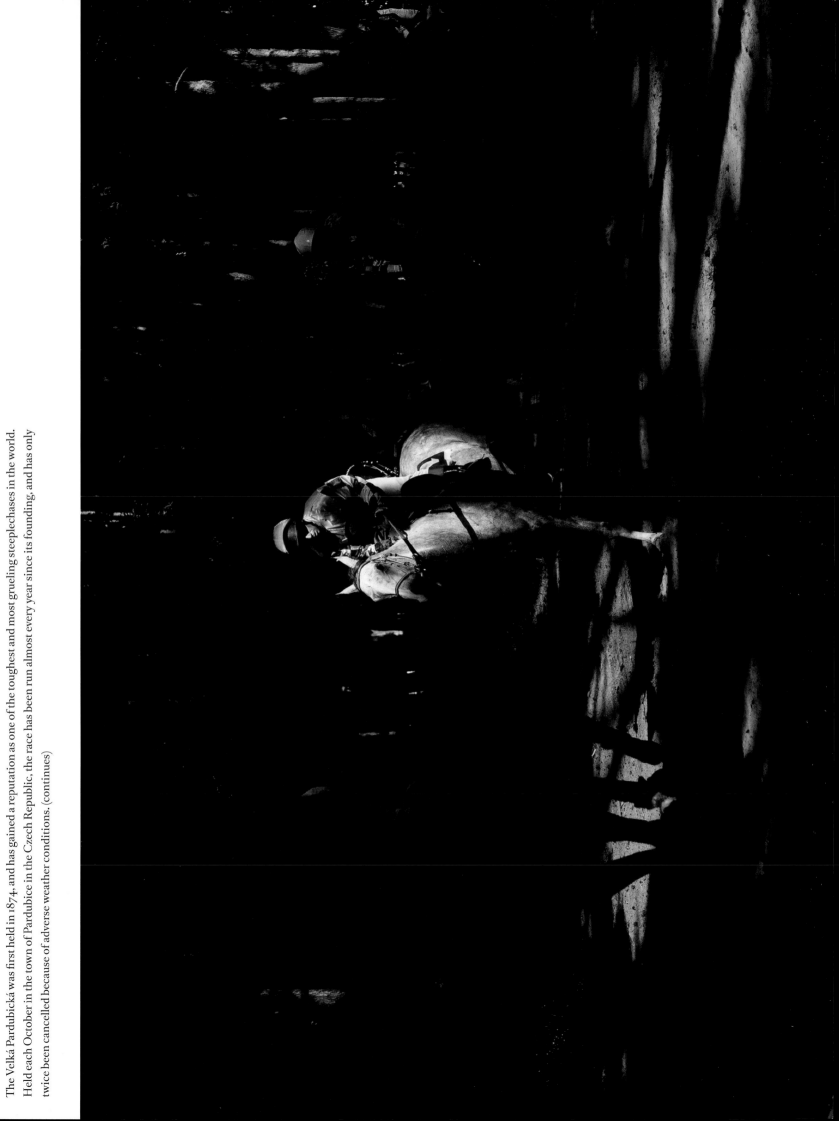

The Velká Pardubická was first held in 1874, and has gained a reputation as one of the toughest and most grueling steeplechases in the world. Held each October in the town of Pardubice in the Czech Republic, the race has been run almost every year since its founding, and has only twice been cancelled because of adverse weather conditions. (continues)

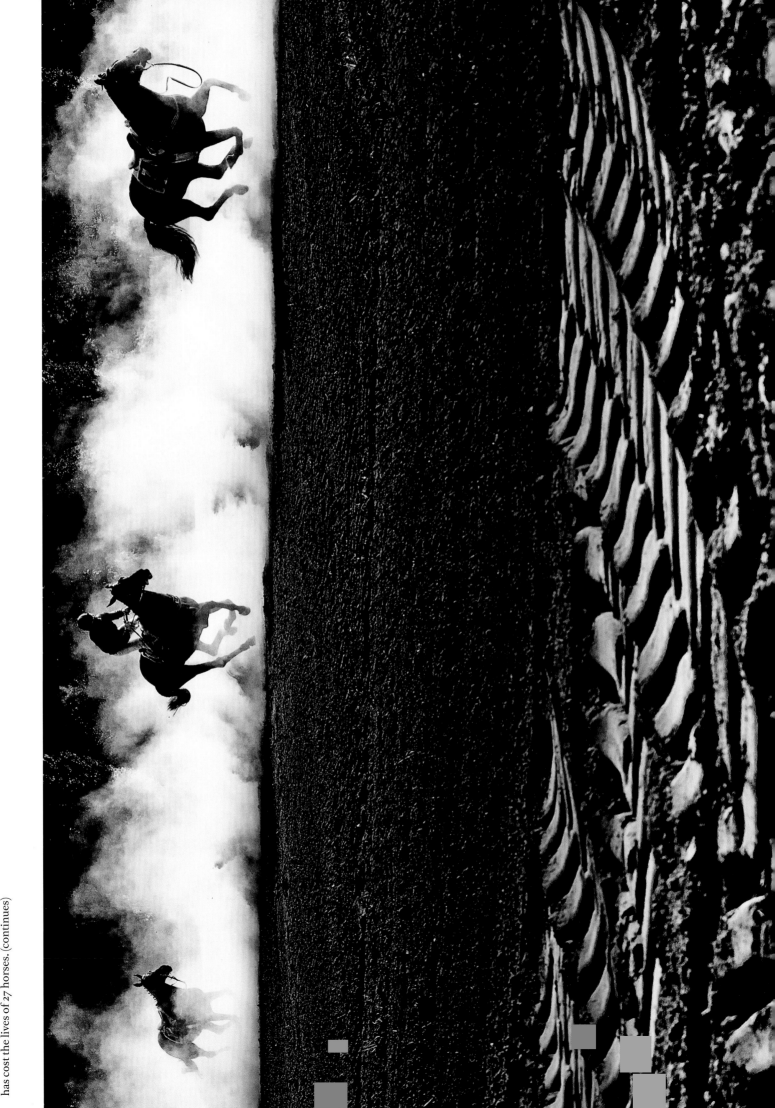

(continued) The Velká Pardubická is run over a distance of 6,900 meters, with the horses having to negotiate a total of 31 obstacles—some of legendary difficulty. The most notorious is Taxis Ditch, a meter-deep ditch hidden behind a 1.5-meter high hedge. Over the years the obstacle has cost the lives of 27 horses. (continues)

(continued) The race usually lasts around ten minutes, and is run by 15 to 20 horses, ridden by some of the best jockeys in the country. Winning, or at least competing in, the Velká Pardubická is considered the highpoint of a jockey's career.

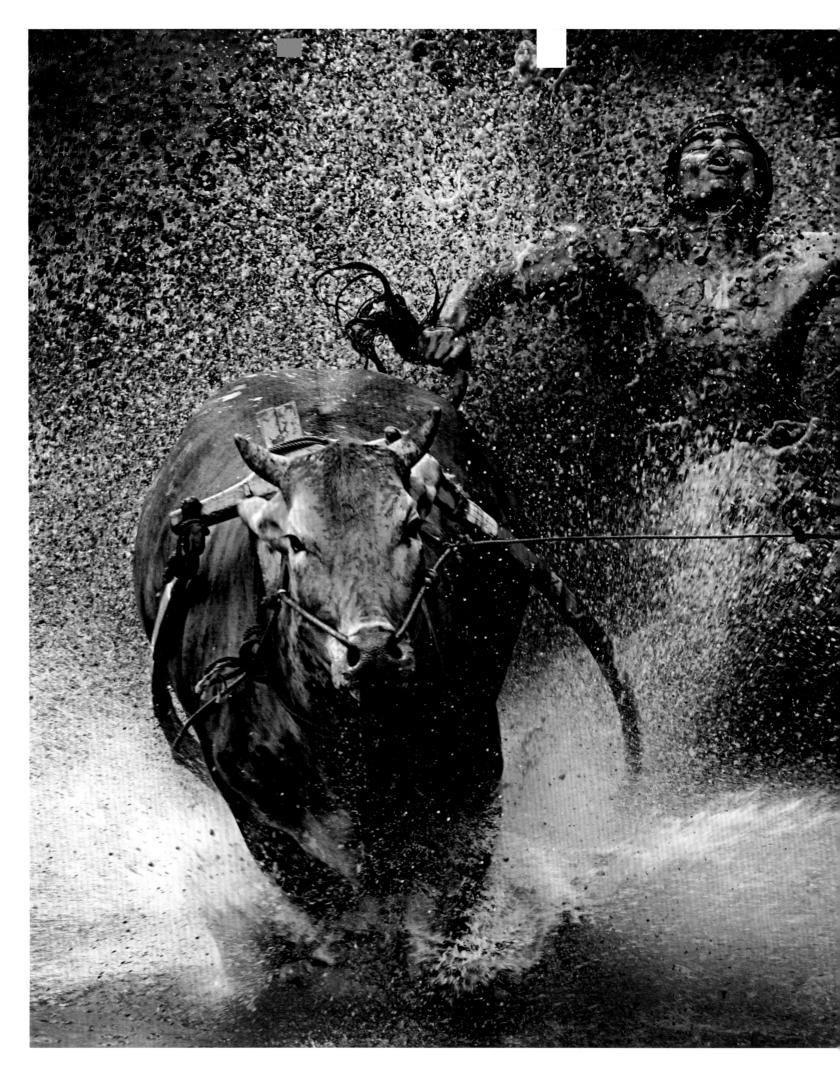

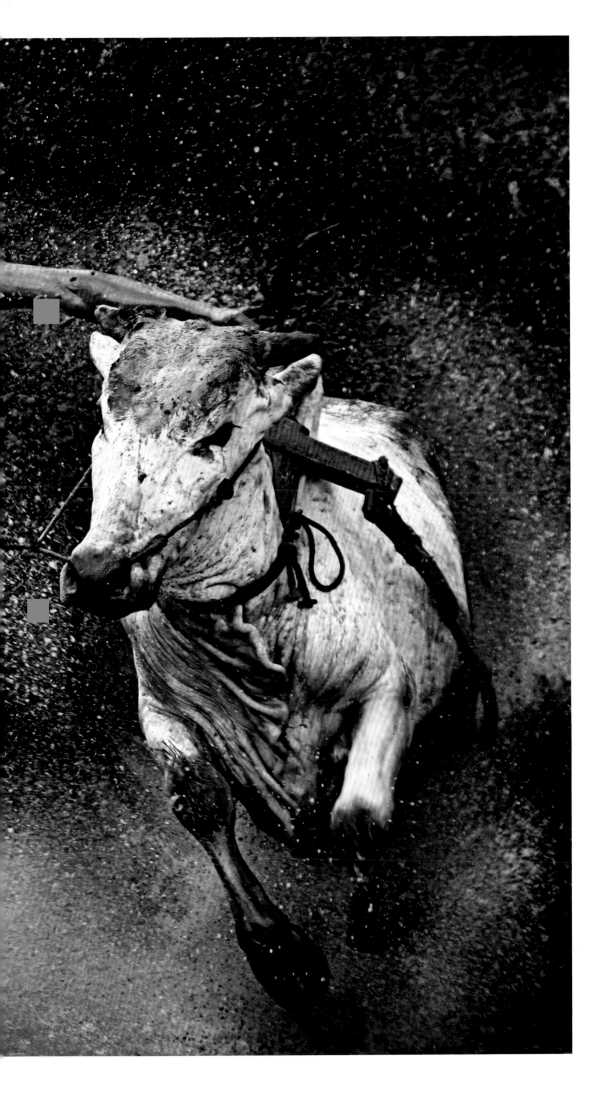

A competitor and his charges reach the finish of a bull race, in Batu Sangkar, West Sumatra, Indonesia. Pacu Jawi is a 400-year-old tradition in the area, held after the rice harvest once the paddies have been cleared. Competitors yoke themselves barefoot to two bulls using a wooden harness, and drive the animals by gripping their tails. Winners are judged by their ability to run in a straight line, and by whether both animals are cooperating. Some 600 bulls and 50 farmers participated over a number of races in Pacu Jawi in February.

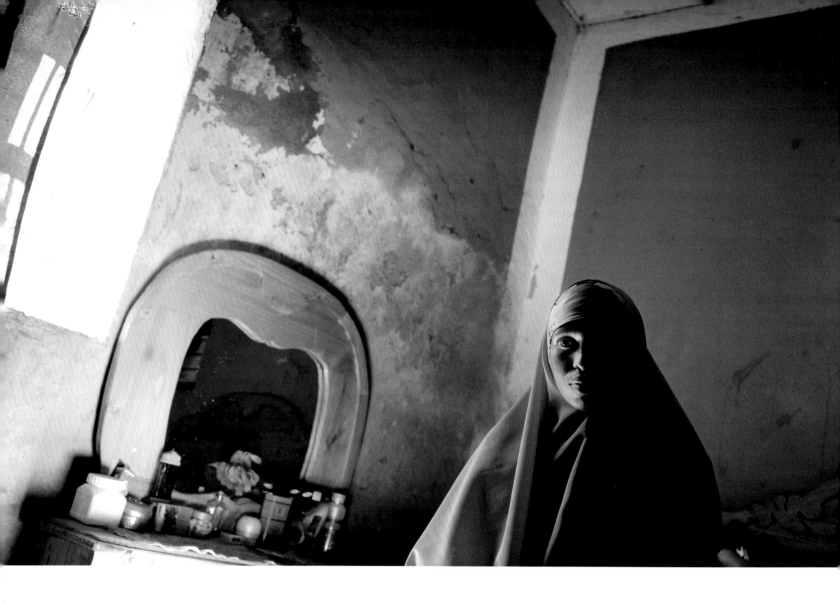

Young women risk their lives to play basketball in Somalia. Even though Somalia's UN-backed government has regained control of the capital Mogadishu, al-Qaeda-linked militants are still active in the city. Al-Shabaab and other radical Islamist groups consider women playing sport to be un-Islamic. Members of the Somali national women's basketball team have received death threats. Above: Women's national basketball team captain Suweys Ali Jama, at home in Mogadishu. She and her mother have been insulted on the streets and forced to move twice in the past year. Facing page, top: A guard, provided by the Somali Basketball Association, watches over the women as they practice. Below: Team members play in an arena pockmarked by bullets, a reminder of Somalia's violent recent history. (continues)

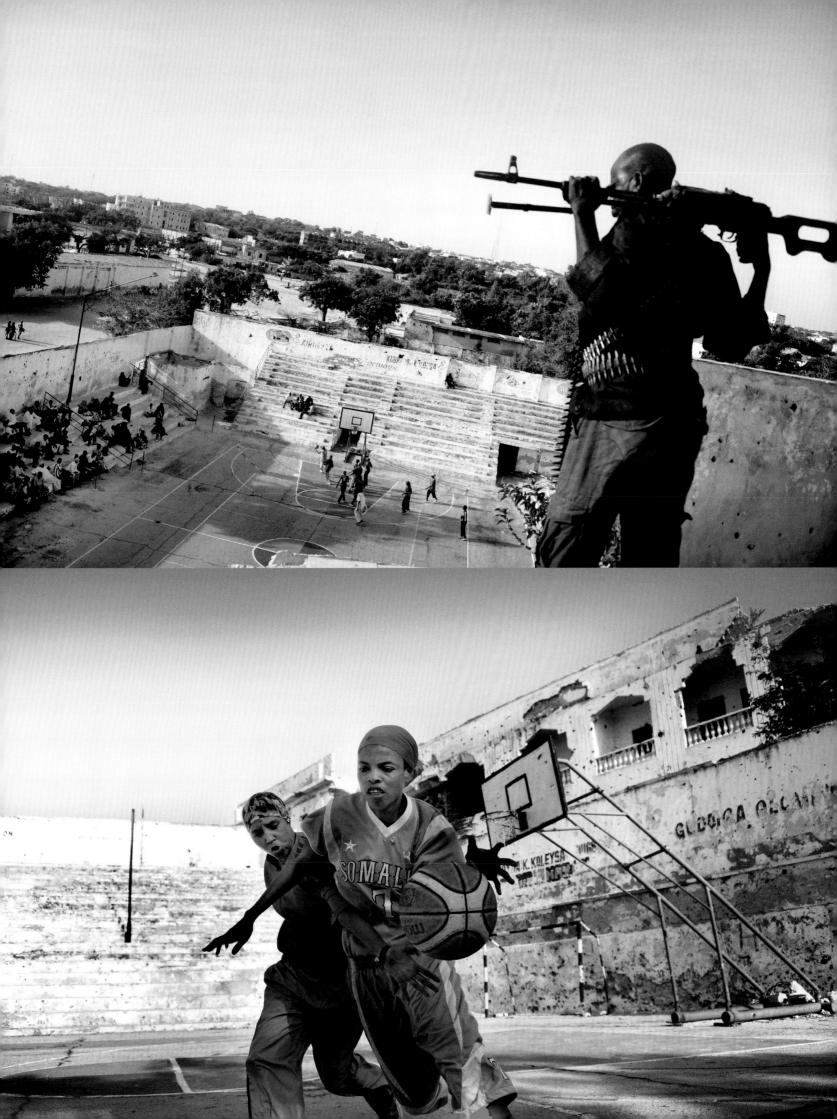

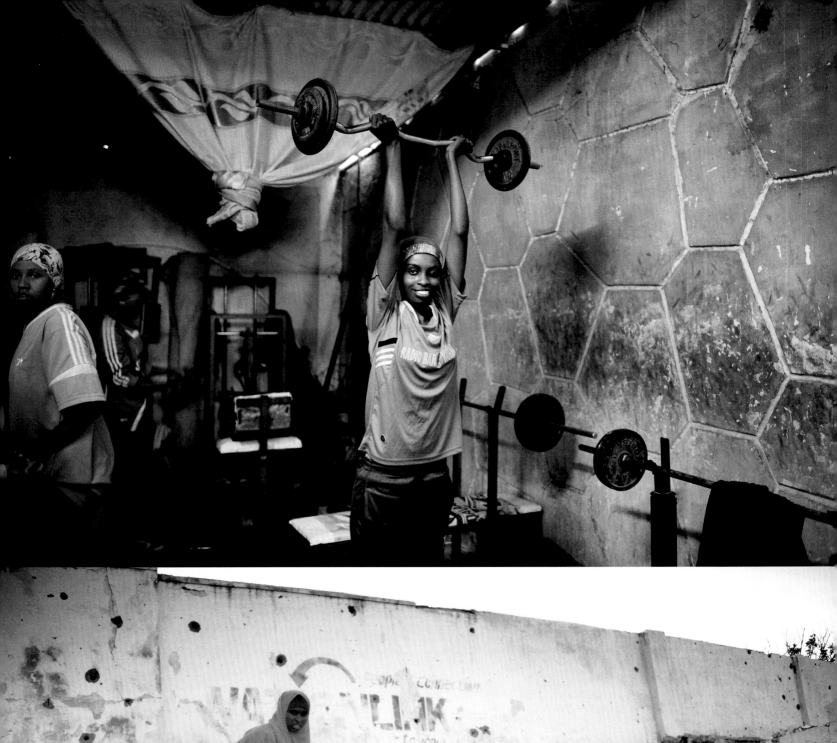
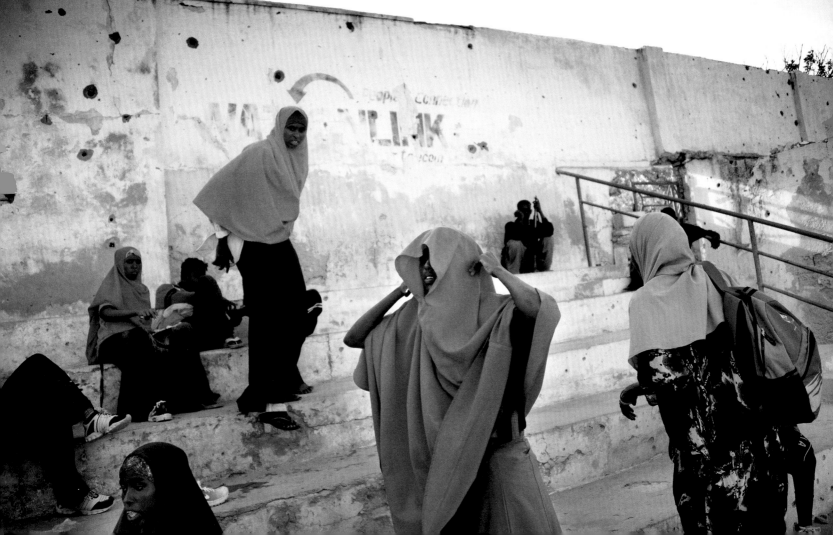

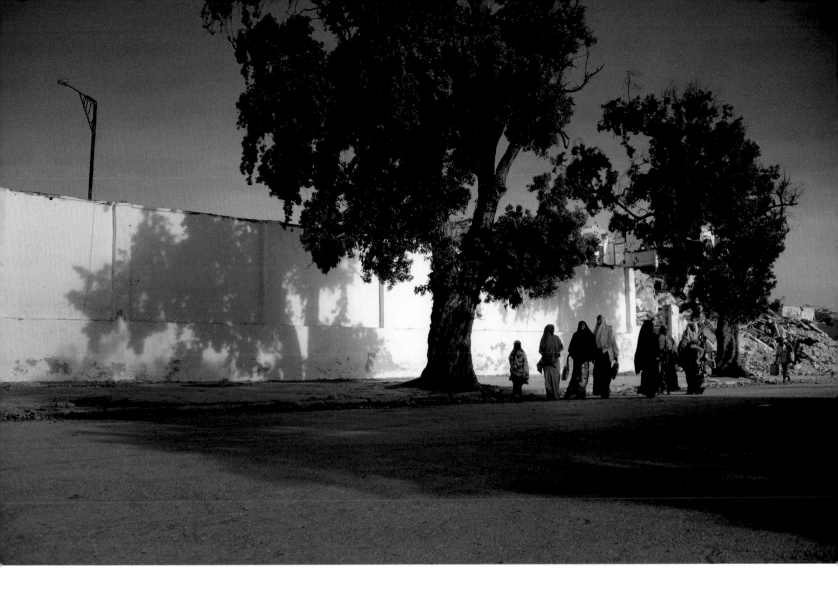

(continued) In 2006, the Somali Islamic Courts Union, a group of Sharia courts, issued an order banning women from playing all sport. One of the proposed punishments for women playing basketball is to cut off the right hand or left foot. Facing page, top: Ali Jama trains before practice. Below: Team members have to exercise extreme discretion. They go veiled and conservatively dressed in public, and carry basketballs deep inside their bags. Above: Ali Jama and her teammates walk home after practice.

Let Wei is an unarmed Burmese martial art, similar to the forms of kickboxing popular in Thailand and Cambodia. In addition to punches, kicks, and knee attacks, Burmese boxers make use of head-butts and knuckle strikes. National champion

Lone Chaw (36) is a folk hero in Myanmar and in 2007 opened a gym to pass on his knowledge to a younger generation of fighters.

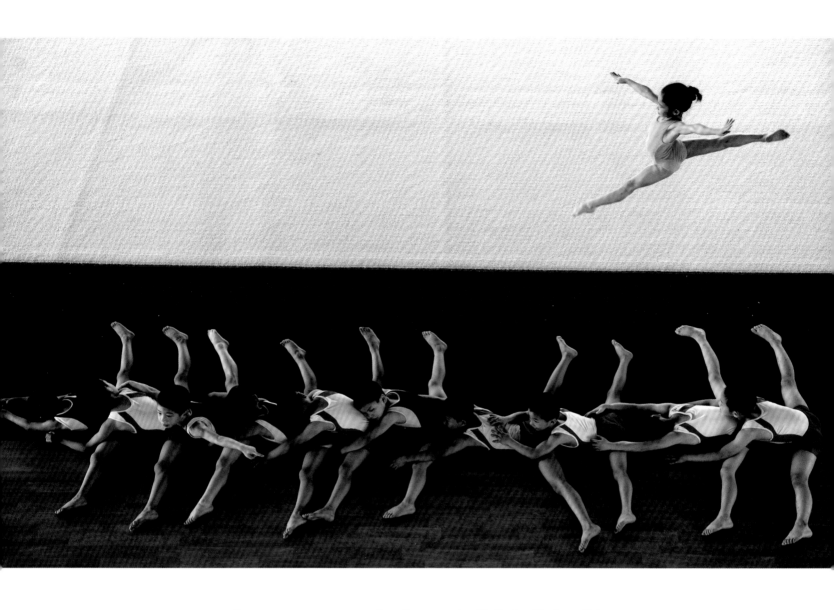

Young gymnasts warm up at a juvenile sports school in Jiaxing, Zhejiang, China.

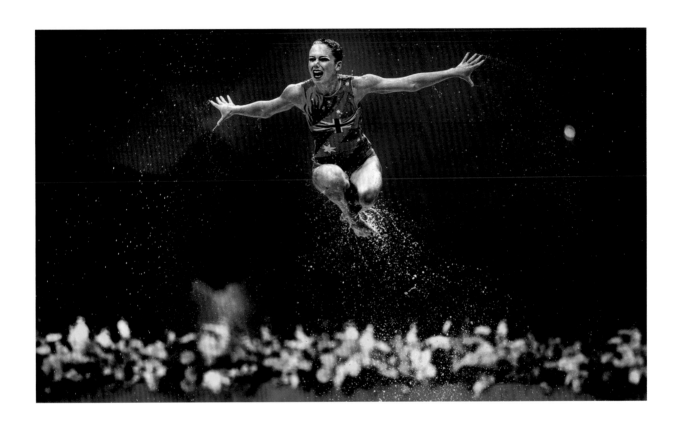

A member of the Australian synchronized swimming team competes at the Olympic Games in London, on 10 August. Russia won gold in the event for the fourth consecutive year. The Australian team came last out of eight finalists.

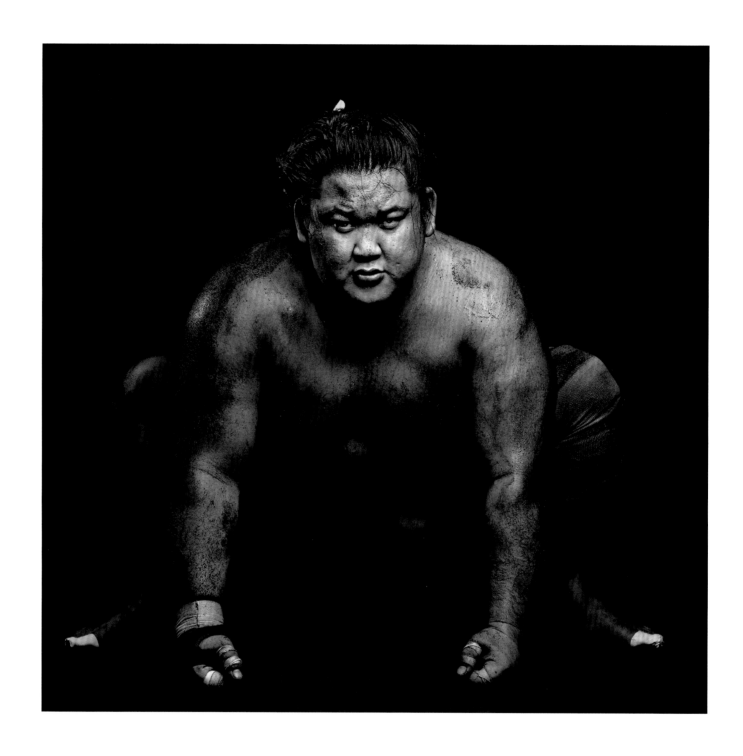

Sumo wrestling in Japan has a tradition that dates back centuries, yet the sport—which demands total dedication and extreme rigor—is attracting the lowest number of young recruits for more than half a century. Above: Kenji Daido. Facing page: Hiroki Oukoryu. (continues)

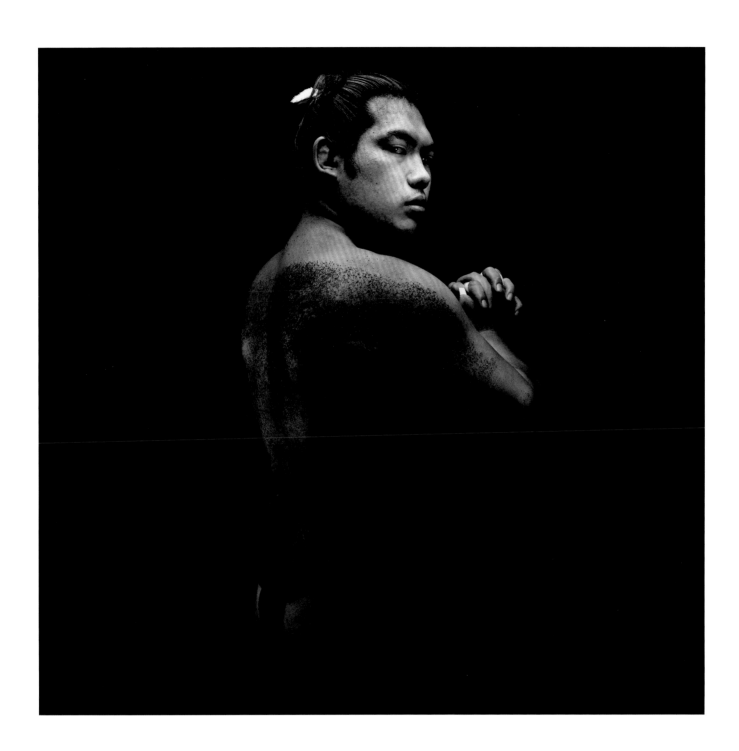

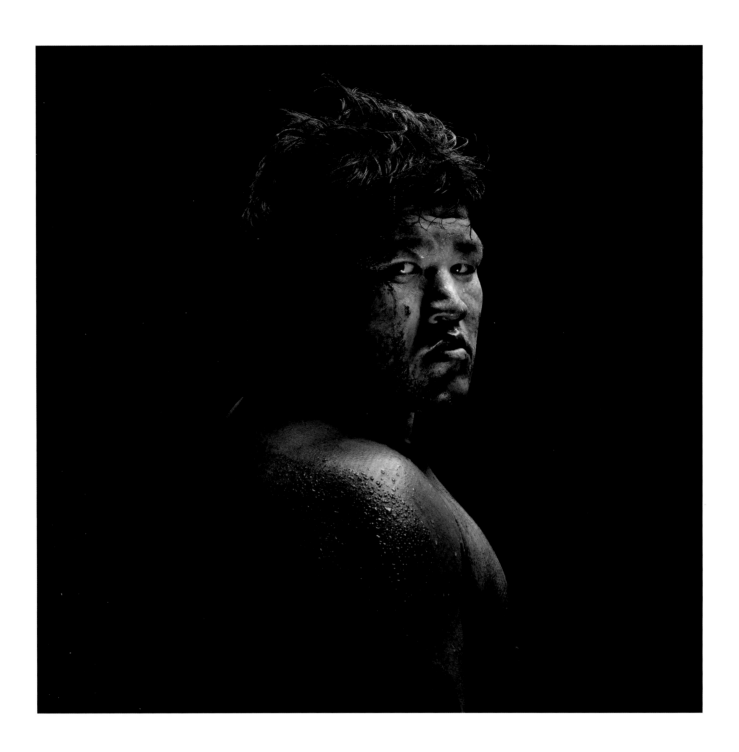

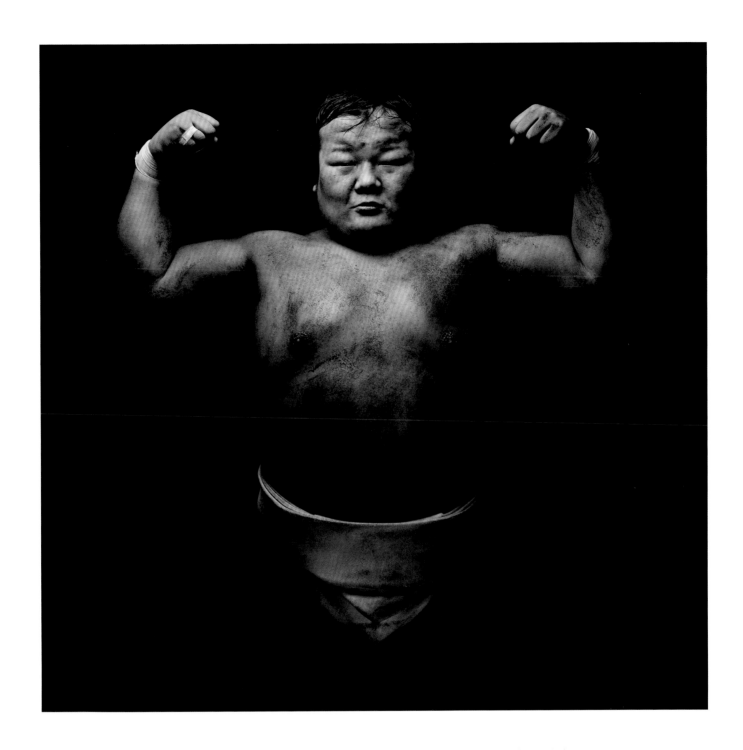

(continued) Trainee sumo wrestlers lead a regimented life, sleep in dormitories, and carry out chores, all while following a grueling exercise program. Facing page: Mitsuhiko Yamamoto. Above: Masashi Nakayama.

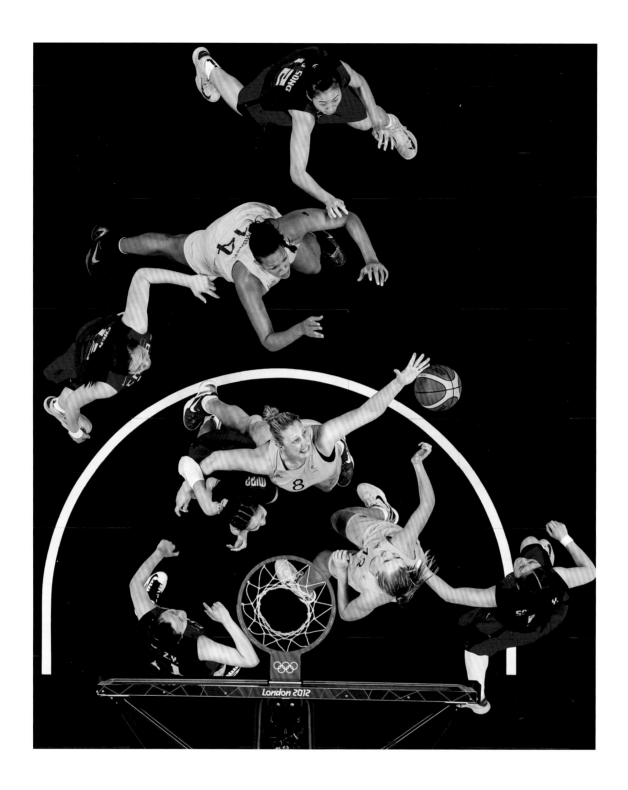

Olympic Games, London 2012—an overview. Above: Suzy Batkovic (no. 8) of Australia reaches for a rebound, during the women's basketball quarterfinal against China, held at the Basketball Arena, on 7 August. Australia won the game 75-60. Facing page, top: Xin Wang of China competes against compatriot Xuerui Li, in the women's singles badminton semifinal, held at Wembley Arena, on 3 August. She lost the match 2-0. Below: Choe Un-Gyong (in red) of North Korea competes with Monika Ewa Michalik of Poland, during the women's freestyle 63 kg wrestling match, on 8 August.

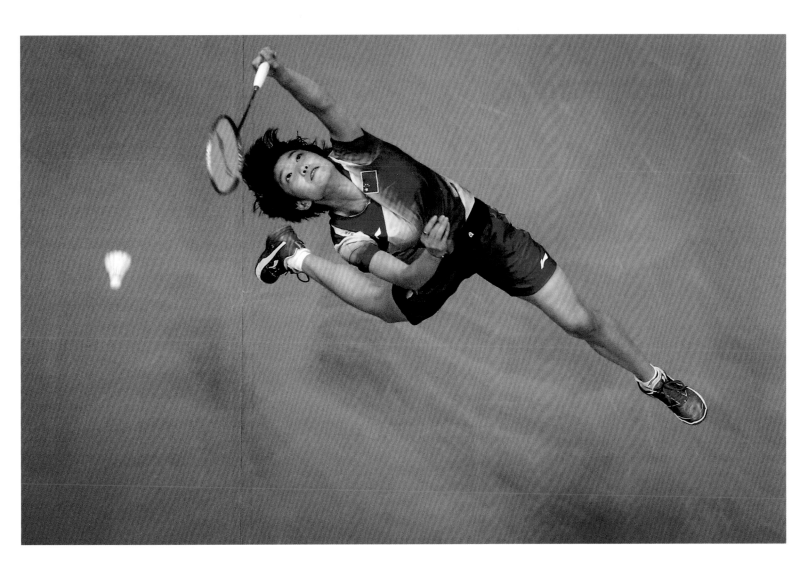

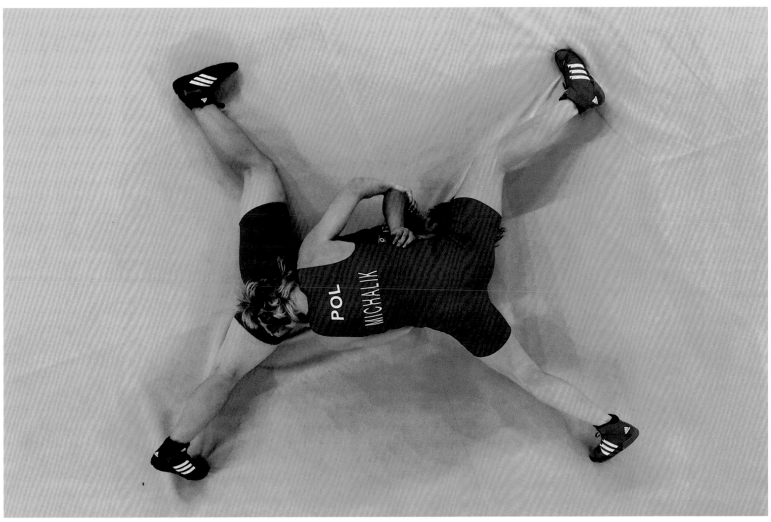

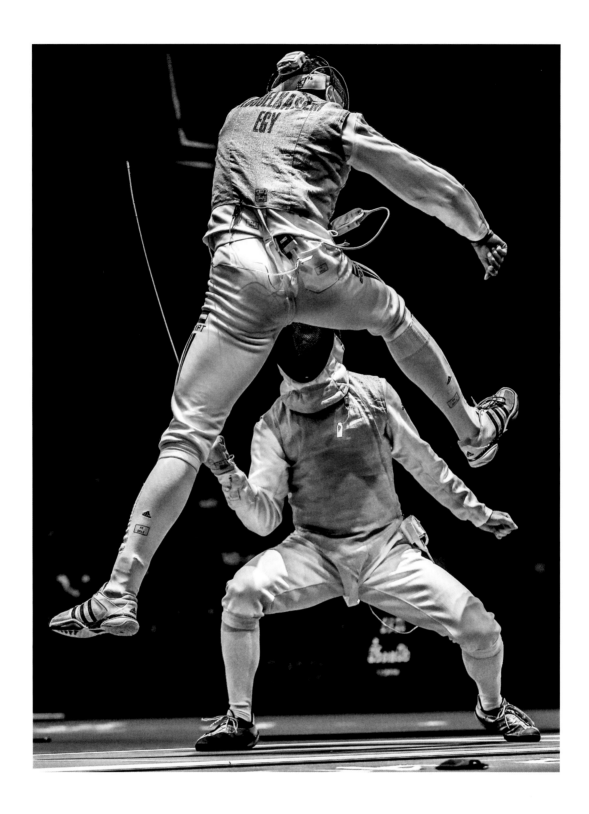

Fencing at the London 2012 Olympics. Above: Alaaeldin Abouelkassem of Egypt (top) in action against Peter Joppich of Germany during the men's foil individual match on 31 July. Abouelkassem won the bout, and went on to take a silver medal. Facing page, top: Abouelkassem celebrates his win over Joppich. Below: Nikolay Kovalev of Russia reacts after his victory over Rares Dumitrescu of Romania, following their men's sabre individual bronze medal match, on 29 July.

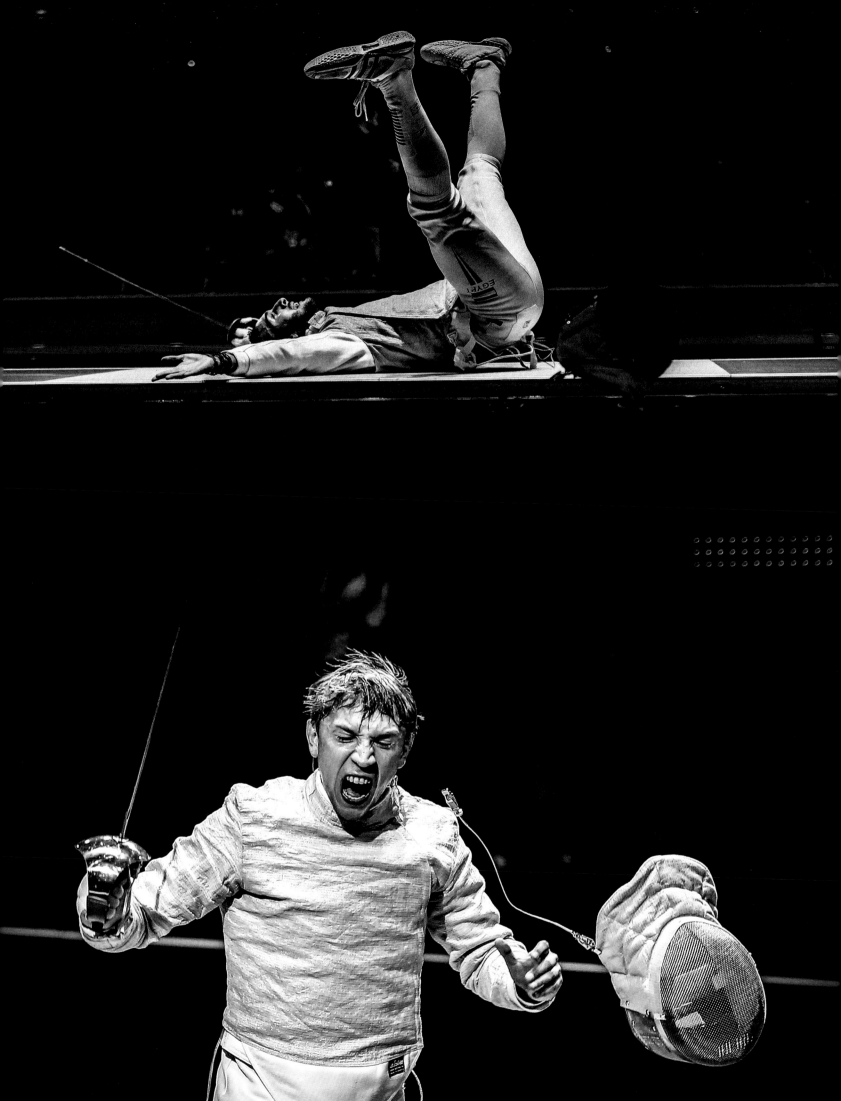

The 2013 Jury

Photos: Michael Kooren / Hollandse Hoogte

Chair:
Santiago Lyon, USA,
vice president and director of
photography The Associated Press

Bill Frakes, USA,
photographer *Sports Illustrated*

Barbara Stauss, Switzerland,
photo director and founding
member *Mare* magazine

Ghaith Abdul-Ahad, Iraq,
special correspondent *The Guardian*

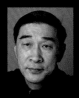

Gu Zheng, China,
professor at School of Journalism,
Fudan University, Shanghai

Véronique de Viguerie, France,
photographer Reportage by
Getty Images

Monica Allende, Spain,
photo editor *The Sunday Times
Magazine*

Mayu Mohanna, Peru,
photographer and curator

Staffan Widstrand, Sweden,
photographer and managing
director Wild Wonders of Europe

Jocelyn Bain Hogg, UK,
photographer VII Photo Agency

Riason Naidoo, South Africa,
director South African National
Gallery, Iziko Museums of South
Africa

Anne Wilkes Tucker, USA,
curator photography Museum
of Fine Arts, Houston

Elisabeth Biondi, Germany/USA,
independent curator

Anja Niedringhaus, Germany,
photographer The Associated Press

Steve Winter, USA,
contributing photographer *National
Geographic* magazine

Jérôme Bonnet, France,
photographer

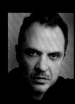

Platon, UK,
photographer CLM/David Maloney

Secretary:
Daphné Anglès, France/USA,
European photo assignments editor
The New York Times

Rena Effendi, Azerbaijan,
photographer

Pim Ras, the Netherlands,
freelance photographer *Algemeen
Dagblad*

Secretary:
Simon Njami, Cameroon,
independent curator, lecturer
and art critic

Participants 2013 Contest

In 2013, 5,666 photographers from 124 countries submitted 103,481 entries. The participants are listed here according to nationality, as filled in by them in the entry registration system. In unclear cases, the photographers are listed according to the country of postal address.

Afghanistan
Barat Ali Batoor
Rahmat Gul
Massoud Hossaini
Shahmarai
Musadeq Sadeq
S. Sabawoon
Qais Usyan

Albania
Armando Babani
Arben Bici
Majlend Bramo
Edvin Celo
Petrit Kotepano
Arben I Llapashtica
Elidon Veshaj
Valdrin Xhemaj

Algeria
Hamid Attig
Ferhat Bouda

Argentina
Enrique Abbate Pinaud
Rodrigo Abd
Martin Acosta
Paula Acunzo
Eugenio Adorni
Manuel Arce Molino
Martin Arias Feijoo
Facundo Arrizabalaga
Walter Astrada
Diego Azubel
Lucia Baragli
Carlos Barria
Nicolás Bravo
Victor R. Caivano
Carolina Camps
Maximiliano C. Vernazza
Juan Carlos Corral
Pablo Cuarterolo
Pablo De Luca
César De Luca
Gerardo Dell'Oro
Paula Delrieux
Eduardo DiBaia
Pablo Dondero
Marcos Carrizo
Santiago Filipuzzi
Nestor García
Marcos Gomez
Pablo Gomez
Ileana A. Gómez Gavinoser
Renzo Gostoli
Sergio Gabriel Goya
Rosario Heer
Daniel Jayo
Gustavo Jononovich
Alejandro Kirchuk
Andres Kudacki
Andrés Larrovere
Emiliano Lasalvia
Gabriela Li Puma
Alicia Lilo
Eduardo Longoni
Maximiliano Luna
Fabián Mattiazzi
Juan Medina
Francisco Mendes
Emiliana Miguelez
Gerónimo Molina
Sam Moriconi
Juan Obregon
Atilio Orellana
Gabriel Pecot
Adrián Pérez
Caro Pierri
Nicolás Pousthomis
Hugo O. Ramos
Pedro Luis Raota
Nicolas Riente
Héctor Rio
Natalia Roca
Juani Roncoroni

Coni Rosman
Sebastián Salguero
Carlos Sarraf
Mario Sayes
Cristian Scotellaro
Fernando Serani
Hernán Silvosa
Eduardo Soteras
Nicolás Stulberg
Pablo Tosco
Mario Travaini
Tony Valdez
Gisela Volá
Hernan Zenteno

Armenia
Nazik Armenakyan
German Avagyan
Arthur Lumen Gevorgyan
Anahit Hayrapetyan
Hrant Khachatryan
Diana Markosian
Karen Mirzoyan
Vahan Stepanyan
Tigi Mehrabyan

Australia
David Adams
Joe Armao
Nicolas Axelrod
Zac Baillie
Ben Baker
Janie Barrett
Daniel Berehulak
Michael Bowers
Philip Brown
Simon Bullard
Aletheia Casey
Livia Cheng
Steve Christo
Robert Cianflone
Warren Clarke
Tim Clayton
Brett Costello
Graham Crouch
David Darcy
Tim Georgeson
Keturah de Klerk
Andy Drewitt
Jason Edwards
Alex Ellinghausen
Brendan Esposito
Jenny Evans
Mark Evans
Adam Ferguson
Michael Franchi
Andrea Francolini
Ed Giles
Kirk Gilmour
Craig Golding
Steve Gosch
Philip Gostelow
David Gray
Toni Greaves
Brett Hemmings
Phil Hillyard
Ian Hitchcock
Lisa Hogben
David Kelly
Dallas Kilponen
Adam Knott
Mark Kolbe
Nick Laham
Tanya Lake
Dean Lewins
Sylvia Liber
Claire Martin
Brendan McCarthy
Chris McGrath
Justin McManus
Paul Miller
Palani Mohan
Graham Monro
Dean Mouhtaropoulos
Jason O'Brien
Warrick Page
Martine Perret
Ryan Pierse
Gregg Porteous
Vivek Prakash
Adam Pretty
Andrew Quilty
Mark Ralston
Jason Reed
Quinn Rooney
Raphaela Rosella
Sam Ruttyn
Dean Saffron

Dean Sewell
Russell Shakespeare
Tracey Shelton
Cameron Spencer
Marc Sinclair Stapelberg
Virginia Star
Adrian Steirn
Dave Tacon
Patrick Tombola
Therese Tran
Tamara Voninski
Barbara Walton
Clifford White
Lisa Maree Williams
Andy Zakeli

Austria
Heimo Aga
Heinz-Peter Bader
Lukas Beck
Matthias Cremer
Helmut Fohringer
Hans Hochstöger
Philipp Horak
Lois Lammerhuber
Mario Marino
Ronnie Niedermeyer
Marlies Plank
Mirjam Reither
Erwin Scheriau
Tina Schula
Aram Voves
Claudia Ziegler

Azerbaijan
Vugar Amrullaev
Ilkin Huseynov
Ilgar Jafarov
Osman Karimov
Emil Khalilov
Elturan Mammadov
Mark Rafaelov

Bahrain
Mohammed Al-Shaikh
Mazen Mahdi
Hamad Mohammed

Bangladesh
Abir Abdullah
Quamrul Abedin
Maruf Hasan Abhi
A. M. Ahad
Arfun Ahmed
Sumon Yusuf
GMB Akash
Md. Akhlas Uddin
M Hasan Akhter
Taslima Akhter
Monirul Alam
Samsul Alam Helal
Shahidul Alam
Amin
K. M. Asad
Ashraful Alam Tito
Wahid Adnan
Andrew Biraj
Kumar Biswas
Rasel Chowdhury
Ranak Martin
Anurup Kanti Das
Suvra Kanti Das
Emdadul Islam Bitu
F. Omar
Shoeb Faruquee
Gazi Nafis Ahmed
A J Ghani
Indrajit Ghosh
Hasan Md. Rakibul
Khaled Hasan
Rashed Hasan
Ekramul Hoque
Shajjad Hossain Shajib
Shafayet Hossain Apollo
Nazrul Islam
Shafiq Islam
Shariful Islam
M N I Chowdhury
K.M. Jahangir Alam
Tamim Jamshed
Kabir Hossain
S.M. Kakon
Kauser Haider
K. Golam Quddus Helal
Md. Shahnewaz Khan
Tanvir Murad Topu
Abu Taher Khokon
Saiful Huq Omi

MRK Palash
Mamunur Rashid Mamun
Jannatul Mawa
Sujan Mondal
Md. Moniruzzaman
Palash Khan
Shahadat Parvez
Tapash Paul
Zahidur Rahman Biplob
Mahbub
Reza Shahriar Rahman
Tushikur Rahman
Probal Rashid
Hasan Raza
Rimon Ahmed
Stephan Uttom
Sudeepto Salam
Jewel Samad
Shaikh Mohir Uddin
Lailunnahar
Md. K. Rayhan Shawon
Rashed Shumon
Reaz Ahmed Sumon
Anurup Titu
Jashim Salam
Munir uz Zaman

Belarus
Marina Begunkova
Anton Dotsenko
Vasily Fedosenko
Hudzilin Siarhei
Nick Hurski
Vadim Kachan
Ivan Kokoulin
Dmitrij Leltschuk
Leonid Levshinov
Eugene Reshetov
Vitus Saloshanka
Alexandra Soldatova
Tsuranau Viachaslau
Tatsiana Zenkovich
Alex Zozulya

Belgium
Layla Aerts
Aurore Belot
Pauline Beugnies
Jef Boes
Nicolas Bouvy
Frederik Buyckx
Michael Chia
Filip Claus
Joost De Raeymaeker
Peter de Voecht
Iori De Windt
Stijn Decorte
Marika Dee
Delfosse
Vanessa Dewanin
Bruno Fahy
Cédric Gerbehaye
Brigitte Grignet
Max D. Gyselinck
Nick Hannes
Yves Herman
Olivier Hoslet
Yorick Jansens
Roger Job
Tim Dirven
An-Sofie Kesteleyn
Jimmy Kets
Alex Kouprianoff
Francois Lenoir
Linsy Loose
Wendy Marijnissen
Virginia Mayo
Mashid Mohadjerin
Virginie Nguyen Hoang
Daniel Dolne
Olivier Papegnies
Fred Pauwels
Ivan Put
Michèle Sennesael
Dieter Telemans
Gaël Turine
Katrijn Van Giel
Tomas van Houtryve
Sébastien Van Malleghem
Mireille van Rysselberghe
Cedric Van Turtelboom
Wouter van Vaerenbergh
Thomas Vanden Driessche
Geert vanden Wijngaert
Vincent Peal
Stephan Vanfleteren
Eva Vermandel
Olivier Vin

John Vink
Dirk Waem
Warnand Julien

Bolivia
Verónica Avendaño
Jorge Bernal
Patricio Crooker
David Mercado
Marcelo Pérez del Carpio
La Ale
Wara Vargas lara

Bosnia-Herzegovina
Ziyah Gafic
Sljivo Husein
Danilo Krstanovic
Damir Sagolj

Brazil
Gabo Morales
Raphael Alves
Patrícia Santos
Paulo Amorim
Keiny Andrade
Eduardo Anizelli
Alberto Cesar Araujo
Wagner Assis
Nário Barbosa
Lunaé Parracho
Mario Bourges
Jefferson Botega
Mateus Bruxel
Mbuainain
Guilherme Zauith
J.L. Bulcão
Daniel Kfouri
Jonathan Campos
Luciano Candisani
Rubens Cardia
Fred Chalub
Ricardo Chicarelli
Joao Guilherme
Julio Cordeiro
Antonio Costa
Allan Costa Pinto
Marizilda Cruppe
Anderson Barbosa
Heuler Andrey
Luiz Maximiano
Felipe Dana
Fernando Dantas
Paulo Vitor
Eduardo Lima
Mastrangelo Reino
Cláudio Vieira
Diego Krüger
Guilherme Dionizio
Edvaldo Santos
Sergio Dutti
Claudio Reis
Dado Galdieri
Elio Rizzo
Sergio Barzaghi
Alan Marques
Bruno Falção
Ana Carolina Fernandes
Márcia Foletto
Eduardo Nicolau
André François
Nilton Fukuda
Diogo Oliva
Apu Gomes
Marcos Cesário
Luiz Vasconcelos
Rafael Guadeluppe
Francisco Guedes de Lima
Alexandre Guzanshe
Marcelo Regua
Tyler Hicks
Mônica Imbuzeiro
Andrea Motta
Ione Moreno
Joel Rosa
Marcelo Justo
Bruno Kelly
Antonio Lacerda
Fabio V. Lanes de Souza
Odair Leal
Moisés Schini
Claus Lehmann
Marco André Lima
Mauricio Lima
Raphael Lima
Ulisses Job Lima
Cristina Livramento
Helvio Romero
Davi Ribeiro

Alexandre Loureiro
Celso Luiz
Alexandre Rezende
Cezar Magalhaes
Gustavo Magnusson
Ueslei Marcelino
Marcelo Andrade
Ricardo Nogueira
Amanda Nero
Guga Matos
Mazzo
Carolina Meirelles
Alexandre Meneghini
Michell Mello
Henry Milléo
Ricardo Moraes
Sergio Moraes
Guito Moreto
Marta Nascimento
Rafael Neddermeyer
Pedro Kirilos
Michael Patrick O'Neill
Pablo Jacob
Paulo Pampolin
Rahel Patrasso
Hamilton Pavam
Nirley Sena
Arthur Monteiro
Amanda Perobelli
Paulo Pinto
Rodrigo Pinto
Ricardo Beliel
André Porto
Fabio Rodrigues-Pozzebom
Daniel Ramalho
Marcos Ramos
Sergio Ranalli
Daniel Vilela
Ricardo Oliveira
Diego Rinaldi
Carlos Roberto
André Rodrigues
Marcio Rodrigues
Roosevelt Cássio
Jonne Roriz
João Marcos Rosa
Albari Rosa
Werther Santana
Jean Schwarz
Monica Silva
Sandrovox
Paulo Siqueira
André Americo
Hélia Scheppa
Marcus Steinmeyer
Rogerio Stella
Ricardo Teles
Thiago Leon
Tadeu Vilani
Maíra Villela
Weimer Carvalho
Widio Joffre
Michele Zambon
Alejandro Zambrana
Mônica Zarattini
Adriana Zehbrauskas

Bulgaria
Andrey Antov
Mehmed Aziz
Dimitar Dilkoff
Evgeni Dimitrov
Boryana Katsarova
Nellie Doneva
Nikolay Doychinov
Yanne Golev
Georgi Kozhuharov
Joker
Dimitar Kyosemarliev
Julia Lazarova
Eugenia Maximova
Stoyan Nenov
Nina Nikolova
Plamen Petkov
Ekaterina Titova
Tsvetan Tomchev
Horse
Vlado Trifonov
Krasimir Tsvetkov Todorov
Boris Voynarovitch

Burkina Faso
Yempabou Ouoba

Burundi
Mohamed Ndayishimiye

Cambodia
Kim Hak

Cameroon
Kamta Jean
Happi Raphaël Mbiele

Canada
Carlo Allegri
Christopher Anderson
Tyler Anderson
Berge Arabian
Colleen Flanagan
Sergei Bachlakov
Mathieu Belanger
Michael Blake
Mark Blinch
David Bloom
Christopher Bobyn
Brent Braaten
Bernard Brault
Douglas Brown
Kitra Cahana
Marco Campanozzi
Juozas Cernius
David Champagne
Dave Chan
Philip Cheung
Andy Clark
Éric Côté
Guillaume D. Cyr
Nathalie Daoust
Didier Debusschere
Ivanoh Demers
Radu Diaconu
Mike Drew
Conrad Duroseau
Darryl Dyck
Emma Findlen LeBlanc
Joel Ford
Tony Fouhse
Benoit Gariepy
Ryan Gauvin
Greg Girard
Frank Gunn
Ramin Hashempour
Jenna Hauck
Daniel Hayduk
Kiana Hayeri
Louis Helbig
Leah Hennel
Gary Hershorn
Michel Huneault
Emiliano Joanes
Yonathan Kellerman
Jeremy Kohm
Todd Korol
Nick Kozak
Paul-André Larocque
Jen Osborne
Esmond Lee
Mark Lehn
Jean Levac
Brent Lewin
John Lucas
Fred Lum
Lindsay Mackenzie
Douglas MacLellan
Rick Madonik
Liam Maloney
Jeff McIntosh
Kari Medig
Stephen Morrison
Jacques Nadeau
Scott Naysmith
Paul Nicklen
Guang Niu
Gary Nylander
Carlos Osorio
Ed Ou
Louie Palu
Marc André Pauzé
François Pesant
Renaud Philippe
Wendell Phillips
Vincenzo Pietropaolo
Christopher Pike
Edouard Plante-Fréchette
Peter Power
Salima Punjani
Jim Rankin
Ryan Remiorz
Alain Roberge
Jose Rosado
Lara Rosenoff Gauvin
Robin Rowland
Liz Rubincam

149

Steve Russell
Derek Ruttan
Matthieu Rytz
Matthew Sherwood
Dave Sidaway
Guillaume Simoneau
Jack Simpson
Lung S Liu
Sami Siva
Rob Skeoch
Lana Slezic
David Maurice Smith
Tim Smith
Michel Tremblay
Jen Tse
Stephen Uhraney
Robert van Waarden
Aaron Vincent Elkaim
Steve Wadden
Christopher Wahl
Bernard Weil
Ian Willms
Larry Wong
Jim Young
Warren Zelman
Iva Zimova

Chile
David Alarcón
Orlando Barría
Andrés Bravo
Victor Ruiz Caballero
Harold Castillo
Daniel Castro Lagos
Fabián España
Edgard Garrido
Javier Godoy
Rodrigo Gomez Rovira
Nacho Izquierdo
Chino Leiva
Ariel Marinkovic
Tomás Munita
Carlos Newman
Alfredo Nunez
Alejandro Olivares
Cristobal Olivares
Claudio Rojas Vargas
Armando Romero
Victor Salas
Richard Salgado
Pedro Ugarte
P. Valderas Villagran
Claudio Vera
Verabarahona
Carlos Villalon

China
An'Jian Gang
Guangxi An
Bai Shuzhen
Bai Ying
Baixue
Jinhe Bai
Zhoufeng Bai
Chunhua Bi
He Bin
Delong Cai
Minqiang Cai
Xurong
Cao Zhi Zheng
Guangwen Cao
Chan Wai Hing
Chang Liang
Chen Chuanping
Chen Fan
Chen Jianyuan
Chen Jie
Chen Junjie
Chen Qun
Chen Shihong
Chen Wen Bi
Chen Wenjin
chen xiaodong
Chen Xiaoyue
Chen Xu
Chen Yongheng
Chen Zhiqiang
Chen Zixuan
Chenjian
Chenliang
Chennan
Chen qiang
Chenxi
Chen Ruishi
Geng Sheng Chen
Jianli Chen
JianZeng Chen
Jie Chen
Li Chen
Mingzhe Chen
Ronghui Chen
Xiaomei Chen
Xiye
Yan Chen
Zhongqiu Chen
Cheng Heping
Cheng Qiling
Jian Ping Cheng
Wang Cheng
Ellis
Yongzhi Chu
Machunbin
Hu Cong
Cui Heping
Cuinan
Jia DaiTengFei
Dao Shurun
Sun De Li
Deng Bo
Deng Dongfeng
Deng Jianbin
Denghuosheng
Wudi
Dong Yuguo
Zhang Dong
Du Xiaowei
Du Xinwei
Duan Jimin
Fan Fangbin
Fan Liyong
Fan Shi San
Fang Sheng
Tian Fei
Feng Haijun
Feng HuaPing
Feng Ning
Hongwei Feng
Fu Yongjun
Sibo Fu
Chang Gang
Gao Daqing
Gao Hetao
Lu Gao
Jianhua Gong
Vincent Gu
Yi Gu
Yingchun Guo
Guo Jijiang
Guo Jing
Guo Qiang
Guo Yong
GuoZhiHua
Guo Hai
Xu Haifeng
Pan Haiqi
Han Chong
Han Qiang
Han Shiqi
Hehaier
Miao He
Ben Ho
Jae C. Hong
Eugene Hoshiko
Hou Yu
Shaoqing Hou
Hu Yi Qiang
Hu Guoqing
Hu Tiexiang
Huweiming
Tingmei Hu
Hua Linping
Hua Qing
Dongfangyugong
Chengfeng Huang
Huang Mingyi
Huang Qingjun
Huang Yu
Jin Huang
Songhe Huang
Zhen Huang
Huo Yan
Guangfei Ji
Ji Chen
Ji Chunyang
Ji Dong
Jia Guorong
Jiang Donghai
Jiang Hao
Jiang Tao
Jiang Yue
Jiangshenglian
Linxi Jiang
Zhai Jianlan
Sheng Jia Peng
Alani King
Jin Liwang
Jin Siliu
Jinsong
Yi Jin
Zhenqiang Jin
Li Jinhe
Xuan Kan
Xu Kangping
Huimin Kuang
Hongguang Lan
Lan Jun
Lang Shuchen
Lee Lin
Fan Leng
Huifeng Li
Feng Li
Feng Li
Ganggang
Hui Li
Jason Lee
Jiangang Li
Jiangwen Li
Jie Li
Li Fan
Li Fan
Li Fei
Li Feng
Li Ga
Li JianLin
LI Jun-jian
Li Muzi
Li Pin
Li Qizheng
Li Qun
Li Rongwei
Li Wei
Li Wenbo
Li Zhaohui
Lihao
Lijianshu
LiJie
Linlin Li
Litie
Lizhenyu
Qiang Li
Tongye Li
Zhanjun Li
LeWeiLi
Liang Daming
Liang Meng
Liang Yanjie
Liang Zhentang
Jin Liangkuai
Cris L.
Liao Pan
Liao Zhengyan
Shi Lifei
Lin Changhai
Lin Li
Lingbin
Aiguo Liu
Fuguoliu
Guanguan Liu
Guilin Liu
Guoxing Liu
Liu Chang
Liu Chang
Liu Debin
Liu Hongqun
Liu Ji
Liu Na
Liu Tao
Liu Weidan
Liu Youzhi
Liu Zhongcan
LiuAng
LiuSong
LiuZheng
Mingli Liu
Mr Liu Yu
Long Yudan
Daoxin Lu
Guozhong Lu
Lu Guang
Yun Lu
Luan Shengjie
Luan Zheng Xi
Luo Jiarong
Luo Yunfei
Pei Jun Luo
Lv Wenzheng
LvHao
Tingchuan Lv
Maqibing
Mao Shang Wen
Mao Yanzheng
Fei Maohua
Mengge
Miao Ao
Miao Jian
Miao Shulin
Xie Minggang
Mingjia Zhou
Jiwu Mu
Ng Han Guan
Huachu Ni
Ni Li Xiang
Ning Biao
Ning Feng
Xingkai Ouyang
Pan Haisong
Pan Jinglin
Pan Songgang
Pang Ka
Peng Hui
Peng Nian
Ping Wei
Feng Pu
Chao Qi
Qi JieShuang
Qi Xiaolong
Shihui Qi
Han Qian
Jin Qian
Qian Dongsheng
Qiao Jianguo
Qin Haishi
Qiu Haochen
Qiu Taijian
Qiu Weirong
Qiu Yan
Cheng Quan
Ran Wen
Rao Binbin
Ren Shi Chen
Sha Jiang
Shang Huage
Shao Quanhai
Jian Shen
Xiang Shen
Hongxu Sheng
Ping Shi
Shi Tao
Shiwei
Yi Shi
Aly Song
Jinyu Song
Rongcheng Song
Simon Song
Song Wei Tao
Song Yue Feng
He Songqing
Liguo Sun
Lin Sun
Sun Chen
Sun Guoshu
Sun Hai
Sun Hai
Sun Jie
Sun Lin
Sun Shanshan
Sun Shubao
Sun Yanqun
Sunxin
Sunhuajin
Tan Qingju
Wei Shan Tan
TangGuo
Zhiyang Tang
Deng Tao
Tao Huan
Zheng Tao
Haiguang Tian
Tian Zhenlong
TianMing
Tuanjie Chen
Guibin Wang
Hongjun Wang
Hui Wang
Huisheng Wang
Lili Wang
Shen Wang
Zhengyi Wang
Bin Wang
Wang Bin
Wang Chen
Wang He
Wang Jianing
Wang Jin
Wang Jing
Wang Jing
Wang Jingchun
Wang Pan
Wang Pingsheng
Wang Qibo
Wang Qin
Wang Qingqin
Wang Shi Jun
Wang Shibo
Wang WeiTao
Wang Wenyang
Wang Xiao
Wang Xiaoming
Wang Yonggang
Wang Yueping
Wang Yuheng
Wangjie
Wangyi
Weixuan Wang
Xiaoming Wang
Yishu Wang
Yongsheng Wang
Zheng Wang
Zhou Wang
Wei Fengzheng
Wei Xiaohao
Wei Zheng
Cao Weisong
Wen Qingqiang
Fang Wu
Jin Jin
Lin Wu
WenXing Wu
Wenmin Wu
Wu Chuan Ming
Wu Hao
Wu Haobin
Wu Hong
Wu Xiaoling
Wu Xiaotian
Wu Yunsheng
Wu Zongqi
Xiaorong Wu
Xiaoyu
Xuehua Wu
YongGang Wu
Xi Haibo
Quan Xia
Xia Shiyan
Zhang Xiaoyu
Xie Xiudong
Yonggui Xie
Li Xinzhao
Xin Yi
Dawei Xu
Xu Cong Jun
Xu Jingxing
Xu Ping
Xu Qifei
Xu Xiaolin
Xu Xinya
Xu Yuanchang
Gangqiang Xuan
Xue Xiuli
Tu Xuli
Li Yalong
Bailiang Yan
Jing Yan
ShanliangYan
Yan Zhou
Bo Yang
Chenglong Yang
Dengfeng Yang
Fan Yang
Ning Yang
Ri Yue
Shuhuai Yang
Yang Fang
Yang HuiQuan
Yang Jian
Yang Kejia
Yang Shutian
Yang Yang
Yangshen
Yangxin
Zhongmin Yang
Yang Fan
Yao Dong
Wang Yaxin
Yemaolin
Yewei
Hong Tai Yi
JianTao Yi
YiFan
Zhang Yi
Lihua Yin
Yin Gang
Yin YiZhan
Li Yong
Zou Yong
You Sihang
Huitong Yu
Junjieyu
TongYu
Wang Yu
Yu Chunshui
Yu Ming
Yu Ningtai
Yupeng
Han Yu Hong
Alexander F. Yuan
Lisong Yuan
Liyang Yuan
Xiao Qijang Yuan
Yuan Changxin
Yuan Xuqing
Yun Hongbo
Zeng Junshang
Zhan Qi
Zhanyu
Caochongninan
Changxi Zhang
Cuncheng
Guo Zhang
HongYiZhang
Kexin Zhang
LaoCu
Lijie Zhang
Paul Zhang
Peijian Zhang
Wei Zhang
Wengliang Zhang
Wenwu
Youqiong Zhang
Yujie Zhang
Zhang Chengbin
Zhang Feng
Zhang Hongbing
Zhang Jian
Zhang Jinqi
Zhang Kechun
Zhang Lei
Zhang Lide
Zhang Mingshu
Zhang Peizhi
Zhang Peng
Zhang Renyu
Zhang Tianming
Zhang Xiao
Zhang Xiaodong
Zhang Xinmin
Zhang Yong
Zhang Zihong
ZhangYuan
Zhang Changming
Zhang Hongwei
Zhangxinghai
Chaojun Zhao
Jacky Zhao
Yong Zhao
Zhao Caixia
Zhao Chongyi
Zhao Kang
Zhao Qing
Zhao Qiuqing
Zhao Wei
ZhaoBin
ZhaoDuan
Zhongshan Daily
Guoqiang Zheng
Xiaoqun Zheng
Zheng Chuan
Zheng Lianjie
Zheng Pingping
Zheng Siqi
Zheng Xiaoyun
Sun Zhijun
Cunyun Zhou
Gukai Zhou
ShaoHua Zhou
Xiaohui Zhou
Xin Zhou
Zhou Bing
Zhou Chao
Zhou Guoqiang
Zhou Haisheng
Zhou Huahua
Zhou Jianyong
Zhou Lei
Zhou Lijun
Zhou Lingxiang
Zhou Qing
Zhou Yan
Zhouen
Zhouwei
Xiyong Zhu
Zhu Haiwei
Zhu Jialei
Zhu Jiangyun
Zhu Xingxin
Weiguo Zhu Zhu
Zhuang Rungui
Zhuang Yingchang
Zou Hong
Zou Zheng
Zousen
Zuo Qing

Colombia
Luis Acosta
Henry Agudelo
Emilio Aparicio
Gabriel Aponte Salcedo
Juan Barrero
Alvaro Barrientos
Geraldkurt
Natalia Botero
Fredy Builes
Jose Isaac Bula Urrutia
Felipe Caicedo Chacón
Nelson Cárdenas
Abel E. Cardenas O.
Alvaca
Jonathan Carvajal
Christian Castillo M.
Iván Dario Herrera
Milton Diaz
Santiago Escobar-Jaramillo
Christian Escobar Mora
Salym Fayad
Jose Miguel Gomez
Juan Pablo Gomez
Guillermo González
Miguel Gutierrez
Jorge Enrique Payares
Luis Lizarazo
Albeiro Lopera
William F. Martinez
Julian Moreno
Daniel Munoz
Eduardo Munoz
Jaiver Nieto Álvarez
Jorge E. Orozco Galvis
León Peláez
Bernardo Peña
Jaime Perez
Luis Robayo
Henry Romero
Jaime Saldarriaga
Manuel Saldarriaga
J. A. Sanchez Ocampo
Joana Toro
Marco Valencia
Nicolas Van Hemelryck
Hernan Vanegas
Esteban Vanegas
Adriana Vergara M.

Democratic Republic of Congo
Junior Diatezua
Justin Makangara
Georges Senga

Costa Rica
Jeffrey Arguedas
Abelardo Fonseca
Fabian Hernandez Mena
Mayela López
Priscilla Mora Flores
Mónica Quesada C.
Juan Carlos Ulate Moya

Croatia
Zvonimir Barisin
L. Gerlanc
Zeljko Hajdinjak
Goran Jakuš
Davor Javorovic
Fjodor Klaric
Vlado Kos
Igor Kralj
Petar Kurschner Jr.
Dragan Matic
Slavko Midzor
Marijan Murat
Goran Pozek
Damir Senčar
Josip Seri
Igor Šoban
Sanjin Strukic
Andrej Svoger
Ivo Vucetic

Cuba
Heidi Calderón
Juan Pablo Carreras
Arien Chang Castan

Cyprus
Katia Christodoulou
Alexandros Demetriades
Andreas Lacovou

Czech Republic
Jana Asenbrennerova
Lukas Biba
Michal Bílek
Nina Bumbalkova
Radek Burda
Jan Cága
Jiri Dolezel
Alena Dvorakova
Eduard Erben

Viktor Fischer
Michael Fokt
Hynek Glos
Dereck Hard
Martin Hladik
Lukas Houdek
Julie Hrudova
Jana Hunterová
Milan Jaros
Petr Josek
Tom Junek
Joe Klamar
Stanislav Krupar
Pavel Lisý
Veronika Lukasova
Jan Němeček
Nguyen Phuong Thao
Michal Novotny
Jan Ponert
Jan Rasch
Jiri Rezac
Vladimir Rys
Filip Singer
Petr Toman
Michal Tyl
Ivan Vetvicka
Roman Vondrous

Denmark
Christian Als
Bobby Anwar
Nicolas Asfouri
Jens Astrup
Mari Bastashevski
Kristian Bertel
Søren Bidstrup
Jeppe Bøje Nielsen
Laerke Posselt
Michael Bothager
Andreas Hagemann Bro
Martin Bubandt
Jeppe Carlsen
Klaus Bo
Mathias Christensen
Casper Christoffersen
Claus Randrup
Casper Dalhoff
Miriam K. S. Dalsgaard
Astrid Dalum
Jacob Ehrbahn
Cathrine Ertmann
Jørgen Flemming
Maria Fonfara
Kirstine Fryd
Morten Germund
Uri Golman
Jan Grarup
Marie Hald
Michael Hansen
Michael Harder
David Høgsholt
Magnus Holm
Christian Holst
Niels Hougaard
Anna Kåri
Henrik Kastenskov
Kristine Kiilerich
Tim Kildeborg Jensen
Sofie Amalie Klougart
Lars Krabbe
Mette Kramer Kristensen
Mogens Laier
Lasse Bak Mejlvang
M. Korsgaard Lauritsen
Thomas Lekfeldt
Nikolai Linares
Bax Lindhardt
Erik Luntang
Poul Madsen
Thomas Madsen
Morsi
Joachim Adrian
Lars Moeller
Nikolaj Møller
Ekstra Bladet
Mads Nissen
Ulrik Pedersen
Simon Wedege
Søren Rønholt
Anders Birger
Lars Schmidt
Erik Schultz
Tobias Selnaes Markussen
Thomas Sjoerup
Carsten Snejbjerg
Claus Soendberg
Morten Stricker
Sisse Stroyer
Michael Svenningsen
Klaus Thymann

Gregers Tycho
Anthon Unger
Christian Vium
Robert Wengler

Dominican Republic
Jorge Cruz
Pedro Farias-Nardi
Miguel Gomez

Ecuador
Santiago Arcos
Xavier Caivinagua
Alfredo Cárdenas
Richard Castro Rodriguez
Benjamín Chambers
Lylibeth Coloma
Karla Gachet
Michelle Gachet
Vicente Gaibor
Gabriel Gonzalez
Marcos Pin
Carlos Pozo Alban
Alejandro Reinoso
Fernando Sandoval Jr
Misha Vallejo

Egypt
Mohamed Abd Elghany
Ahmed Abd El-Latef
Amr Abdallah Dalsh
Shawkan
Mohamed Ali Eddin
Mahmoud Khaled
Omnia Arfin
Tahsin Bakr
Nour El Refai
Khaled Elfiqi
Kismet Elsayed
Mosa'ab Elshamy
Bassam El-Zoghby
Ahmed Hayman
Aly Hazzaa
Eman Helal
Mohamed Hossam El-Din
Khaled Desouki
Nameer Mohamed Galal
Ashraf Talaat
Georges Mohsen
Samuel Mohsen
Mohammad Nouhan
Jonathan Rashad
Amru Salahuddien
Lobna Tarek
Asmaa Waguih

El Salvador
Mauricio Cáceres
Mauro Arias
José Cabezas
Omar Carbonero
Marlon Hernandez
Giovanni E. Lemus Fuentes
Lissette Lemus
Luis Alonso López
Frederick Meza
Jorge U. Morán Rodríguez
Marvin Orellana
Juan Carlos
Marvin Recinos
Oscar Rivera
Ulises Rodriguez
Salvador Sagastizado
Douglas Alberto Urquilla
Miguel Villalta

Estonia
Kaido Haagen
Annika Haas
Tairo Lutter
Heiki Rebane
Jekaterina Saveljeva

Finland
Tommi Anttonen
Tatu Blomqvist
Pekka Fali
Esko Jämsä
Minna Jerrman
Petteri
Meeri Koutaniemi
Karina-Sirkku Kurz
Laura Larmo
Timo Marttila
Niklas Meltio
Sakari Piippo
Timo Pyykkö
Kaisa Rautaheimo
Ville Rinne
Aino Salmi

Kari Salonen
Marko Simonen
Kai Sinervo
Maija Tammi
Petri Uutela
Mikko Vähäniitty

France
Olivier Adam
Pascal Aimar
Guilhem Alandry
Denis-Charles Allard
Amet
Arnaud Andrieu
Christophe Archambault
Patrick Artinian
Frederik Astier
Natalie Ayala
Capucine Bailly
Joan Bardeletti
Anaïs Barelli
Martin Barzilai
Yacine
Jean-Jacques Bernard
Alban Biaussat
Keyser
Guillaume Binet
Patrick Blanche
Olivier Boëls
Vincent Boisot
Régis Bonnerot
David Bouchet
Sebastien Boue
Pierre Boutier
Franck Boutonnet
Eric Bouvet
Patrick Bruchet
Anne-Laure Camilleri
Alain Carayol
Sarah Caron
Fabrice Catérini
Jacques Cauda
Thierry Chantegret
Chapuis
Sylvain Cherkaoui
Lucile Chombart de Lauwe
Olivier Chouchana
Martin Colombet
Stephane Compoint
Yannick Cormier
Magali Corouge
Olivier Corsan
Scarlett Coten
Philippe Cottin
Olivier Coulange
Stéphane Coutteel
Pierre Crom
Denis Dailleux
Viviane Dalles
Julien Daniel
William Daniels
Guillaume Darribau
Georges Dayan
James Keogh
Beatrice De Gea
Gabriel de la Chapelle
Matthieu de Martignac
Gratiane De Moustier
Johanna de Tessieres
Jerome Delay
Pascal Della Zuana
Dominique Delpoux
Mathias Depardon
Jeromine Derigny
Pierre-Olivier Deschamps
Tany Kely
Bénédicte Desrus
Eric Dexheimer
Fabrice Dimier
Stephen Dock
Joséphine Douet
Claudine Doury
Barbara Doux
Gwenn Dubourthoumieu
Francois Dufour
Fred Dufour
Richard Dumas
Emmanuel Dunand
Edouard Elias
Alain Ernoult
Isabelle Eshraghi
Romain Etienne
Viviane Negrotto
Jean-Eric Fabre
Pascal Fellonneau
Olivier Fermariello
Bruno Fert
Franck Ferville
Franck Fife
Corentin Fohlen

Roberto Frankenberg
Frionnet Cyril
Eric Gaillard
Nicolas Gallon
Bertrand Gaudillère
Olivia Gay
Grégory Gérault
Flore Giraud
Baptiste Giroudon
Pierre Gleizes
Julien Goldstein
Mathieu Grandjean
Capucine Granier-Deferre
Gerard Gratadour
Frederic Grimaud
Alain Grosclaude
Olivier Grunewald
Stanislas Guigui
Ivan Guilbert
Jeoffrey Guillemard
Jean-Paul Guilloteau
Philippe Guionie
Antoine Gyori
Valery Hache
Eric Hadj
Laurent Hazgui
Guillaume Herbaut
Guillaume Horcajuelo
Françoise Huguier
Olivier Jobard
Gérard Julien
Laurent Julliand
Jérémie Jung
Moctar Kane
Daniel Karmann
Vincent Kessler
Oan Kim
Samuel Kirszenbaum
A. Kremer-Khomassouridze
Benedicte Kurzen
Olivier Laban-Mattei
Stephane Lagoutte
Jean-François Lagrot
Ian Langsdon
Stéphane Lavoué
Le Gall
Pascal Le Segretain
Ulrich Lebeuf
Martin Leers
Camille Lepage
Christophe Lepetit
Herve Lequeux
Sylvain Leser
Lewkowicz
Baptiste Lignel
Vincent Lignier
Philippe Lopez
John MacDougall
Stephane Mahe
Alexandre Marchi
Pierre-Philippe Marcou
David Mareuil
Rodolph Marics
François-Xavier Marit
Pierre Marsaut
Alexandre Martin
Catalina Martin-Chico
Pierre-Yves Marzin
Valérian Mazataud
Marc Melki
Georges Merillon
Isabelle Merminod
Nicolas Messyasz
Jc Millet
Gilles Mingasson
Pierre Morel
Francois Mori
Olivier Morin
Vincent Mouchel
Sonia Naudy
Roberto Neumiller
Stanley Leroux
José Nicolas
Samuel Nja Kwa
Sebastien Nogier
Frederic Noy
Hector Olguin
Emmanuel Ortiz
Jeff Pachoud
Tadeusz Paczula
Matthieu Paley
Anne Paq
Nicolas Pascarel
Eric Pasquier
Gutner
Franck Perrogon
Philippon
Jessica Pierné
Théo
Frédéric Mery Poplimont

Cyprien Clément-Delmas
Philip Poupin
Eric Rechsteiner
Jaime Reina
Nicolas Richoffer
Juliette Robert
Franck Robichon
Matthieu Rondel
Vincent Rosenblatt
Johann Rousselot
Denis Rouvre
Cyril Ruoso
Lizzie Sadin
Erik Sampers
Thomas Samson
Alexandre Sargos
Frédéric Sautereau
Franck Seguin
Roland Seitre
Jérôme Sessini
Christophe Simon
Frédéric Stucin
Jeremy Suyker
Thierry Suzan
Antoine Tempé
Pierre Terdjman
Ambroise Tézenas
Aimée Thirion
Antonin Thuillier
Nicolas Tolstoï
Patrick Tourneboeuf
Olivier Touron
Vincent Tremeau
Gerard Uferas
Vancon Laetitia
Eric Vandeville
Eric Vazzoler
Nicolas Villaume
Christophe Viseux
Franck Vogel
D.N. Webb-Hicks
Mélanie Wenger
Philippe Wojazer
Rafael Yaghobzadeh
Vasantha Yogananthan

Georgia
Irakli Dzneladze
Mikhail Galustov
Giorgi Gogua
Khatia Jijeishvili
Levan Kherkheulidze
Michael Korkia
Waznareli
Ketevan Mghebrishvili
Dina Oganova Dikarka
Davit Rostomashvili
Mzia Saganelidze
Daro Sulakauri
Niko Tarielashvili

Germany
Valeska Achenbach
Anne Ackermann
Theo Allofs
Bastian Andreas
Ingo Arndt
Bernd Arnold
Petra Arnold
Puerta de Hierro
Thorsten Baering
Lajos-Eric Balogh
Debra Bardowicks
Lars Baron
Petra Barth
Theodor Barth
Gil Bartz
Kathrin Baumbach
Nico Baumgarten
Michael Bause
Siegfried Becker
Fabrizio Bensch
Stefan Berg
Guido Bergmann
Darius Bialojan
Graca Bialojan
Henning Bode
Stefan Boness
Katharina Bosse
Hubert Brand
Marcus Brandt
Hermann Bredehorst
Roland Breitschuh
Gero Breloer
Philipp Breu
Hansjürgen Britsch
Robert Andreas Brodatzki
Jörg Brüggemann
Sabine Bungert
Arno Burgi

Hans-Jürgen Burkard
Florian Büttner
Dominik Butzmann
Malte C. Christians
Dirk Claus
Nabiha Dahhan
Michael Dalder
Peter Dammann
Claudia Daut
Stefan Dauth
Barbara Dombrowski
Thomas Duffé
Ralf Dujmovits
Birgit-Cathrin Duval
Thomas Ebert
Johannes Eisele
Ole Elfenkämper
Ahmed El-Salamouny
Daniel Etter
Enrico Fabian
Ralf Falbe
Stefan Falke
Ina Fassbender
Jan Faßbender
Fabian Fiechter
Stefan Finger
Bettina Flitner
Walter Fogel
Sebastian Forkarth
Kai Peter Försterling
Samantha Franson
Sascha Fromm
Hanna Fuhrmann
Thomas Gebauer
Dirk Gebhardt
Frank Gehrmann
Christoph Gerigk
Bodo Goeke
Oliver Goernandt
Jan Gott
Gosbert Gottmann
Marcel Gräfenstein
Kai Griepenkerl
Dennis Grombkowski
Stefan Gruber
Julia Gunther
Patrick Haar
Insa Cathérine Hagemann
Adam Halup
Alfred Harder
Martin Hartmann
Jan-Christoph Hartung
Alexander Hassenstein
Axel Heimken
Katja Heinemann
Tina Heinz
Ilja C. Hendel
Claudia Henzler
Frank Herfort
Juliane Herrmann
Meiko Herrmann
Katharina Hesse
Benjamin Hiller
Erik Hinz
Stefan Hoederath
Monika Hoefler
Torben Hoeke
Marc Hofer
Helge Holz
Rebecca Hoppé
Eva Horstick-Schmitt
Sandra Hoyn
Andreas Hub
T. Hutzler
Britta Jaschinski
Judith Jockel
Christopher Dömges
Hannes Jung
Matthias Jung
Kati Jurischka
Juergen Kader
Sebastian Kahnert
Enno Kapitza
Christiane Kappes
Marcus Kaufhold
Birte Kaufmann
Claus Kiefer
Dagmar Kielhorn
Silke Kirchhoff
Sophie Kirchner
David Klammer
Christian Klant
Thorsten Klapsch
Alexander Klein
Christian Klein
Marco Kneise
Stephan Knoblauch
Betram Kober
Hans-Jürgen Koch
Heidi Koch

Christof Koepsel
Atwist
Robert W. Kranz
Gert Krautbauer
Tobias Kruse
Guido Krzikowski
Andrea Künzig
Oliver Lang
Katja Lenz
Michael Lobisch-Delija
Kai Löffelbein
Michael Löwa
Helena Schaetzle
Nele Martensen
Uwe H. Martin
Bettina Matthiessen
Fabian Matzerath
Daniel Maurer
Peter Udo Maurer
Andreas Meichsner
Günther Menn
Kevin Mertens
T. Metelmann
Jens Meyer
Markus Mielek
Thorsten Milse
Daria Mnych
Moritz Mueller
Florian Müller
Lene Münch
Merlin Nadj-Torma
Kai Nedden
Simone M. Neumann
Ralf Niemzig
Klaus Nigge
Joanna Nottebrock
Geert Boie
Ingo Otto
Isabela Pacini
Jens Palme
Laci Perenyi
Thomas P. Peschak
Carsten Peter
Kai Pfaffenbach
Helge Prang
Thomas Rabsch
Wolfgang Rattay
Hermann Recknagel
Andreas Reeg
Hartmut Reeh
Pascal Amos Rest
Daniel Rettig
Sascha Rheker
Stefan Richter
Astrid Riecken
Moritz Roeder
Jens Rosbach
Martin Rose
Daniel Rosenthal
Kaveh Rostamkhani
Steffen Roth
Stephan Sagurna
Martin Sasse
Peter Schatz
Zacharie Scheurer
Jordis Antonia Schlösser
Roberto Schmidt
Steffen Schmidt
Oliver Schmieg
Thilo Schmülgen
Hendrik Schneider
Martin Schoeller
Julius Schrank
David Schreiner
Annette Schreyer
Thomas Schreyer
Olaf Schuelke
Kai-Uwe Schulte-Bunert
Frank Schultze
Hartmut Schwarzbach
Jaqueline Scupin
Bernd Seydel
Marcus Simaitis
Agata Skowronek
Philipp Spalek
Andy Spyra
Christophe Stache
Wolfgang Stahr
Martin Steffen
Berthold Steinhilber
Stephanie Steinkopf
Marc Steinmetz
Björn Steinz
Peter Steudtner
Patrik Stollarz
Carsten Stormer
Julian Stratenschulte
Uwe-S. Tautenhahn
Tuna Tekeli
Bernd Thissen

Yannick Tylle
Marc-Steffen Unger
Heinrich Voelkel
Timo Vogt
Mika Volkmann
Hans von Manteuffel
Vanja Vukovic
Edith Wagner
Nikolai Weber
Oliver Weiken
Fabian Weiß
Sandra Weller
Ludwig Welnicki
Gordon Welters
Christian Werner
Mario Wezel
Birgit Widmann
Sebastian Widmann
Kai Wiedenhoefer
Christian Willner
Carsten Windhorst
Ann-Christine Woehrl
Jan Woitas
Solvin Zankl
Sven Zellner
Christian Ziegler
Julia Zimmermann
Reto Zimpel
Samuel Zuder

Ghana
Geoffrey Buta
Nyani Quarmyne
Emmanuel Quaye

Greece
Christos Stamos
Socrates Baltagiannis
Yannis Behrakis
Evangelos Bougiotis
Androniki Christodoulou
Nikos Exarhopoulos
Yannis Galanopoulos
Vangelis Georgas
Petros Giannakouris
Angelos Giotopoulos
Louisa Gouliamaki
Yannis Kabouris
Yorgos Karahalis
Alexander Katsis
Gerasimos Koilakos
Yannis Kolesidis
Alkis Konstantinidis
Stefanos Kouratzis
Maro Kouri
Dionysis Kouris
Yiannis Kourtoglou
Costas Lakafossis
Sakis Lalas
Georgios Makkas
Michele A. Macrakis
Kostas Mantziaris
Aris Messinis
Dimitri Messinis
Dimitris Michalakis
Stefania Mizara
Giorgos Moutafis
Myrto Papadopoulos
Marita Pappa
Antonis Pasvantis
Kostas Pikoulas
Nikos Pilos
Olga Stefatou
Kostas Tsironis
Angelos Tzortzinis
Aristidis Vafeiadakis
Angelos Zymaras

Guatemala
Jesus Alfonso
J Decavele
Luis Echeverria
Esteban Biba
William Gularte
Wilder D. López
Ed Sebastián Lozano
Saul Martinez
Sergio Muñoz
Johan Ordonez
Andrea Pennington
Ricardo Ramírez Arriola
Luis Soto
Sergio L. Vasquez Perez
Alvaro Yool

Haiti
Jean Jacques Augustin
Homere Cardichon
Daniel Morel

Hong Kong
Lam Chun Tung
Chung Ming Ko
Lam Yik Fei
Jih Sheng Lei
Lui Siu Wai
Luo Kanglin
Tsz Yeung Tsang
Bobby Yip
Vincent Yu

Hungary
Hamvas Balint
Zoltán Balogh
Andras Bankuti
Laszlo Beliczay
Krisztián Bócsi
Maximiliano Braun
Noemi Bruzak
Gyula Czimbal
Bela Doka
Krisztina Erdei
Erdélyi Gábor
Fazekas István
Imre Foldi
Balazs Gardi
György Gáti
Glázer Attila
H. Szabó
András Hajdú D.
Tamas Horvath
Tibor Illyes
Marton Kallai
Peter Kallo
Bea Kallos
Richard Kalocsi
M. István Kerekes
Péter Kollányi
Peter Komka
Szilard Koszticsak
Kristó Róbert
Péter Lakatos
Zoltan Madacsi
Marton Szilvia
Zoltan Molnar
Simon Móricz
Tamas Revesz
Zsolt Reviczky
Gaspar Risko
Sánta István Csaba
Tamas Schild
Janos M Schmidt
Segesvari Csaba
Lajos Soos
David Sopronyi
Akos Stiller
Peter Szalmas
Robert Szaniszlo
Joe Petersburger
Zsolt Szigetváry
Laszlo Szirtesi
Lara Eva Tompa
Zoltán Tuba
Gabor Turcsi
Adam Urban

Iceland
Vilhelm Gunnarsson
Christina Simons

India
Aathibagavan Aathi
Adnan Abidi
Jagadeesh
S. N. Acharya
Piyal Adhikary
Mukhtar Khan
Khalid Ahmed
Chandan Ahuja
Abhijit Alka Anil
Channi Anand
Aditya Anupkumar
Pradeep Kocharekar
Bindu Arora
Ashhad Ashik
Pratik Dutta Babu
Anand Bakshi
Rakesh Bakshi
Sundeep Bali
Suman
Pritam Bandyopadhyay
Poulomi Basu
Subhashis Basu
Vivek Bendre
Salil Bera
Kamalendu Bhadra
Shraddha Bhargava
Anup Bhattacharya
Ashok Bhaumik
Sibu Bhuvanendran

Bijoy Kumar Jain
Biju Boro
Narendra Bisht
Kishor Kumar Bolar
Copshiva
Debajyoti C. Bubun
Ranjan Basu
Burhaan Kinu
Munish Byala
Rana Chakraborty
Amit Chakravarty
Ch. Vijaya Bhaskar
Puneet Chandhok
Bhanu Prakash Chandra
Sajal Chatterjee
C. Suresh Kumar
K.K. Choudhary
Ravi Choudhary
N. Rao Chowdavarapu
Rupak De Chowdhuri
Dar Yasin
Javed Dar
Bikas Das
Indranil Das
Sanjit Das
Sucheta Das
Sudipto Das
Arko Datto
Mukunda De
Debajyoti Chakraborty
Debasih Dey
Deepak Mali
Mandar Deodhar
Uday Deolekar
Sandesh Rokade
Tony Dominic
Devendra Dube
Arijit Dutta
Subrata Dutta
Pattabi Raman
Rohit Gautam
V. Kumar Ghantasala
Aayush Goel
Prasad Gori
Prodip Guha
Ashish Shankar
Sanjeev Gupta
Santosh Gupta
Sanjay Hadkar
Subir Halder
Sajjad Hussain
Arvind Jain
Siddharth Jain
Jasjeet Plaha
Dhruba Dutta
Dilip Kagda
Vikramjit Kakati
Atul Kamble
Sanjay Kanojia
Tushar Sharma
Aditya Kapoor
Ruhani Kaur
Bijumon Kavallur
Omkar Kocharekar
Imran Ali Koka
Sasi.K
Ajit Krishna
Jerome KulandaiYesu
Bachchan Kumar
Selvaprakash Lakshmanan
Zishaan Akbar Latif
L.R. Shankar
Amit Madheshiya
Shouvik
Caisii Mao
Rafiq Maqbool
Riyasannamanada
Samir Madhukar Mohite
Faisal Khan
Anindito Mukherjee
Arindam Mukherjee
Indranil Mukherjee
Paroma Mukherjee
Mahesh Bhat
Gnanavel Murugan
Rajtilak Naik
Nalgonda Shiva Kumar
Suresh Nampoothiri
Ashima Narain
Anupam Nath
Ramanathan Nileshwaram
Anand Oinam
Pabitra Das
Sujith Padinjare Varieth
P.V. Sunder Rao
Nagesh Panathale
Shailendra Pandey
Adhvait Pandya
Dinesh Parab
Manas Paran

Shriya Patil
Partha Paul
Vijayan.P
P. Ravikumar
Ravi Posavanike
Anshuman Poyrekar
Kunal Pradeep Patil
Chhandak Pradhan
Sathish Kumar
Altaf Qadri
Ashish Raje
R. Senthil Kumaran
Rajesh Damodar Dangle
B A Raju
K. Ramesh Babu
Nishant Ratnakar
R. Raveendran
Nilanjan Ray
Biswaranjan Rout
Kumar Roy
Padam Saini
Sajeesh Sankar
R S Gopan
Dibyangshu Sarkar
Sabu Scariachen
Arijit Sen
Gautam Sen
Ronny Sen
Parthasarathi Sengupta
Ajeet Kumar Shaah
Showkat Shafi
Anil Shakya
Shantanu Das
Mahesh Shantaram
SL Shanth Kumar Shanth
Ashish Sharma
Deepak Sharma
Money Sharma
Subhash Sharma
Jayanta Shaw
Anand Shinde
Raju Shinde
Shome Basu
Adeel Halim
Danish Siddiqui
Sharatt Siddoju
Mihir Singh
Prakash Singh
Rajesh Kumar Singh
Raminder Pal Singh
Vivek Singh
Nirvair Singh Rai
Sanat Kumar Sinha
Ajit Solanki
Divyakant Solanki
Shekhar Soni
Sonu Mehta
Arun Sreedhar
SreeKumar EV
R.R. Srinivasan
Anant Srivastava
Amirtharaj Stephen
Vidya Subramanian
Anantha Subramanyam.K.
Sameer Tawde
Manish Swarup
Swarup Banerjee
T. Srinivasa Reddy
Mustafa Tauseef
Tashi Tobgyal
Deepak Turbhekar
Harish Tyagi
Unni
Ritesh R Uttamchandani
Karan Vaid
Manan Vatsyayana
V. Ganesan
Ajay Verma
Vijay Verma
Vicky Roy
Vinoth V
Chirag Dilip Wakaskar
Danish Ismail Wani

Indonesia
Sutanta Aditya
Yuniadhi Agung
Akrom Hazami
Jefri Aries
Binsar Bakkara
Agung Kuncahya B.
Beawiharta
Roni Bintang
Dwianto Wibowo
Hendra Eka
Tjahjono Eranius
Arif Fadillah
Mohammad Hilmi Faiq
Iggoy el Fitra
Junaidi Gandy

Jongki Handianto
Raditya Helabumi
Wihdan Hidayat
Afriadi Hikmal
Donal Husni
Jhoni Hutapea
Ulet Ifansasti
Fauzan Ijazah
Bagus Indahono
Sandhi Irawan
Mast Irham
Bay Ismoyo
Raditya Jati
Kemal Jufri
Joko Kristiono
Rezza Estily
Feri Latief
P.J. Leo
Ali Lutfi
Chaideer Mahyuddin
Basri Marzuki
Roderick Adrian Mozes
Prima Mulia
Irsan Mulyadi
Gembong Nusantara
Pang Hway Sheng
Lucky Pransiska
Idris Prasetiawan
Arief Bagus
Boby Noviarto
Rommy Pujianto
Panca Syurkani
Agung Rahmadiansyah
Ingki Rinaldi
Aman Rochman
Roy Rubianto
Safir Makki
Dwi Oblo
Selo
Yuli Seperi
Dhoni Setiawan
Iwan Setiyawan
Fransiskus Simbolon
Dedy Sinuhaji
Poriaman Sitanggang
Sihol Sitanggang
Tarko Sudiarno
Agus Susanto
Arief Suhardiman Sutardjo
Dedhez Anggara
Muhammad Adimaja
Atho' Ullah
Jerry Adiguna
Putu Sayoga
Adek Berry
Taufan Wijaya
Yudhi Sukma Wijaya
Totok Wijayanto
Jessica Helena Wuysang
Rony Zakaria
Yuli Seperi
Iwan Setiyawan
Oscar Siagian
Fransiskus Simbolon
Dedy Sinuhaji
Sihol Sitanggang
Jurnasyanto Sukarno
Arief Suhardiman Sutardjo
M. Syachban Firmansyah
Boy T Harjanto
Dadang Tri
Donang Wahyu
Guntje
Andika Wahyu
Yudhi Sukma Wijaya
Taufan Wijaya
Adek Berry
Will Wiriawan
Rony Zakaria
Zulkarnain

Iran
Ali Agharabi
Md. Reza Alimadadi
Alaa al-Marjani
Azin Haghighi
Aslon Arfa
Hamed Arib
Vahid Moghadam
Maryam Ashrafi
Farhad Babaei
Mohammad Babaei
Hamid Reza Bazargani
Mostafa Bazri
Babak Bordbar
Reza
Hatis
Javad Erfanian Aalimanesh
Hossein Fatemi
Caren Firouz

Arez Ghaderi
Mehdi Ghasemi
Mostafa Ghotbi
Mohammad Golchin Kohi
Reza Golchin
Milad
Seyed Hossien Hadeaghi
Abbas H.
Ahmad Halabisaz
Mohammad Hoseini
Aref Karimi
Ali Kaveh
Farzaneh Khademian
Arash
Asghar Khamseh
Younes Khani
Mohammad Kheirkhah
Siavash Laghai
Madadi
Soleyman Mahmoudi
Shokoufeh Malekkiani
Ali Masoodimanesh
A. Mehrabi
Behrouz Mehri
Behnam Moazen
Kamal
Mehdi Monem
Hady Moslehi
Nafise
Musavi
Tayebeh Nasrolahi
Hamed
Emad Nematollahi
Abolfazl Nesaei
Hassan Nezamian
Morteza Nikoubazl
Ebrahim Noroozi
Parizad
Aydin Rahbar
Mahdi Razavi
Amir Foad
Sahar
Tahir Sadati
Hossein
Majid Saeedi
Sajjad Safari
Hosein Saki
Mohsen Sanei Yarandi
Farid Sani
Babak Sedighi
Amin Shahamipour
Hashem Shakeri
Jalal
Sina Shiri
Mamrez
Tajik
Abedin Takerkenareh
Farshid
Alireza

Iraq
Ali Arkady
Ali Haider
Azad Lashkari
Ibrahim S. Nadir
Kamaran Najm

Ireland
Julien Behal
Laurence Boland
Desmond Boylan
Deirdre Brennan
Matthew Browne
Cyril Byrne
John Carlos
Niall Carson
Jason Clarke
Aidan Crawley
Barry Cregg
James Crombie
Dan Dennison
Kieran Doherty
Michael Donald
Colman Doyle
Denis Doyle
David Farrell
Eamonn Farrell
Darragh Mason Field
Brenda Fitzsimons
Kieran Galvin
Brian Gavin
Diarmuid Greene
Steve Humphreys
Cillian Kelly
John C Kelly
Brian Lawless
Barbara Lindberg
Dan Linehan
Eric Luke
Dara Mac Dónaill

David Maher
Stephen McCarthy
Andrew McConnell
Gareth McConnell
Ross McDonnell
Daniel McGrath
John D McHugh
Ian McIlgorm
Michelle McLoughlin
Ray McManus
Cathal McNaughton
Charles McQuillan
Denis Minihane
Paul Mohan
Brendan Moran
Seamus Murphy
Jeremy Nicholl
Cathal Noonan
Mick O'Neill
Douglas O'Connor
Kenneth O'Halloran
Joe O'Shaughnessy
Lorraine O'Sullivan
Valerie O'Sullivan
Oliver McVeigh
Fergal Phillips
Jacques Piraprez Ta
Dave Ruffles
Daniel Sheridan
David Thomas Smith
Bill Smyth
Billy Stickland
Morgan Treacy
Fran Veale
Domnick Walsh
Ian Walton
Eamon Ward
Henry Wills

Israel
Nir Alon
Bar Am-David
Lihee Avidan
Dan Balilty
Oded Balilty
Rafael Ben-Ari
Rina Castelnuovo
Gil Cohen Magen
Oz Dror
Natan Dvir
Dror Einav
Nir Elias
Dror Garti
Meged Gozani
Yan Grinshtein
Amnon Gutman
Shafax Haber
Nitzan Hafner
Naftali Hilger
Yoav Horesh
Tomer Ifrah
Ben Kelmer
Motti Klinger
Ziv Koren
Tali Mayer
Shay Mehalel
Roya Mey Dan
Mati Milstein
Omer Miron
Lior Mizrahi
Yakov Nahomie
Oren Nahshon
Jorge Novominsky
Antonina Reshef
Ori Sadeh
Atef Safadi
Marc Israel Sellem
Ahikam Seri
Amit Sha'al
Avishag Shaar-Yashuv
Jonathan Shaul
Tsur Sehzaf
Uriel Sinai
Shir Stein
Abir Sultan
Dafna Tal
Dafna Talmon
Daniel Tchetchik
Yuval Tebol
Gali Tibbon
Miriam Tsachi
David Vaaknin
Eyal Warshavsky
Pavel Wolberg
Kobi Wolf
Ilia Yefimovich
Yehoshua Yosef
Oren Ziv
Ronen Zvulun
Ohad Zwigenberg

Power to evolve

Within the rugged, compact magnesium alloy body of the EOS 5D Mark III lies a superfast DIGIC 5+ processor and full frame sensor for superb stills and stunning cinematic movies. Coupled with the wide range of Canon EF lenses available, the EOS 5D Mark III redefines creativity.

canon.co.uk/EOS5DMarkIII

you can

Italy

Francesco Acerbis
Anna Aamo
Edoardo Agresti
Alessandro Albert
Vito Amodio
Marco Ansaloni
Francesco Anselmi
Angelo Antolino
l'Angeloviaggiatore
Raul Ariano
Matteo Armellini
Giampiero Assumma
Giovanni Attalmi
Tommaso Ausili
Martina Bacigalupo
Diana Bagnoli
Antonio Baiano
Isabella Balena
Jacob Balzani Lööv
Massimo Barberio
Paolo Barbuio
Andrea Erdna Barletta
Pietro Baroni
Giorgio Barrera
Nicola Bartolone
Nino Bartuccio
Matteo Bastianelli
Daniele Belosio
Cristiano Bendinelli
Giorgio Benvenuti
Valerio Berdini
Andrea Bernardi
Massimo Berruti
Guia Besana
Carlo Bevilacqua
Mario Biancardi
Matteo Biatta
Vanda Biffani
Maria Teresa Bilotta
Alfredo Bini
Valerio Bispuri
Roberto Boccaccino
Mjrka Boensch Bees
Stephen J Boitano
Roberto Bongiorni
Paolo Bona
Tommaso Bonaventura
Marcello Bonfanti
Federico Borella
Ugo Lucio Borga
Gregorio Borgia
Alberto Bortoluzzi
Michele Borzoni
Susetta Bozzi
Annalisa Brambilla
Roberto Brancolini
Leonardo Brogioni
Daniele Brunetti
Luca Bruno
Talos Buccellati
Fabio Bucciarelli
Mario Bucolo
Riccardo Budini
Fulvio Bugani
Monika Bulaj
Giulio Bulfoni
Antonio Busiello
Vittore Buzzi
Alberto Buzzola
Mattia Cacciatori
Roberto Caccuri
Niccolo Cadirni
Raffaella Cagnazzo
Jean-Marc Caimi
Simona Caleo
Daniele Calisesi
Giuliano Camarda
Cinzia Camela
Serena Campanini
Stefano Cantù
Francesca Cao
Federico Caponi
Leonardo Caprai
Raffaele Carnevale
Giuseppe Carotenuto
Gio Sbriz
Federica Casali
Davide Casella
Luigi Casentini
Marco Casini
Eduardo Castaldo
Daniele Castellani
Pablo Castellani
Piero Castellano
Adriano Castelli
Lorenzo Castore
Luca Catalano Gonzaga
Salvatore Cavalli
Gianluca Cecere

Pierfrancesco Celada
Chiara Ceolin
Giancarlo Ceraudo
Carlo Cerchioli
Simone Cerio
Lorenzo Ceva Valla
János
Giuseppe Chiantera
Alfredo Chiarappa
Chinellato Matteo
Giuseppe Chiucchiu
Federico Ciamei
Giuseppe Ciccia
Emanuele Ciccomartino
Tiziana Cini
Stefano Cioffi
Giordano Cipriani
Paolo Ciregia
Massimiliano Clausi
Ignacio Maria Coccia
Giovanni Cocco
Alex Coghe
Elio Colavolpe
Antonino Condorelli
Alberto Conti
Mauro Corinti
Matt Corner
Endrio
Marzia Cosenza
Alessandro Cosmelli
Luigi Costantini
Alfredo Covino
Thomas Cristofoletti
Francesco Cusenza
Massimo Cutrupi
Fabio Cuttica
Albertina d' Urso
Ottavia Da Re
Jacopo Daeli
Stefano Dal Pozzolo
Francesco Dal Sacco
Daniel Dal Zennaro
Simone Dalmasso
Cinzia D'Ambrosi
Mario D'Angelo
Andrea Dapueto
Giovanni De Angelis
Rocco De Benedictis
Francesco A. de Caprariis
Dario de Dominicis
Stefano De Grandis
Paola de Grenet
Stefano De Luigi
Isabella De Maddalena
Giuliano Del Gatto
Edoardo Delille
Paolo della Corte
Ilaria Di Biagio
Armando Di Loreto
Domiziano Di Figlia
Pietro Di Giambattista
Marco Di Lauro
Giulio Di Sturco
Giovanni Diffidenti
Davide Diso
Simone Donati
Linda Dorigo
Patrizia Dottori
Elena Perlino
Salvatore Esposito
Tiziana Fabi
Neri Fadigati
Alessandro Falco
Marcello Fauci
Max Ferrero
Marco Ficili
Gaia Light
Mauro Fiorese
Pietro Firrincieli
Delizia Flaccavento
Vincenzo Floramo
Nanni Fontana
Gabriele Forzano
Chiara Fossati
Andrea Frazzetta
Gabriele Galimberti
Gianfranco Gallucci
Alessandro Gandolfi
Enrico Gaoni
Matilde Gattoni
Guido Gazzilli
Stephanie Gengotti
Alessio Genovese
Enrico Genovesi
Tony Gentile
Simona Ghizzoni
Carlo Gianferro
Alfio Giannotti
Antonio Gibotta
Pierluigi Giorgi

Gianni Giosue
Claudio Giovannini
Pino Rampolla
Chiara Goia
Alessandro Grassani
Annibale Greco
Marco Gualazzini
Daniele Gussago
Marco Iacobucci
Daniele Iodice
Roberto Isotti
Emanuele Lami
Oskar Landi
Nico Lanfranchi
Marco Lapenna
Michele Lapini
Mario Laporta
Francesco Lastrucci
Germana Lavagna
Massimiliano Leanza
Francesca Leonardi
Daniele Leone
Alessia Leonello
Simone Lettieri
Laura Lezza
Stefano Lista
Laura Liverani
Nicola Lo Calzo
Francescolosapio
Luca Locatelli
Martino Lombezzi
Marco Longari
Fabio Lovino
Cristiano Lucarelli
Guillermo Luna
Diego Mayon
Alex Majoli
Alessio Mamo
Beatrice Mancini
Livio Mancini
Christian Mantuano
Romina Marani
Manuel Marano
Gianmarco Maraviglia
Paolo Marchetti
Giulia Marchi
Marco Cantile
Claudio Marcozzi
Nicola Marfisi
Diambra Mariani
Fabio Marras
Piero Martinelli
Simone Martinetto
Enrico Mascheroni
Lorenzo Masi
Pino Mastrullo
Pietro Masturzo
Giulio Mazzarini
Lorenzo Meloni
Myriam Meloni
Giovanni Mereghetti
Francesco Merlini
Erik Messori
Christian Minelli
Sara Minelli
Giovanni Minozzi
Michele Miorelli
Dario Mitidieri
Pierpaolo Mittica
Giuseppe Moccia
Federico Modica
Mimi Mollica
Laura Montanari
Filippo Monteforte
Davide Monteleone
Antonella Monzoni
Claudio Morelli
Stefano Morelli
Alberto Moretti
Aggie Morganti
Michele Morosi
Franco Mottura
Pierluigi Mulas
Sara Munari
Filippo Mutani
Fabio Muzzi
Fabrizio Nacciareti
Luigi Narici
Annalisa Natali Murri
Luca Neve
Francesco Nonnoi
Antonello Nusca
Francesca Oggiano
Stefano Oliverio
Oliviero Olivieri
Gianluca Oppo
Franco Origlia
Gabriele Orlini
Roberto Orrù
Alberto Ostini

Alessio Paduano
Michele Palazzi
Michela Palermo
Giulio Paletta
Giorgio Palmera
Stefano Paltera
Gianluca Panella
Giovanni Panizza
Manfredi Pantanella
Gianmarco Panucci
Pietro Paolini
Fabiano Parisi
Lavinia Parlamenti
Edoardo Pasero
Luca Pasquale
Masiar Pasquali
Luciana Passaro
Paolo Patrizi
Alice Pavesi
Stefano Pedroni
Paolo Pellegrin
Sara Pellegrino
Matteo Pellegrinuzzi
Paolo Pellizzari
Alessandro Penso
Massimo Percossi
Viviana Peretti
Michele Pero
Simone Perolari
Giorgio Perottino
Stefano Pesarelli
Mariagrazia Petito Di Leo
Giulio Petrocco
Giuseppe Piazzolla
Dario Picardi
Ilenia Piccioni
Marco Pighin
Emiliano Pinnizzotto
Piergiorgio Pirrone
Beniamino Pisati
Giulio Piscitelli
Francesco Pistilli
Massimo Pistore
Alberto Pizzoli
Fausto Podavini
Antonio Politano
Francesca Pompei
Piero Pomponi
Laura Portinaro
Paolo Porto
Gianluca Pulcini
Jacopo Querci
Cesare Quinto
Tommaso Rada
Giuliano Radici
Cristiano Ragab
Sergio Ramazzotti
Alessandro Rampazzo
Andrea Raso
Simone Raso
Niccolò Rastrelli
Stefano Rellandini
Andy Rocchelli
Renata Romagnoli
Filippo Romano
Alessio Romenzi
Italo Rondinella
Rocco Rorandelli
Anna Rosati
Max Rossi
Patrick Russo
Andrea Sabbadini
Marco Salustro
Luca Santese
Emanuele Satolli
Giuseppe Giulio Sboarina
Luca Scabbìa
Giorgio Scala
Matteo Scarpellini
Stefano Schirato
A. Maximilian Schroder
Massimo Sciacca
Federico Scoppa
Alessandro Scotti
Tobia Serotini
Sara Serpilli
Alessandro Serranò
Massimo Sestini
Luca Sgamellotti
Angelo Smaldore
Nicola Smaldore
Pietro Snider
Luca Sola
Aldo Soligno
Pasquale Sorrentino
Emanuele Spano
Mauro Spanu
Andrea Spinelli
Gaia Squarci
Francesco Stelitano

Alessandro Stellari
Fabrizio Stipari
Mario Taddeo
Daniele Tamagni
Christian Tasso
Luigi Tazzari
Antonio Tiso
Dario Tommaseo
Giulio Tonincelli
Francesca Tosarelli
Gianfranco Tripodo
Giovanni Troilo
Alessandro Trovati
Lorenzo Tugnoli
Serena Tulli
Nicola Ughi
Marco Vacca
Mattia Vacca
Giorgio Vacirca
Alida Vanni
Alessandro Veca
Filippo Venezia
Riccardo Venturi
Albert Verzone
Paolo Verzone
Francesca Vieceli
Alessandro Viganò
Francesco Vignozzi
Fabrizio Villa
Mauro Villone
Zoe Vincenti
Valerio Vincenzo
Roberto Vincitore
Theo Volpatti
Daniele Volpe
Antonio Zambardino
Filippo Zambon
Francesco Zanet
Barbara Zanon
Bruno Zanzottera
Adriana Zega
Antonia Zennaro
Francesco Zizola
Mattia Zoppellaro
Paola Zorzi
Vittorio Zunino Celotto

Jamaica

A Gilbert Bellamy
Norman Grindley
Bebeto Matthews
Ruddy Roye

Japan

Koji Aoki
Yasuyoshi Chiba
Shiho Fukada
Masaki Furumaya
Shinji Hamasaki
Toru Hanai
Chieko Hara
Koji Harada
Yusuke Harada
Tsutomu Hasegawa
Hayasaka Yosuke
Noriko Hayashi
Tetsuya Higashikawa
Teruaki Iida
Shinichi Iizuka
Itsuo Inouye
Kei Nagayoshi
Itoh Takashi
Yuki Iwanami
Shohei Izumi
Koichi Kamoshida
Yasushi Kanno
Yosuke
Keisuke Kato
Toshifumi Kitamura
Shigetaka Kodama
Koide Yohei
Dai Kurokawa
Junji Kurokawa
Ikuru Kuwajima
Shingo Kuzutani
Kota Kyogoku
Naoki Maeda
Hiroko Masuike
Tsuyoshi Matsumoto
Yuzo Uda
Minoru Matsutani
Fumiko Matsuyama
Dora
Miyazaki Makoto
Takuma Nakamura
Shiro Nishihata
Takashi Noguchi
Kazuma Obara
Takao Ochi
Kosuke Okahara

Naoya Osato
Q. Sakamaki
Hiroto Sekiguchi
Shuzo Shikano
Kazushige Shirahata
Akira Suemori
Ryuzo Suzuki
Takagi Tadatomo
Kuni Takahashi
Satoshi Takahashi
Tadao Takako
Noriko Takasugi
Atsushi Taketazu
Mika Tanimoto
Terazawa Masayuki
Koichiro Tezuka
Keigo Tsuruta
Umemura Naotsune
Kenichi Unaki
Ryoko Uyama
Daisuke Wada
Shin Yahiro
Tsuyoshi Yamamoto
Toru Yamanaka
Kazuhiko Yamashita
Hiroshi Yamauchi
Tomoko Yasuda
Toru Yokota
Kazuhiro Yokozeki

Jordan

Ammar Awad
Mohamed A.A. Salamah

Kazakhstan

Grigoriy Bedenko
Rizabek Issabekov
Karla Nur
Askar Shalmanov
Maxim Shatrov
Shamil Zhumatov

Kenya

Stephen Mudiari
Noor Khamis
Collins Kweyu
Mbugua
Thomas Mukoya
Norbert Allen Odhiambo
Boniface Okendo
Jennifer Muiruri

Kosovo

Jetmir Idrizi
Aljabak
Armend Nimani

Latvia

Arnis Balcus
Jānis Deinats
Tina Remiz
Reinis Hofmanis
Juris Kmins
Wilhelm Mikhailovsky
Maris Morkans
Edijs Palens
Sergej Samulenkov
Alnis Stakle

Lebanon

Toufic Beyhum
Joseph Eid
Mustapha Elakhal
Wael Hamzeh
Christina Malkoun
Hussein Malla
Haitham Moussawi
Natalie Naccache
Hasan Shaaban
Marwan Tahtah

Lithuania

Vidmantas Balkunas
Robertas Dackus
Ramunas Danisevicius
Vladimiras Ivanovas
Kazimieras Linkevičius
Rolandas Parafinavicius
Jonas Staselis
Romualdas Vaitkus

Luxembourg

Jean-Claude Ernst
Marc Schroeder

Macedonia

Tomislav Georgiev
Boban

Madagascar

Mamy Mael Raelisaona
Fidisoa Ram
Onja Andriniaina

Malawi

Bobby Kabango

Malaysia

Osman Adnan
Supian Ahmad
Aizuddin Saad
Ahmad Izzrafiq Alias
Muhamed Fathil Asri
Azman Ghani
Tan Chee Hon
Ted Chen
Wei Seng Chen
Eiffel Chong
Tim Chong
Victor
Chong Voon Chung
Stefen Chow
Lee Geok Cheng
Glenn Guan
Lai Seng Sin
Kylee
Kah Meng Lek
Kengyin
Jeffry Lim Chee Yong
Bazuki Muhammad
Pan Kah Vee
Samsul Said
Abd Rahman Saleh
Mazlan Samion
Lo Sook Mun
Art Chen
Sang Tan
Ian Teh
James Tseu Kui Jin
Andy Wong
FL Wong
Wong Liang Huei
Marcus Yam
Layzhoz Yeap

Maldives

Mohamed Abdulla Shafeeg

Malta

Darrin Zammit Lupi

Mauritius

George Michel

Mexico

Octavio Aburto
Alejandro Acosta
Daniel Aguilar
Orlando Alfaro Cañedo
Miguel A. Alvarado Blé
Guillermo Arias
Jerónimo Arteaga-Silva
Daniel Becerril
Arturo Bermúdez
Fernando Brito
Fer Carranza
Edson Caballero
Alejandro Cartagena
Ivan Castaneira
Periódico El Norte
Carlos Cazalis
Julieta Cervantes
Ray Chavez
Narciso Contreras
Julio Cortez
Juan Carlos Cruz
Rodrigo Cruz
G. D. De Huerta Patiño
Jorge Dueñes
Alex Espinosa
Carlos Ferrer
José Flores
Gerardo Flores
JoGoAvi
Monica Gonzales
Jose Carlo Gonzalez
Jose Luis Gonzalez
Hector Guerrero
Fernando Gutiérrez Juárez
Adrián Hernández
Gretta Hernández
David Jaramillo
Rodrigo Jardon
Carlos Jasso
Periodico Excelsior
Alejandro Juarez
Miguel Juarez Lugo
G. Arturo Limon D.
Angel Llamas

154

Raul Lodoza Sepulveda
Jorge Dan Lopez
Hector Lopez Ramirez
Eduardo Loza
Javier Manzano
Felix Marquez
Oscar Martínez
Imelda Medina
Eduardo Mejia
Victor Mendoza
Omar Meneses
Joel Merino
Gilberto Meza
Alberto Millares
David Morales
Arturo Moreno
Eduardo Murillo
Igor Nieto Joly
Francisco Ordaz
Mauricio Palos
Guillermo Perea
Margarito Perez Retana
Ernesto Ramírez
"Puma" Ramos García
Ivan Rendon
Alejandro Rivas
James Rodriguez
Cristopher Rogel
Adán Salvatierra Arreguín
Joel Sampayo Climaco
Oswaldo Ramirez
Francisco Santos Salazar
Enrique R. Serrato Frias
Walter Shintani
Jorge Silva
Diego Simón Sánchez
Christian Torres
Diego Uriarte Quezada
Víctor Hugo Valdivia
Enrique Villaseñor
Adam Wiseman
Antonio Zazueta Olmos
Luis Cortes

Moldova
Vadim Caftanat

Mongolia
Rentsendorj
B. Byamba Ochir
Davaanyam
Odbayar Urkhensuren

Morocco
Abdellah Azizi
Tabate Mohcine

Mozambique
Carlos Litulo

Myanmar
Hnin Tun
Thet Htoo
Minzayar
Sai Kham Lynn
Aung Pyae Soe
Ye Aung Thu
Soe Zeya Tun
Kyaw Win

Namibia
Karel Prinsloo

Nepal
Gemunu Amarasinghe
Bijaya Biju
Uma Bista
Navesh Chitrakar
Arjuma
Bikash Karki
Chandra Shekhar Karki
Prakash Mathema
Narendra Shrestha
Naresh Shrestha
Rohan Shumshere Thapa
Susheel Kumar Shrestha

The Netherlands
Serge Ligtenberg
Marijn Alders
Jaap Arriens
Iwan Baan
André Bakker
Marcel Bakker
Jan Banning
Amit Bar
Nico Bastens
Bram Belloni
Peter Blok
Jan Boeve

Theo Bosboom
Maarten Boswijk
Henk Bothof
Morad Bouchakour
Natasja Bouchakour
Rachel Corner
Roger Cremers
Chris de Bode
Henk de Boer
Anjo de Haan
Raymond de Haan
Bas de Meijer
Hanneke de Vries
Niels de Vries
Sander de Wilde
Allard de Witte
Annette Den Ouden
Chantal Ruisseau
Mathilde Dusol
Karoly Effenberger
Nienke Elenbaas
Fleurbaaij
Guus Geurts
Martijn van de Griendt
Sandra Hazenberg
Roderik Henderson
Piet Hermans
Maria Hermes
Thijs Heslenfeld
Erik Hijweege
Inge Hondebrink
Annemarie Hoogwoud
Rob Hornstra
Evelyne Jacq
Jeroen Jansen
Saad Jasim
Christien Jaspars
Marie-José Jongerius
Jasper Juinen
Ama Kaag
Paul Ketelaar
Chris Keulen
Arie Kievit
Theo Kingma
Ton Koene
Carla Kogelman
Olaf Kraak
Willem Kuijpers
Peter N. Lipton
Bas Losekoot
George Maas
Sander Nieuwenhuys
Ilvy Njiokiktjien
Mark Nozeman
Guy Offerman
Marco Okhuizen
Halil Ibrahim Özpamuk
Mardoe Painter
Mladen Pikulic
Willem Poelstra
Frans Poptie
Pavel Prokopchik
Martin Roemers
Ronny Roman Rozenberg
Raymond Rutting
Hans Sluijter
Corné Sparidaens
Friso Spoelstra
Sanne Steenbreker
Jan-Joseph Stok
Kick Stokvis
Tonny Strouken
Ruud Taal
Elsbeth Tijssen
Ruben Timman
Sven Torfinn
Frank Trimbos
Anne Marie Trovato
Monne
Robin Utrecht
Jan van Breda
David van Dam
Patrick van Dam
Anne van de Pals
Kees van de Veen
Mona van den Berg
Joost van den Broek
Bruno van den Elshout
A.M. van der Heijden
Lizette van der Kamp
Lucienne Van der Mijle
Ananda van der Pluijm
Catrinus van der Veen
Goos van der Veen
Marieke van der Velden
Marcel van der Vlugt
Jerry van der Weert
Klaas Jan van der Weij
Marten van Dijl
Rogér van Domburg

Eveline van Elk
Annie van Gemert
Joël van Houdt
Gé-Jan van Leeuwen
Kadir van Lohuizen
Steven van Noort
Erik van t Woud
Marielle van Uitert
Anoushka van Velzen
Eddy van Wessel
Peter van Zetten
Siese Veenstra
Peter Verdurmen
Anne-Marie Vermaat
Dirk-Jan Visser
Teun Voeten
Rob Voss
Gert Wagelaar
Arthur Wiegman
Emily Wiessner
Henk Wildschut
Aleksander Willemse
Sinaya Wolfert
Paolo Woods
Daimon Xanthopoulos
Xiaoxiao Xu

New Zealand
Scott Barbour
Greg Bowker
Michael Bradley
Jonathan Cameron
Robert Charles
Braden Fastier
Robin Hammond
Chris Hillock
Robert Jefferies
Hannah Johnston
Ruth McDowall
Iain McGregor
Mike Millett
Sandra Mu
Peter James Quinn
Martin de Ruyter
Dwayne Senior
Mark Taylor
Oliver Thompson

Nicaragua
Jorge Cabrera
Oswaldo Rivas
Diana Ulloa
Orlando Valenzuela

Nigeria
Sodiq Adelakun
Ademola Akinlabi
Kola
Akintunde Akinlaye
Sunday Alamba
Emmanuel Arewa
Collins Chukwuezi
Pius Utomi Ekpei
Jide Odukoya
Ray Daniels Okeugo
Muyiwa Osifuye
Emmanuel Osodi
Tife Owolabi
Ben Uwalaka

Norway
Jarle Aasland
Paul S. Amundsen
Odd Andersen
Paal Audestad
Jonas Bendiksen
Havard Bjelland
Stein Jarle Bjorge
Bjorn Steinar Delebekk
Kai Flatekvål
Andrea Gjestvang
Bente Haarstad
Johnny Haglund
Pal Christopher Hansen
Thomas Haugersveen
Pål Hermansen
Adrian Øhrn Johansen
Sigurd Fandango
Luca Kleve-Ruud
Ioannis Lelakis
Sindre Thoresen Lønnes
Ingun A. Maehlum
Kai-Otto Melau
Ole Morten Melgard
Javad M.Parsa
Peter Mydske
Eivind H. Natvig
Kristine Nyborg
Kim Nygård
Christopher Olssøn

Ken Opprann
John Terje Pedersen
Tine Poppe
Espen Rasmussen
Haavard Saeboe
Rune Saevig
Siv Johanne Seglem
Kristian Skeie
Otto von Münchow
Lars Idar Waage

Pakistan
Ameer Hamza
Irfan Ali
Abdul Baqi
Abdul Latif Choudhry
Zahid Hussein
Hasan Jamali
Mian Khursheed
Faisal Mahmood
Asim Ali Rana
Qazi Rauf
Mohsin Raza
Akhtar Soomro

Palestinian Territories
Alaa Badarneh
Laura Boushnak
Ahmed Deeb
Majed Hamden
Mahmud Hams
Adel Hana
Ahmed Jadallah
Majdi Mohammed
Hatem Moussa
Muhammed Muheisen
Ali Ali
Qais Abu Samra
Assam Rimawi
Sameh Rahmi
Mohammed Saber
Osama Silwadi
Mohammed Salem
Suhaib Salem
Ibraheem Abu Mustafa
Ahmed Zakot

Panama
Adriano Duff Leslie
Alexander Arosemena
Tito Herrera
Anselmo Mantovani
Essdras M Suarez

Peru
Eitan Abramovich
Pedro Acosta
Elmer Ayala
Mariana Bazo
Miguel A. Bellido Almeyda
Ernesto Benavides
Manuel Berrios
Max Cabello Orcasitas
Cesar Caceres M
Roberto Cáceres
Sebastian Castaneda
Nancy Chappell Voysest
Alessandro Currarino
Oscar Durand
Gladys Alvarado Jourde
Sebastián Enriquez
Esteban Felix
Carlos Garcia Granthon
Marco Garibay
David Huamaní
Silvia Izquierdo
Douglas Juárez
Franz Krajnik
Carlos Lezama
Luis Sergio
Ingrid Malpartida
Gary Manrique
Miguel Mejía Castro
Vanessa Montero
Musuk Nolte
Alberto Orbegoso
José Luis Quintana
Rodrigo Rodrich
Jhonel Rodríguez Robles
Leslie Searles
Daniel Silva
Manuel Milko
Gihan Tubbeh
Ian Tevo
Santiago Paul Vallejos Coral
Francisco Vigo

Philippines
Jes Aznar
Ted Aljibe

Jes Aznar
Mark Balmores
Richard Balonglong
Estan Cabigas
Noel Celis
Lance Cenar
Gigie Cruz
Victor Kintanar
Aaron Favila
Joel C. Forte
Joe Galvez
L. Guardian Escandor II
John Adrian Javellana
David Leprozo Jr.
Francis R. Malasig
Karlos Manlupig
Bullit Marquez
Mary Grace Montives
Cheryl Ravelo
Kriz John Rosales
Dennis Sabangan
Aaron Vicencio
Romeo V. Ranoco
Veejay Villafranca
Reynan Villena
Rem Zamora

Poland
Tomasz Adamowicz
Adameq
Michal Adamski
Peter Andrews
Piotr Augustyniak
Dorota Awiorko-Klimek
Pawel A. Bachanowski
Mateusz Baj
Andrzej Banas
Grzegorz Banaszak
Anna Bedyńska
Marek M. Berezowski
Krystian Bielatowicz
Piotr Bieniek
M. Billewicz
Andrzej B.
Witold Borkowski
Jan Brykczynski
Grzegorz Celejewski
K. A. Chądzyńska
Roman Chelmowski
Filip Cwik
Lukasz Cynalewski
Marek Czarnecki
Wiktor Dabkowicz
Maciej Dakowicz
Jacenty Dedek
Deko
Delmanowicz
Tomasz Desperak
Krystian Dobuszynski
Muniek
Tom Dulat
Aleksander Duraj
Piotr Fajfer
Ewa Figaszewska
Jadwiga Figula
Michal Fludra
Jacek Fota
Ania Freindorf
Pawel Frenczak
Dominik Gajda
Grzegorz Galezia
Jacek Gasiorowski
Arkadiusz Gola
Tomek Gola
Darek Golik
Szymon Górski
Adam Grabowski
Michal Grocholski
Marek Grzesiak
Tomasz Grzyb
Tomasz Gudzowaty
Rafal Guz
Michał Gwoździk
Khalil Hamra
Marzena Hmielewicz
Bartosz Hołoszkiewicz
Marcin Jamkowski
Ryszard Poprawski
Maciej Jawornicki
Jezierski
Maciej Jeziorek
Karolina Jonderko
Tygodnik Podhalanski
Maciej Kaczanowski
Marcin Kadziolka
Marcin Kalinski
Kuba Kaminski
Mariusz Kapala
Patryk Karbowski
Kasia Kasperska

Maja Kaszkur
Maciej Kielbowicz
Anna Klesse
Filip Klimaszewski
Tytus Kondracki
Koniarz
Luc Kordas
Tomasz Kordys
Michal Korta
Robert Kowalewski
Kacper Kowalski
Andrzej Kozioł
Damian Kramski
Piotr Krupa
Paweł Kubiak
Bartlomiej Kudowicz
Mikołaj Kuras
Adam Lach
Pawel Lączny
Marek Lapis
Arkadiusz Lawrywianiec
Tomasz Lazar
Damian Lemański
Luka Lukasiak
Aleksander Majdanski
Katarzyna Mala
Piotr Malecki
Marek Maliszewski
Rafal Malko
Marraf
Wojciech Matusik
Rafal Meszka
Slawomir Mielnik
Justyna Mielnikiewicz
Rafal Milach
Filip Modrzejewski
Grzegorz Momot
Yarrek
Piotr Dyba
Michał Mrozek
Grazyna Myslinska
Maciek Nabrdalik
Agnieszka Napierala
Pitor Naskrecki
Wojciech Nieśpiałowski
Borys Niespielak
Mikolaj Nowacki
Slawomir Olzacki
Zbigniew Osiowy
Wojciech Pacewicz
Tomasz Padlo
Krzysztof Patrycy
Kasia Pawlica
Mieczyslaw Pawlowicz
Luke Pienkowski
Radek Pietruszka
Jerzy Pinkas
Paweł Piotrowski
Robert Pipała
Piotr Piwowarski
Renata Pizanowska
Radek Polak
Prusak
Artur Radecki
Magda Rakita
Agnieszka Rayss
Piotr Redinski
Jarosław Respondek
Maksymilian Rigamonti
Norbert Roztocki
Mateusz Sarello
Bartosz Sawicki
Michał Sita
Bart Skowron
Mateusz Skwarczek
Lukasz Sokol
Michal Solarski
Maciej Stanik
Bartosz Stróżyński
Mikolaj Suchan
Przemek Swiderski
Jacek Świerczyński
Michal Szlaga
Natalia Szulc
JSzust
Tomasz Szustek
Ilona Szwarc
Dawid Tatarkiewicz
Tomasz Tomaszewski
Łukasz Trzeszczkowski
Jacekt Turczyk
Przemek Walocha
Jacek Waszkiewicz
Grzegorz Wełnicki
Zdzislaw Wichlacz
Tomasz Wiech
Piotr Wittman
Julia Wizowska
Swiatoslaw Wojtkowiak
Bartek Wrzesniowski

Julia Zabrodzka
Szarack
Marek Zakrzewski
Filip Zawada
Grzegorz Ziemianski
Tomasz Ziober

Portugal
Rodrigo Cabrita
Schwantz
Graça Bialojan
Hugo Correia
Ana Brígida
José Carlos Carvalho
Paulo Alexandre Coelho
Bruno Colaço
Paulo Cordeiro
Mário Cruz
Pedro Pink
Nuno Guimaraes
Rui Duarte Silva
Pedro Elias
Rui Farinha
Marcos Fernandes
Joel Santos
Pedro Fiúza
José Carlos Marques
Nuno Jorge
Sérgio Lemos
Nuno Lobito
Artur Machado
Carlo Martins
Luis Melo
Pedro Nunes
Paulo Nunes dos Santos
Rui M. Oliveira
Carlos Palma
Octávio Passos
Paulo Pimenta
João Pina
Ines Querido
João Manuel Ribeiro
Daniel Rodrigues
N. A. Rodrigues Garrido
Hugo Santos
Pedro A. Neto
Paulo Escoto
Alexandre Simoes
Bruno Simões Castanheira
Gonçalo Lobo Pinheiro
Marcos Sobral
Joaquim Dâmaso
Raquel Wise

Romania
Mihai Barbu
Petrut Calinescu
Lucian Calugarescu
Ioana Cîrlig
Razvan Ciuca
Tal Cohen
Bogdan Cristel
Marcella Dragan
Octav Ganea
Robert Ghement
Vadim Ghirda
Raed Krishan
Dragos Lumpan
Liviu Maftei
Matei Silviu
Nagy Melinda
Ioana Moldovan
Radu Neag
Octavian Cocolos
Adelin Petrisor
Andrei Pungovschi
Sebastian Sascau
Radu Sigheti
Dragos Savu
Cristian Tzecu
Alex Tomazatos
Vakarcs Lorand
Mugur Varzariu
Mihai Vasile

Russia
Akelyeva Anna
Alexander Aksakov
Andrey Lyzhenkov
Andrey Arkhipov
Kirill Arsenjev
Alexandre Astafiev
Dmitry Azarov
TB
Dmitry Berkut
Natalia Berkutova
Yan Bogomolov
Alexei Boitsov
Julia Borovikova
Viktor Borovskikh

Victor Borzih
Mark Boyarsky
Viacheslav Buharev
Alexey Bushov
Alexandra Bushova
Den Butin
Andrei Chepakin
Alexander Chernavsky
Yuriy Chichkov
Igor Churakoff
Alexey Danilov
Davidyuk Alexander
Alexander Demianchuk
Konstantin Dikovsky
Misha Domozhilov
Grigory Dukor
Vadim Elistratov
Evgenyi Epanchintsev
Ilya Epishkin
Alexander Fedorenko
V. Fedorenko
Vadim Fefilov
Feldmanyana
Filippov Alexey
Vladimir Finogenov
Sergey Gagauzov
Pavel Golovkin
Grigory Golyshev
Sergey Grachev
Mikhail Grebenshchikov
Andrey Grebnev
Yuri Gripas
Solmaz Guseynova
Tatiana Ilina
Vitaliy Illarionov
Sergei Ilnitsky
Vasily Ilyinsky
Yuri Ivaschenko
Victoria Ivleva
Misha Japaridze
Yuri Kadobnov
Igor Kalashnikov
Sergey Karpov
Vyacheslav Kasyanov
Kaufman
Viner Khafizov
Gulnara Khamatova
Kirill Kudryavtsev
Sergei Kivrin
Denis Kojevnikov
Natalia Kolesnikova
Alexey Kompaniychenko
Sergey A. Kompaniychenko
Yevgeny Kondakov
Alex Kondratyk
Artemy Kostrov
Dmitry Kostyukov
Ludmila Kovaleva
Yuri Kozyrev
Olga Kravets
Alex Kudenko
Maria Kulkova
Alexey Kunilov
Marianna Baumstein
Sergei L. Loiko
Lagunov
Vladimir Lamzin
Oleg Lastochkin
Kirill Lebedev
Sergey
D. Linnikov
Julia Lisnyak
Andrey Luft
Lookianov
Lukin Andrey
Ivova Natalia
Nataliya Makarenko
Olga Makarova
Marina Makovetskaya
Vasily Maksimov
Igor Maleev
Maxim Marmur
Martynov
Alexey Mayshev
Vladimir Melnik
Valery Melnikov
Mikhail Metzel
Sergey Mikheyev
V. Mitrokhin
Sayana Mongush
Victoria Morozova
Gayla Morrell
Boris Mukhamedzyanov
Anton Mukhametchin
Alexander Nemenov
Arseniy Neskhodimov
Andrey Nikolskiy
Kirill Ovchinnikov
Mitya Aleshkovsky
Valentinas Pecininas

Vladimir Pesnya
Alexander Petrosyan
Alexander Petrov
Sergey Petrov
Ilya Pitalev
Maria Pleshkova
Maria Plotnikova
Tatiana Plotnikova
Svetlana Pojarskaya
Alexandr Polyakov
Vova Pomortzeff
Sergey Ponomarev
Dmitry Potapov
Sergei Poteryaev
Pronin Andrei
Boris Register
Jana Romanova
AnaStasia Rudenko
Sergei Sablin
Salavat Safiullin
Konstantin Salomatin
Vitaly Savelyev
Fyodor Savintsev
Pavel 'PaaLadin' Semenov
Vladimir Syomin
Anna Sergeeva
Sergey Shchekotov
Sergey Shcherbakov
Maxim Shipenkov
Vyacheslav Shishkoedov
Velikoretsky Procession
Vladimir Shutafedov
Mikhail Sinitsyn
Denis Sinyakov
Sitdikov Ramil
Vlad Sokhin
Andrey Stenin
Alexander Stepanenko
Yuriy Strelets
Julia Sundukova
Ekaterina Sychkova
Katya Sytnik
Kate Taraskina
Fyodor Telkov
Andrey Tkachenko
Anastasia Tsayder
Anton Tushin
Yuri Tutov
Anton Unitsyn
Aleksandr Ustinov
Alexander Utkin
Pavel Vasilyev
Sergey Pyatakov
Sergey Vdovin
Vladimir Velengurin
Sergei Venyavsky
Aleksandr Verevkin
Sergei Vinogradov
Vladimir Vyatkin
Vyshinskiy Denis
Yartsev Dimitry
Oksana Yushko
Jegor Zaika
Konstantin Zavrazhin
Alexander Zemlianichenko
A. Zemlianichenko Jr
Anatoly Zhdanov
Artem Zhitenev
Zmeyev Maksim
Dima Zverev

Saints Kitts and Nevis
Wayne Lawrence

Saudi Arabia
Mona Zubair

Senegal
Awa Mbaye
Djibril Sy
Mamadou Touré

Serbia
Sasha Colic
Sergei Grits
Andrija Ilic
Sanja Jovanovic
Nemanja Pancic
Marko Risović
Marko Rupena
Srdjan Suki
Goran Tomasevic
Tamás Tóth

Singapore
Suhaimi Abdullah
Ooi Boon Keong
Alphonsus Chern
Chua Chin Hon
Betty WanTing Chua

Shawn Danker
Joyce Fang
Ernest Goh
Gary Goh
Hwee Young How
Zann Huizhen Huang
Edwin Koo
Desmond Lim
Kevin Lim
Low Kai Seng Patrick
Deanna Ng
Mugilan Rajasegeran
Seah Kwang Peng
Sim Chi Yin
Chih Wey Then
Desmond Wee Teck Yew
Woo Fook Leong
Jonathan Yeap

Slovakia
Martin Bandzak
Jozef Barinka
Victor Breiner
Gabriela Bulisova
Zuzana Halanova
Maros Herc
Peter Korcek
Daniel Laurinc
Vladimir Simicek
Vaculikova Silvia
Matus Zajac

Slovenia
Luka Cjuha
Luka Dakskobler
Jošt Franko
Maja Hitij
Matjaz Kacicnik
Matej Povse
Blaz Samec
Samo Vidic
Tomaž Zajelšnik
Tadej Znidarcic
Matic Zorman
Simen Zupancic

South Africa
Courtney Africa
Bonile Bam
Michel Bega
Daniel Born
Rodger Bosch
Ruvan Boshoff
Nic Bothma
Jennifer Bruce
Shelley Christians
Melanie Cleary
Wayne Conradie
Morne de Klerk
Adrian de Kock
Antoine de Ras
Jacques de Vos
Felix Dlangamandla
Duif du Toit
Alan Eason
Leon Lestrade
Brett Eloff
Brenton Geach
Gary Hirson
Pieter Hugo
Nigel Sibanda Jabu
Phandulwazi Jikelo
Matthew Jordaan
Sue Kramer
Halden Krog
David Larsen
Ayi Leshabane
Stephanie Lloyd
Lungelo Mbulwana
Neil McCartney
Gideon Mendel
Joy Meyer
Refilwe Modise
Christine Nesbitt
Craig Nieuwenhuizen
Oupa Nkosi
James Oatway
Raymond Preston
Alet Pretorius
Nelius Rademan
Leon Sadiki
Mujahid Safodien
Chris Saunders
Damien Schumann
Roger Sedres
Sydney Seshibedi
Marc Shoul
Siphiwe Sibeko
Alon Skuy
Chris Stamatiou

Brent Stirton
Giordano Stolley
Kevin Sutherland
Caroline Suzman
Paballo Thekiso
Cornél van Heerden
Schalk van Zuydam
Herman Verwey
Deaan Vivier
Mark Wessels

South Korea
Woohae Cho
Young Ho Cho
Hyungrak Choi
Han Myung-Gu
Hae-in Hong
Kim Jae-Hwan
Jeon Heon-Kyun
Lee Jin-man
Youngho Kang
Hyunsoo Leo Kim
Jinha Kim
Kim Hong-ji
Kish Kim
Kyung-Hoon Kim
Truth Leem
Daniel Sangjib Min
Haseon Park
Park Jong-Keun
Park Min Hyeok
Park Mo
Park Soo Hyun
Shin InSeop
Yoo Beylnam

Spain
Laia Abril
Maysun
Ivan Aguinaga
Oriol Alamany
Blanca Aldanondo
Eloy Alonso
Benito Pajares
Juanfra Alvarez
Manel Antoli
Samuel Aranda
Celestino Arce
Javier Arcenillas
Xoan A. Soler
Bernat Armangue
Rafael Arocha
Arnau Bach
Joan Manuel Baliellas
Carlos Barajas
JC Barberá
Raúl Barbero Carmena
Gabriel Barceló
Pau Barrena
Barrenechea
Consuelo Bautista
Edu Bayer
Pablo Blazquez
Jordi Boixareu
Pep Bonet
Albert Bonsfills
Jordi Borràs
Manu Brabo
Jordi Busque
Jordi Busquets Nuell
Albert Busquets Plaja
Germán Caballero
Biel Calderon
Alfredo Cáliz
Enrique Calvo
Nano Calvo
Olmo Calvo
Jordi Camí
Salva Campillo
Santi Carneri
Felipe Carnotto
Andres Carrasco Ragel
Ricardo Cases
Cristobal Castro
Arantxa Cedillo
José Cendón
Guillermo Cervera
Xavier Cervera
Txomin Txueka
Dani Codina
Jordi Cohen
Pau Coll
Jose Colon
Ramon Costa
Jose Cruces
Gustavo Cuevas
David de la Cruz
Jose Luis Cuesta
Victor Lafuente
Jose de Lamadrid

Francisco de las Heras
Marcelo del Pozo
Oscar del Pozo
Alvaro Deprit
Alberto Di Lolli
E.D. de San Bernardo
Quico Garcia
Nacho Doce
Daniel Duart
Rosmi Duaso
Ramon Espinosa
Patricia Esteve
Alberto Estévez
Rafa Estévez
Javier Etxezarreta
Rafael S. Fabrés
Alvaro Felgueroso Lobo
Erasmo Fenoy Nuñez
Claudio de la Cal
David Fernández Moreno
Javier Fdez-Largo
Carlos Folgoso
Ramon Fornell
Jon Nazca
Carlos Garcia
Alvaro Garcia
Albert Garcia
Zacarias Garcia
Xoan García Huguet
Rodrigo Garcia
Àngel García
Ricardo Garcia Vilanova
Héctor Garrido
Juli Garzon
Eugeni Gay Marín
Albert Gea
Ignacio Gil
Susana Girón
Rafa Arjones
Joaquin Gomez Sastre
M. Gonzalez-Luumkab
Pedro Armestre
César Sánchez
Cesar Górriz
Daniel Gramage
Juanjo Guillen
Jose S. Gutiérrez
Jesus Gutierrez
Jose Haro
Antonio Heredia
Nacho Hernandez
José Ángel Hernández
Juan Herrero
Diego Ibarra
Alberto Iranzo
Ricardo Castiñeira
Álvaro Laiz
Aitor Lara
Emilio Lavandeira Villar
Daniel Leal-Olivas
Jana Leo
Laura Leon
Sebastian Liste
Jorge López Barredo
Antonio Lopez Diaz
J. M. Lopez
Ángel López Soto
Núria López Torres
Javier Luengo
Carlos Luján
Cesar Manso
Hermes Maragall
Rafael Marchante
Fernando Marcos Ibanez
Eduardo Margareto
Xurde Margaride
Francisco Márquez
Aníbal Martel
Uly Martin
Jacobo Medrano
Francisco Mingorance
Álvaro Minguito
Fernando Moleres
Àngel Monlleó
Carla Moral
Alfonso Moral Rodriguez
Freya Morales
Emilio Morenatti
Marcos Moreno
C. Moreno de Acevedo
Janire Najera
Angel Navarrete
Guillermo Navarro
Eduardo Nave
Matias Nieto
Daniel Ochoa de Olza
David Oliete Casanova
Xaume Olleros
Oscar Palomares
Vicente Paredes

Alberto Paredes
Xavier P. Moure
Yolanda Peláez
Juan Pelegrín
Antonio Pérez
Sergio Perez
Maria Pisaca
Jordi Pizarro
Alberto Pla
Edu Ponces
Elisenda Pons
Alberto Prieto
David Ramos
Markel Redondo Larrea
Eli Regueira
David Rengel
Pau Rigol
Eduardo Ripoll
Rafa Rivas
Selvua
Àngel Rivas Hernández
Txema Rodríguez
Alfons Rodriguez
Arturo Rodríguez
Alberto Rojas
Javier Roldan
Abel F. Ros
Pepe Rubio Larrauri
A. Ruiz de Leon Trespando
Luis Miguel Ruiz Gordón
Susanna Sáez
Mireia Salgado
Lluís Salvadó
Txema Salvans
Moises Saman
Ralph Schneider
Samuel Sánchez
Jesús Signes
Álvaro Sánchez-Montañés
Edu Sanz
Lourdes Segade
Oriol Segon Torra
Ramon Serra
Juan Manuel Serrano Arce
Cristobal Serrano
Miguel Sierra
Jose Silveira
David Simon Martret
Gabri Solera
Tino Soriano
Carlos Spottorno
Victor Tabernero
Llibert Teixidó
Gabriel Tizón
José A. Torres
Maria Torres-Solanot
Enrique Truchuelo Ramirez
Felipe Trueba
Francis Tsang
Raúl Urbina
Juan Valbuena Carabaña
Manu Valcarce
Guillem Valle
Lucas Vallecillos
Joan Valls
Susana Vera
Diego Vergés
Jaime Villanueva
Enric Vives-Rubio
Alvaro Ybarra Zavala
Valentí Zapater
Alejandro Zerolo

Sri Lanka
Buddhika Weerasinghe

Sudan
Md. Nureldin Abdallah

Surinam
Ranu Abhelakh
Roy Ritfeld

Sweden
Annika af Klercker
Christian Andersson
Urban Andersson
Henry Arvidsson
Johan Bävman
Lars Brundin
Henrik Brunnsgård
Jimmy Croona
Lars Dareberg
Carl de Souza
Izabella Demavlys
Martin Edström
Daniel Ekbladh
Hussein El-Alawi
Linda Eliasson
Åke Ericson

Jonas Eriksson
Malin Fezehai
Jan Fleischmann
Anders Forngren
Linda Forsell
Jesper Frisk
Fredrik Funck
Jessica Gow
Lena Gunnarsson
Anders G Warne
Niklas Hallen
Niclas Hammarström
Paul Hansen
Anders Hansson
Anton Hedberg
Casper Hedberg
Johanna Henriksson
Robert Henriksson
Christoffer Hjalmarsson
Peter Holgersson
Hook Pontus
Nils Jakobsson
Jarlbro
Ann Johansson
Mattias Johansson
Viktor Johansson Fremling
Moa Karlberg
Jesper Klemedsson
Pavel Koubek
Ingemar D. Kristiansen
Niklas Larsson
Roger Larsson
Jonas Lindkvist
Lars Lindqvist
Alex Ljungdahl
Staffan Löwstedt
Johan Lundahl
Victor Lundberg
Carolina Makkula
Emil Malmborg
Chris Maluszynski
Markus Marcetic
Joel Marklund
Paul Mattsson
Karl Melander
Linus Meyer
Jack Mikrut
Johanna Wallin
Henrik Montgomery
Karim Mostafa
Anette Nantell
Christina Nilsson
Daniel Nilsson
Nils Petter Nilsson
Thomas Nilsson
Loulou d'Aki
Axel Oberg
Malin Palm
Fredrik Persson
Johan Persson
Per-Anders Pettersson
Lennart Rehnman
Håkan Röjder
Torbjörn Selander
Anna Simonsson
Sjöström
Sanna Sjosward
Patrick Sörquist
Vilhelm Stokstad
Sara Strandlund
Linus Sundahl-Djerf
Michael Svensson
Pieter Ten Hoopen
Pontus Tideman
Ola Torkelsson
Ann Tornkvist
Lars Tunbjörk
Roger Turesson
Martin von Krogh
Anna Wahlgren
Joachim Wall
Tom Wall
Magnus Wennman
Asa Westerlund
Jacob Zocherman

Switzerland
Niels Ackermann
Zalmaï
Reto Albertalli
Allenspach Olivier
Sébastien Anex
Daniel Auf der Mauer
Denis Balibouse
Franco Banfi
Fabian Biasio
Michael Buholzer
Laurent Burst
Sarah Carp
Mischa Christen

Fabrice Coffrini
Régis Colombo
Alessandro Della Bella
Philippe Dudouit
Sibylle Feucht
Andreas Frossard
Daisy Gilardini
Laurent Gilliéron
Francesco Girardi
Anina Gmür
Marco Grob
Reza Khatir
Patrick B. Kraemer
Pascal Lauener
Jacqueline Meier
Pascal Mora
Dominic Nahr
Jacek Piotr Pulawski
Nicola Pitaro
Jean Revillard
Nicolas Righetti
Michel Roggo
Didier Ruef
Meinrad Schade
Beat Schweizer
Andreas Seibert
Scott Typaldos
O Vogelsang
Laurence von der Weid
Michael von Graffenried
Stefan Wermuth
Luca Zanetti
Luca Zanier
Matthieu Zellweger
Michaël Zumstein

Syria
Ammar Abd Rabbo
Carole AlFarah
Thanaa Arnaout
Nouh Hammami
Ali Jarekji
Nour Kelzi
Hisham Zaweet

Taiwan
Keye Chang
Simon Chang
Chen Zhen-Tang
Nana Chen
Jen-Nan Cheng
Chi Chih-Hsiang
Pichi Chuang
Chien-Min Chung
Andy Duann
Fang Chun Che
Tzuming Huang
Wei-Sheng Huang
Chuang-Kun-Ju
Pinyuan.Kao
Lingxuemin
Tzu Cheng Liu
Ma Li Chun
Wu Po-Yuan
Shen Chao-Liang
Tsai Hsien-Kou

Thailand
Piti A Sahakorn
Nod Buranasiri
Songwut In-Em
Pornchai Kittiwongsakul
Sakchai Lalit
Ohm Phanphiroj
Ekkarat Punyatara
Ornin Ruang
Natis S.
Piyavit Thongsa-Ard

Trinidad and Tobago
Andrea de Silva

Tunisia
Ons Abid
Marouen Arras
Sophia Baraket
Emir Ben Ayed
Med Amine Ben Aziza
Hamideddine Bouali
Chehine Dhahak
Wassim Ghozlani
Selim Harbi
Kimo
Amine Landoulsi

Turkey
Ali Atmaca
Özgür Ayaydın
Mahmut Bunyami Aygun
Anıl Bağrık

Umit Bektas
Ö. Bilgin
Necdet Canaran
Aydin Çetinbostanoglu
Onur Çoban
Serkan Çolak
Şebnem Coşkun
Kutup Dalgakiran
Bulent Doruk
Pari Dukovic
Salih Zeki Fazlıoğlu
Sinan Gul
Sait Serkan Gurbuz
Emrah Gurel
Ali Güreli
Veli Gürgah
Mühenna Kahveci
Mehmet Kaman
Bulent Kilic
Ertugrul Kilic
Dilek Mermer
Ozan Emre Oktay
Kerim Okten
Osman Orsal
Mali
Kayhan Ozer
Okan Ozer
Emin Özmen
Aajihsan
Mehmet Ali Poyraz
Murat Saka
Murat Sengul
Murad Sezer
Isa Simsek
Selahattin Sönmez
Ali Ünal
Aykut Unlupinar
Ömer Ürer
Ilhami

Uganda
Edyegu Daniel Enwaku
Edward Echwalu
Nsubuga Michael

Ukraine
Arthur Bondar
Covalyov Vladimir
Sergei Dolzhenko
Maxim Dondyuk
Yuriy Dyachyshyn
Gleb Garanich
Kirill Golovchenko
Havka Mykola
Alexander Kharvat
Oleksandr Klymenko
Igor Kryvonos
Andriy Lomakin
Efrem Lukatsky
Oleg Nikitenko
Kadnikov Oleksandr
Mykhaylo Palinchak
Alex Portniagin
Stepan Rudik
Tetiana Shcheglova
Anatolii Spytsia
Anatoliy Stepanov
Mila Teshaieva
Volodymyr Tverdokhlib
Ivan Tykhy
Roman Vilenskiy
Anna Voitenko
Petro Zadorozhnyy

United Kingdom
Roderick Aichinger
Ed Alcock
Esme Allen
Julian Andrews
Cedric Arnold
Marc Aspland
Stewart Attwood
Thomas Ball
Nick Ballon
Jane Barlow
Craig Barritt
Alison Baskerville
Emily Bates
Guy Bell
Brendan Bishop
Harry Borden
Tom Bourdon
Andrew Boyers
Kayte Brimacombe
Adrian Brown
Simon Brown
Clive Brunskill
Jason Bryant
Tessa Bunney
Will Burrard-Lucas

Jason Larkin
Geoff Caddick
Gary Calton
Piers Calvert
André Camara
Lynne Cameron
Richard Cannon
Brian Cassey
Peter Caton
David Chancellor
Dean Chapman
Dan Charity
Matthew Chattle
William Cherry
Wattie Cheung
Musa Chowdhury
D.J. Clark
CJ Clarke
Garry Clarkson
Anthony Collins
Michael Conroy
Rebecca Conway
Christian Cooksey
Jonathan M. Coombs
Gareth Copley
Dave Couldwell
Damon Coulter
Carl Court
Georgina Cranston
Alan Crowhurst
Colin Crowley
Simon Dack
Nick Danziger
Prodeepta Das
Adam Dean
Venetia Dearden
Peter Dench
Adrian Dennis
Chloe Dewe Mathews
Jackie Dewe Mathews
Alex Dias
Francis Dias
Nigel Dickinson
Kieran Dodds
Liz Drake
Luke Duggleby
Giles Duley
Matt Dunham
Nic Dunlop
Jillian Edelstein
Patrick Eden
Mike Egerton
Neville Elder
Marc Ellison
Stuart Emmerson
Drew Farrell
Sally Fear
Tristan Fewings
Anna Filipova
Rick Findler
Julian Finney
Jason Florio
Stuart Forster
Ian Forsyth
Andrew Fosker
Andrew Fox
Peter J. Fox
Stuart Freedman
Clive Frost
James Robert Fuller
Christopher Furlong
Robert Gallagher
Sean Gallagher
Nick Gammon
Andrew Garbutt
Stephen Garnett
Sophie Gerrard
David Gibson
John Giles
James Glossop
Martin Godwin
Jonathan Goldberg
David Graham
Charlie Gray
Johnny Green
Laurence Griffiths
Andy Hall
Benjamin Hall
Neil Hall
Rosie Hallam
Johan Hallberg-Campbell
Sara Hannant
Paul Harding
Brian Harris
Olivia Harris
Richard Heathcote
Mark Henley
Mike Hewitt
Jack Hill
Paul Hilton

Liz Hingley
Jim Hodson
David Hoffman
Alex Hofford
Katherine Holt
Andrew Hone
Andy Hooper
Rip Hopkins
Mike Hutchings
Jonathan Hyams
Caroline Irby
Chris Jackson
Thabo Jaiyesimi
Vicki Couchman
Tom Jenkins
Justin Jin
Ed Jones
Tobin Jones
Nadav Kander
Sonal Kantaria
Eddie Keogh
Mike King
Ian Kington
Ross Kinnaird
Dan Kitwood
Colin Lane
Kalpesh Lathigra
Mark Leech
Alex Livesey
Ian Longthorne
Lucy Ray
Amy Lyne
Peter Macdiarmid
Luke Macgregor
Ian MacNicol
David Maitland
Christopher Manson
Guy Martin
Dylan Martinez
Leo Mason
Jenny Matthews
Stuart Matthews
David Mbiyu
Duncan McKenzie
Toby Melville
Kois Miah
Graham Miller
Jeff Mitchell
Siegfried Modola
Bora Shamlo
Jeff Moore
Phil Moore
James Morgan
Eddie Mulholland
Leon Neal
Simon Needham
Zed Nelson
Lucy Nicholson
Phil Noble
Ayman Oghanna
Charles Ommanney
Jeff Overs
Mark Pain
Laura Pannack
Mark Esper
Andrew Parkinson
James Mackay
Adam Patterson
Ben Stansall
John Perkins
Marcus Perkins
Robert Perry
Kate Peters
Tom Pilston
Louis Quail
Andy Rain
Simon Rawles
Darran Rees
James Robertson
Stuart Robinson
Will Robson-Scott
Nigel Roddis
Tom Ross
Anita Russo
Ian Rutherford
Jeff Gilbert
David Sandison
Oli Scarff
Michael Schofield
Matt Scott-Joynt
Mark Seager
Sharron Lovell
David Shopland
John Sibley
Jamie Simpson
Guy Smallman
Paul Smith
Toby Smith
Zute Lightfoot
Simon Stacpoole

Craig Stennett
Jane Stockdale
Tom Stoddart
Rob Stothard
Chris Stowers
Graham Stuart
Andrew S.T. Wong
Jeremy Sutton-Hibbert
Justin Tallis
Jason Tanner
Sam Tarling
Paul Taylor
Edmond Terakopian
Andrew Testa
Ed Thompson
Hazel Thompson
Lee Thompson
Abbie Trayler-Smith
Tommy Trenchard
Amelia Troubridge
Mary Turner
Mike Urwin
David Vintiner
Robert Wallis
Barrie Watts
William Webster
Kirsty Wigglesworth
Jonathon Williams
Thomas Williams
James Williamson
Andrew Winning
Will Wintercross
Kris Wood
Oliver Woods
Alexander Yallop
Chris Young

United States
R. Umar Abbasi
Mustafah Abdulaziz
Jenn Ackerman
Nick Adams
Lynsey Addario
Lola Akinmade
Åkerström
Micah Albert
Carol Allen Storey
Joe Amon
Holly Andres
Jason Andrew
Bryan Anselm
Michael Appleton
J. Scott Applewhite
Charles Rex Arbogast
Roger Arnold
Jonathan Lucas Auch
Frank Augstein
Asca S.R. Aull
Andrew Spear
Erik Hill
Peter Blakely
Bill Bangham
Michael Barkin
Richard Barnes
Rebecca Barnett
Tina Barney
Don Bartletti
Will Baxter
Paul Beaty
Robert Beck
Robyn Beck
Al Bello
Bruce Bennett
Randall Benton
Nina Berman
Alan Berner
Aluka Berry
Keith Birmingham
Matt Black
Rebecca Blackwell
Craig Blankenhorn
Gregg Bleakney
Victor J. Blue
Antonio Bolfo
Lance Booth
Mark Boster
Bie Bostrom
Samantha Box
Torin Boyd
Anna Boyiazis
Brandon Magnus-Ledesma
M. Scott Brauer
John Brecher
David Briggs
Daniel C. Britt
David Friedman
Paula Bronstein
Kate Brooks
Gerry Broome

Everett Kennedy Brown
Michael Christopher Brown
Milbert O. Brown Jr.
Andrea Bruce
Simon Bruty
Joe Buglewicz
Gregory Bull
Joe Burbank
David Burnett
Andrew Burton
David Butow
Renée Byer
Yoon S. Byun
Mary Calvert
Steve Camargo
Gary A. Cameron
Zackary Canepari
Christopher Capozziello
Ricky Carioti
Chris Carlson
Lauren Carroll
K.C. Alfred
Seth Casteel
John Castillo
Radhika Chalasani
Bruce Chapman
Jahi Chikwendiu
Barry Chin
Michael Chow
Trevor Christensen
Andre Chung
Daniel Cima
Elizabeth M. Claffey
Giles Clarke
Jay Clendenin
Victor Cobo
Nadia Shira Cohen
James Colburn
Jed Conklin
Fred R. Conrad
Greg Constantine
David Cooper
Thomas Cordova
Ron Cortes
Cotton Coulson
Andrew Craft
Bob Croslin
Scott Dalton
Keith Dannemiller
Dennis Carlyle Darling
Linda Davidson
Autumn De WIlde
Sam Dean
David Degner
James Whitlow Delano
Bryan Denton
Bryan Derballa
Julie Dermansky
Charles Dharapak
Peter DiCampo
Andrew Dickinson
Kevork Djansezian
Mark Dolan
Olivier Douliery
Travis Dove
Michael Downey
Carolyn Drake
Daniel Dreifuss
Richard Drew
Brian Driscoll
Jeanna Duerscherl
James Lawler Duggan
Cody Duty
Michael Dwyer
Aristide Economopoulos
Matt Eich
Sean D. Elliot
Sarah Elliott
Mitch Epstein
Ronald Erdrich
David Eulitt
Craig F. Walker
Timothy Fadek
Katie Falkenberg
Gina Ferazzi
Stephen Ferry
Brian Finke
Lauren Fleishman
Kate Flock
Charles Fox
Frank Franklin II
Kevin Frayer
Sarah Fretwell
Gary Friedman
Misha Friedman
Rick Friedman
Preston Gannaway
Francis Gardler
Elie Gardner
Mark Garfinkel

Morry Gash
Robert Gauthier
Jim Gehrz
Dave Getzschman
Haraz N. Ghanbari
Danny Ghitis
David Gilkey
Thomas E. Gilpin
Melissa Golden
David Goldman
Andrew Gombert
Glenna Gordon
Chet Gordon
Jeff Goulding
Michael Graae
Kyle Green
Bill Greene
Stanley Greene
Lauren Greenfield
Mike Groll
Tim Gruber
Roberto (Bear) Guerra
Barry Gutierrez
David Guttenfelder
Bob Hallinen
Paul Reese
Johnny Hanson
Michael Hanson
Peter Hapak
Mark Edward Harris
Genevieve Hathaway
Todd Heisler
Sean Hemmerle
Mark Henle
Ryan Henriksen
Elizabeth D. Herman
Andrew Hida
Oscar Hidalgo
Jessica Hill
Ed Hille
Brendan Hoffman
Jeremy Hogan
Andrew Holbrooke
Jim Hollander
Jonathan Hollingsworth
Derik Holtmann
Mark Holtzman
Alexandra Hootnick
Sarah Hoskins
Aaron Huey
Sandy Huffaker
Boza Ivanovic
Lester J. Millman
Lucas Jackson
Jed Jacobsohn
Julie Jacobson
Samuel James
Jay Janner
Janet Jarman
Jay Westcott
Shannon Jensen
Sara Jerving
Marvin Fredrick Joseph
Allison Joyce
Joni Kabana
Joseph Kaczmarek
Greg Kahn
Nikki Kahn
Hyungwon Kang
Anthony Karen
Ed Kashi
Ivan Kashinsky
Carolyn Kaster
Stephanie Keith
James Keivom
Casey Kelbaugh
Deborah Keller
Andrew Russell
James H. Kenney Jr.
Mike Kepka
Laurence Kesterson
Natalie Keyssar
Pete Kiehart
Yunghi Kim
John Kimmich-Javier
T.J. Kirkpatrick
Paul Kitagaki Jr
Stephanie Klein-Davis
Heinz Kluetmeier
Meridith Kohut
Brooks Kraft
Abby Kraftowitz
Lisa Krantz
Suzanne Kreiter
Elizabeth Kreutz
Andy Kropa
Amelia Kunhardt
Jack Kurtz
Kevin Lamarque
Rod Lamkey

Wendy Sue Lamm
Justin Lane
Keith Lane
Jerry Lara
Adrees Latif
Gillian Laub
David Lauer Read
Luis Sinco
Neil Leifer
Mark Lennihan
Mark Leong
Marc Lester
Heidi Levine
Andrew Lichtenstein
Ariana Lindquist
Chip Litherland
Dina Litovsky
Jim Lo Scalzo
Jeremy Lock
Saul Loeb
Rick Loomis
Delcia Lopez
Kevin Lorenzi
Jon Lowenstein
Benjamin Lowy
Robin Loznak
Kirsten Luce
Max Becherer
Patsy Lynch
Melissa Lyttle
Michael Macor
Jose Luis Magana
Todd Maisel
Mark Makela
John Markely
James Y.R.Mao
Melina Mara
Pete Marovich
Dan Marschka
Jacquelyn Martin
Ronald Martinez
Pablo Martinez Monsivais
Matt Marton
Felix Masi
Marianna Massey
AJ Mast
David Maung
Justin Maxon
Dania Maxwell
Ilona McCarty
Matt McClain
Sean McCormick
John W. McDonough
Michael F. McElroy
Kirk D. McKoy
Charles Meacham
Eric Mencher
Justin Merriman
Rory Merry
Nhat Meyer
Sebastian Meyer
Steve Meyer
Johnny Milano
Matt Miller
Peter Read Miller
Doug Mills
Stew Milne
Lianne Milton
John Minchillo
Donald Miralle, Jr.
Logan Mock-Bunting
Genaro Molina
Philip Montgomery
M. Scott Moon
John Moore
Andrea Morales
P. Kevin Morley
Stephen Morten
Laura Morton
Charles Mostoller
Bonnie Jo Mount
Marilyn Mueller
Pete Muller
Dijana
Rachel Mummey
Edward J. Murray
Mark Murrmann
Amanda Mustard
Burim Myftiu
Amos Nachoum
Adam Nadel
Go Nakamura
Ana Nance
Sol Neelman
Charlie Niebergall
Steve Nesius
Grant Lee Neuenburg
Gregg Newton
Jonathan A. Newton
Jehad Nga

Matthew Niederhauser
Adriane Ohanesian
Liz O. Baylen
Kathleen Orlinsky
Zach Ornitz
Francine Orr
Leonard Ortiz
Nick Oza
Darcy Padilla
Yana Paskova
Peggy Peattie
Randy Pench
Joe Penney
Corey Perrine
John Francis Peters
Christian Petersen
Brian Peterson
Mark Peterson
David J. Phillip
Terry Pierson
Spencer Platt
William B. Plowman
Suzanne Plunkett
John W. Poole
Gus Powell
Mike Powell
Karen Pulfer Focht
Gene J. Puskar
Staton Rabin
Joe Raedle
Anacleto Rapping
Anne Rearick
Eli Reed
Jim Reed
Andrea Star Reese
Tom Reese
Julia Rendleman
Damaso Reyes
Adam Reynolds
Michael Reynolds
Helen H. Richardson
Rick Rickman
Jessica Rinaldi
Amanda Rivkin
Larry Roberts
Michael Robinson Chávez
Diego James Robles
Rick Rocamora
Mike Roemer
Aaron Rosenblatt
Jenny E. Ross
Benjamin Rusnak
J.B. Russell
Craig Ruttle
Mike Sakas
Barbara L. Salisbury
Amy Sancetta
R.J. Sangosti
April Saul
Mindy Schauer
Meryl Schenker
Marc Schlossman
Bastienne Schmidt
Alyssa Schukar
Camille Seaman
C.S. Muncy
Mike Segar
Jim Seida
Evan Semón
Bill Serne
Sallie Dean Shatz
Ezra Shaw
Whitney Shefte
Callie Shell
Allison Shelley
Cindy Sherman
Sam Simmonds
Denny Simmons
Mike Simons
Stephanie Sinclair
Jeff Siner
Ashok Sinha
Wally Skalij
Brian Skerry
Laurie Skrivan
Matt Slaby
Lynne Sladky
Brian Smith
Bryan Smith
Drew Anthony Smith
Michael Kirby Smith
Patrick Smith
Trevor Snapp
Brian Snyder
Jared Soares
Brian Sokol
Chip Somodevilla
Alec Soth
Brea Souders
Alan Spearman

Tristan Alexei Spinski
Jamie Squire
Kieth Srakocic
Andrew Stanbridge
Jeremiah Stanley
Susan Stava
Matthew Staver
Jordan Stead
Sharon Steinmann
George Steinmetz
Maria Stenzel
Lezlie Sterling
Larry Downing
Arkasha Stevenson
Jamey Stillings
Sean Stipp
Robert Stolarik
Scott Strazzante
Theo Stroomer
Anthony Suau
Andrew Sullivan
Chitose Suzuki
Lea Suzuki
Lexey Swall
Chris Sweda
Charles Sykes
Joseph Sywenkyj
Kayana Szymczak
Shannon Taggart
Mario Tama
Andri Tambunan
Ross Taylor
Patrick Tehan
Daniel Tepper
Mark J. Terrill
Bizuayehu Tesfaye
Bob Thayer
Eric Thayer
Shawn Thew
Chelsea Dee Thom
Bryan Thomas
Thomas Turney
Elaine Thompson
Al Tielemans
Lonnie Timmons III
Tara Todras-Whitehill
Sebastiano Tomada
Jonathan Torgovnik
Ken Touchton
Daniel Traub
Linda Troeller
Scout Tufankjian
John Tully
Nicole Tung
Tyrone Turner
Susan Tusa
Jane Tyska
Dana Ullman
Walt Unks
Gregory Urquiaga
Will van Overbeek
Streeter Lecka
Alicia Vera
Brad Vest
Alejandra Villa
José Luis Villegas
Dilip Vishwanat
Paris Visone
Sarah L. Voisin
Stephen Voss
Evan Vucci
Carey Wagner
David M Warren
Guy Wathen
Billy Weeks
Steven Weinberg
Sandra Chen Weinstein
Diane Weiss
Ethan Welty
Seth Wenig
Nick Whalen
John H. White
Patrick Whittemore
Susan Wides
Stephen Wilkes
Rick T. Wilking
Kathy Willens
Matt Lutton
Shaie Williams
Tim Williams
Tracie Williams
Mark Wilson
Lisa Wiltse
Damon Winter
Dan Winters
Michael S. Wirtz
Sam Wolson
Joseph Woolhead
Alison Wright
Caroline Yang

David Yoder
Liyun Yu
Daniella Zalcman
Mark Zaleski
Zhao Jingtao
David Zimmerman
Chris Zuppa
Peter van Agtmael

Uruguay
Santiago Barreiro
Federico Estol
Julio Etchart
Giovanni Sacchetto
Christian Rodriguez
Nicolás Scafiezzo

Uzbekistan
Anzor Bukharsky

Venezuela
Alejandro Paredes
Gil Montaño
Gustavo Bandres
Jesus O. Baquero Suarez
Carlos Hernandez
Oscar B. Castillo
Dm Fenelon
Juan Carlos Hernandez
Nilo Jimenez
Leo Liberman
Fernando Llano
Frank López Ballesteros
Edsau Olivares
Jacinto Oliveros
Leo Ramirez
Mauricio Rivero Gonzalez
Luis Cobelo
Emanuele Sorge
Malva Suárez
Franklin Suárez
Jimmy Villalta

Vietnam
Vu Anh Tuan
Lai Khanh
Luong Phu Huu
Ly Hoang Long
Na Son Nguyen
Maika Elan
Phan Quang
Tran Viet Van
Vo Trung Nghia Trinh

Yemen
Alhasel
Yahya Arhab

Zimbabwe
Angela Jimu
Davina Jogi
Cynthia R Matonhodze
Annie Mpalume
Nancy Mteki
Tsvangirayi Mukwazhi
Desmond Zvidzai Kwande

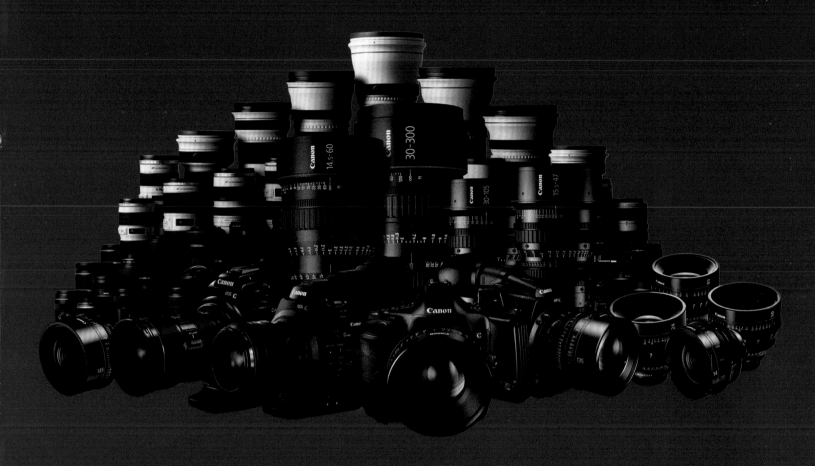

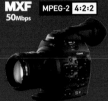

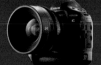

First published in Great Britain in 2013 by
Thames & Hudson Ltd,
181A High Holborn, London WC1V 7QX
www.thamesandhudson.com

First published in the United States of America
in 2013 by Thames & Hudson Inc.,
500 Fifth Avenue, New York, New York 10110
www.thamesandhudsonusa.com

Art director
Teun van der Heijden
Advisors
Daphné Anglès
Paul Ruseler
Design
Heijdens Karwei
Production coordinator
Tessa Hetharia
Picture coordinators
Noortje Gorter
Anna Lena Mehr
Nina Steinke
Captions and interview
Rodney Bolt
Editorial coordinators
Manja Kamman
Todd Savage
Femke van der Valk
Editor
Kari Lundelin

Color management
Debby Aries
S-Color, Amsterdam, the Netherlands,
www.scolor.nl

Paper
BVS FSC Mixed Credit 150 grams, cover 300
grams
Papierfabrik Scheufelen GmbH, Lenningen,
Germany, www.scheufelen.com
Print & Logistics Management
KOMESO GmbH, Stuttgart, Germany,
www.komeso.com
Lithography, printing and binding
ColorDruckLeimen GmbH, Leimen, Germany,
www.colordruck.com
Production supervisor
Maarten Schilt
Mariska Vogelenzang de Jong
Schilt Publishing, Amsterdam, the Netherlands,
www.schiltpublishing.com

ISBN 978-0-500-97047-8

Cover photograph
Paul Hansen, Sweden, *Dagens Nyheter*
Gaza Burial, Gaza City, Palestinian Territories,
20 November
World Press Photo of the Year 2012

Back cover photograph
Nadav Kander, UK, for *The New York Times*
Magazine
Daniel Kaluuya

About World Press Photo

Our aim is to inspire understanding of the world through high quality photojournalism.

World Press Photo is committed to supporting and advancing high standards in photojournalism and documentary photography worldwide. We strive to generate wide public interest in, and appreciation for, the work of photographers, and to encourage the free exchange of information.

Each year, World Press Photo invites photographers throughout the world to participate in the World Press Photo Contest, the premier international competition in photojournalism. All entries are judged in Amsterdam by an independent international jury composed of 19 experts. The prizewinning images are displayed in an annual exhibition that tours to 100 locations in 45 countries, and is seen by millions of visitors.

Our activities further include an annual contest for multimedia, exhibitions on a variety of current themes, and the stimulation of photojournalism through educational programs.

World Press Photo is run as an independent, non-profit organization with its office in Amsterdam, the Netherlands, where World Press Photo was founded in 1955.

For more information about World Press Photo and the prizewinning images, for interviews with the photographers, and for an updated exhibition schedule, please visit: www.worldpressphoto.org

Patron
HRH Prince Constantijn of the Netherlands

Supervisory Board
Chairman: Pieter Broertjes, Mayor of Hilversum, former editor-in-chief *De Volkskrant*
Members: Ebba Hoogenraad, partner law firm Hoogenraad & Haak, Advocaten
Kadir van Lohuizen, photojournalist Noor
Margot Scheltema, non-executive director Triodos Bank NV, ASR Insurance Netherlands,
Schiphol Group, supervisory board member ECN
Jenny Smets, director of photography *Vrij Nederland*

Advisory Council
Chairman: Alexander Rinnooy Kan, professor Economics and Business University of Amsterdam
Members: Peter Bakker, former chief executive officer TNT
Jan Banning, photographer
Lillan Baruch, management consultant
Niek Biegman, former Dutch ambassador
Antony Burgmans, former chairman/CEO Unilever
Wiebe Draijer, chairman The Social and Economic Council of the Netherlands (SER)
Femke Halsema, former member of Dutch parliament
Geert van Kesteren, photojournalist
Wim Pijbes, general director Rijksmuseum
Hans Smittenaar, country marketing director Canon Nederland NV
Dirk van der Spek, senior editor Focus Media Groep

World Press Photo holds the official accreditation for good practices from the Central Bureau on Fundraising (CBF).

World Press Photo receives support from the Dutch Postcode Lottery and is sponsored worldwide by Canon.

Canon has been a corporate partner of World Press Photo since 1992 and even though the nature in which journalists tell their stories continues to evolve, the Power of Image is as important and influential now as it has always been. Canon's longstanding relationship with World Press Photo is fuelled by Canon's passion to empower anyone to tell a story.

Supporters
Ammodo • Asahi Shimbun • CSM • Delta Lloyd Group • Deutsche Bahn • Mondriaan Foundation • The Netherlands Ministry of Foreign Affairs • Robert Bosch Stiftung

Contributors
Associates of World Press Photo
Acquia • Allen & Overy • Aris Blok, Velsen-Noord • The Associated Press • Capgemini • DoubleTree by Hilton Hotel Amsterdam • Drukkerij Mart.Spruijt • Fiat Group Automobiles Netherlands BV • FotografenFederatie of the Netherlands • Hilton Amsterdam • Hotel V • Human Rights Watch • Insinger de Beaufort • NDP Nieuwsmedia • Protocolbureau • Schilt Publishing • SkyNet Worldwide Express • Stichting Sem Presser Archief

Office
World Press Photo
Jacob Obrechtstraat 26
1071 KM Amsterdam
The Netherlands

Tel. +31 (0)20 676 60 96
Fax +31 (0)20 676 44 71

office@worldpressphoto.org
www.worldpressphoto.org

Managing director: Michiel Munneke
Deputy managing director: Maarten Koets